97 world longboard champion
Life is to short so go surfing!

DIRECTOR WORLD
BRUCE BROWN FILMS - SL
"SURFERS WALK OF FAME"
"SURFING HAS BEEN MY
SURFING HAS FORMED
AND DRIVES ME DAILY
WAVES AND BE ACTIVE AND HEALTHY.
AND STOKED!

At the time, the biggest
was the thought,
was med, pipe, sunset
cant be afraid to eat it.

The Thrill Is Back and Getting Better

Lets go

Surf life!
'We're at the greatest moment
in our life, always. Surf it!

Follow your dreams
Love the life because life loves you.

I AM HAWAIIAN AND VERY PROUD
HAWAIIAN. LOVE YOUR FRIENDS, LOVE YOUR
FAMILY, LOVE YOUR CULTURE. MAHALO NUI
LOA. THANK YOU VERY MUCH...

Co founder of Quicksilver
"MR SUNSET"!

Hand shaping a board for a friend
is very satisfying, especially later
when your all out surfing
together

LIVE ALOHA !!!

Surfing is a wild sport that no one
can compare to if they have never
tried it. It's got that element of surprize
and you never know what's going to
happen.

GO TO THE PLACE TO HAVE DONE
FOR A LIFETIME THIS BEEN A
MARVELOUS JOURNEY FOR ME.

From Hermosa Beach, Eucinitas, Maui, former top 16 AAAA pro surf
Contest Victories Span 6 decades with over 40 wins

Stay wet !!! Waves are where you find them.

THE OCEAN IS MY CHURCH AND MY PLAYGROUND
SURFING IS MY PASSION, SURFING IS WHAT
I LIVE FOR. IT IS SO PERSONAL SO AMAZING
YOU THE OCEAN AND YUR BOARD
THERE IS NOTHING LIKE IT
GO SURFFN!!!
SHARING AND EXPERIENCING IS WHAT ITS ALL
ABAT

Surfing in Hawaii
gift to the world
Surf with Aloha
fr O mmmmy

- BORNED IN HONOLULU
- Waikiki BEACH BOY
- LOVE Long boarding
- Surf instructor and canoe Capt.
I like entering longboard comp.
But the best one is the noseriding.
And HAPPY for the OLD BEACHBOYS
(COOKIE, BLUE, DIDI, KIMO) FOR GUIDING
my way threw life and being a BEACHBOY

"Noted as originator of modern longboard
"Appreciate the life you have"

Started surfing 1957, writing about it
in 1968, paying attention to it still,
54 years spent watching something,
Trying to see it clearly.

Born in Maui. Been Surfing my
whole life and it will never be old there's
always different waves and ways of surfing
to always get a rush and have fun.

Surfing is unpredictable, Pipe
is unpredictable... I have no
choice but to be unpredictable
I love this unpredictable life.

I have more respect for the ocean than any man on earth. Its given me everything I have. Friends, Food, a Job and a life time of unreal experiences.

SURFING 40 yrs. Competed 25 years. Coordinate + run Amateur Surfing competitions for the Wester Surfing Association. I am Honored to be a Malibu Surfing Legend and San Clemente Surf Legend. Featured on a Flag hanging in Town. Also was Featured on the First West Magazine in the La Times 1966.

SHAPING ALMOST 50 years and STILL LEARNING...

Material possetions will never amount to the feelings surfing brings. I came in to this world with nothing and I'll leave this world with nothing. Mean while surfing makes me as wealthy as can be!

- Born and raised on Maui. Hookipa Bay (HGA)
- Self-sponsored - solar electrician
- Love Big waves - Peahi, Pipeline, Tavarua
- Tavarua Lifeguard
- Surfing also + ocean are in my blood
- Raised by surfers

Been surfing for many years. Competed in many events. Had A Few results. My sons Mason Ho and Coco Ho are professional surfers.

I've been surfing for 30 years with my mom. Surfed professionally for 12 years and surfed professionally for 10 years. Wrote articles for major surf publications for 10 years. Featured in numerous surf films including Step Into Liquid, The Sprout, and the Seedling. Featured in major surf publications from the mid 90's - mid 2000's. Member of the Wind n Sea Surf Club.

Pioneered Barrel riding for women
First women to score 2 perfect 10's in a single heat (still hold the record)
Runner up to the world title 2004
3x surfer poll winner
Held surf camps for girls (Development programs)
Stunt Double in Blue Crush
My love for the ocean & passion for riding waves particularly in the barrel has kept the kid alive me + inspires me to share w/ others

Love each other sincerely. True to Life ANY day But don't Lie OR quit

Both parents surfed + continue to today. I have won multiple national titles in shortboarding than a Pan-American championship (1995) but am most proud that I have 3 world longboard titles (2000, 2001 + 2010). I have also won a longboard event at Pipeline (2009)

Began surfing at the age of 5.

Surfing is the easy part
Surviving is hard

SURF OR DIE!

THE HAWAII COACH FOR HAWAII'S ELITE YOUTH SURF TEAM. DO MY BEST TO GUIDE THE UP + COMERS TOWARD SUCCESS IN WHAT THEY DO, BUT MORE IMPORTANTLY, TO BE GOOD HUMANS THAT HAVE SOMETHING TO GIVE BACK TO THE WORLD.

born and raised on the North Shore of Oahu
swam before I took my first step
Living the dream!

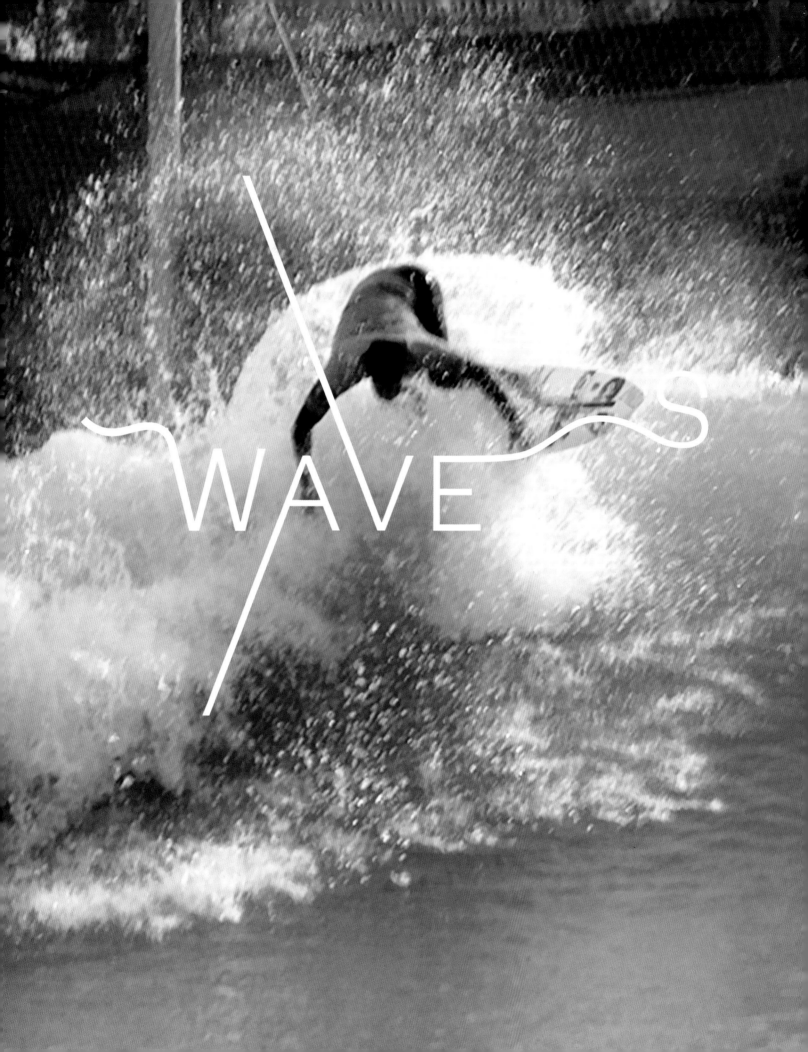

Editor: David Cashion & Garrett McGrath
Designers: John Gall & Eli Mock
Production Manager: Michael Kaserkie

Library of Congress Control Number: 2018958324
ISBN: 978-1-4197-3821-0
eISBN: 978-1-68335-663-9

Text and photographs copyright © 2019 Thom Gilbert

Steve Pezman interview by Glenn Sakomoto.
Reprinted by permission from online magazine Liquid Salt.

John Severson essay by Mat Arney originally published online
for Surf Simply. Reprinted with permission from Mat Arney.

Photograph on page 18 of author with Kelly Slater
and spectators by Todd Glaser, reproduced with permission.

Photographs on page 55 courtesy of Bruce Brown Films, LLC
Archives

Photograph on page 90 of John Severson by Tom Kelley/
Fulton Archive/Getty Images, reproduced with permission.

Cover © 2019 Abrams

Published in 2019 by Abrams, an imprint of ABRAMS.
All rights reserved. No portion of this book may be reproduced,
stored in a retrieval system, or transmitted in any form or by
any means, mechanical, electronic, photocopying, recording, or
otherwise, without written permission from the publisher.

Printed and bound in China
10 9 8 7 6 5 4 3 2 1

Abrams books are available at special discounts when purchased
in quantity for premiums and promotions as well as fundraising
or educational use. Special editions can also be created to
specification. For details, contact specialsales@abramsbooks.com
or the address below.

Abrams® is a registered trademark of Harry N. Abrams, Inc.

ABRAMS The Art of Books
195 Broadway, New York, NY 10007
abramsbooks.com

July 20, '20

Thomas,

By Land, by Sea, & now by Air!
From the Wild-Child days, I knew you
weren't going to let much pass you by on your
lifes journey. Boy was I right!
The Tree climbing child became a Master
teacher of caring for Trees. The skate boarding Teen
went from half pipes to careening down College Hill
& Paris streets. From skate board to surf board
riding waves from Coast to Coast + far away places.
And you weren't about to let your beautiful wife
get one up on you with a sky dive by herself for her 50th!
Your sense of adventure with your love, Care +
enthusiasm of life in all you do have made me
a very proud Mom.
Happy 50th Birthday, my Yogi, Beach Boy, Sky diving, Free
Bird, Wild Child —
I Love You
Mom

Previous page: Surfer competing at first WSL competition at Kelly Slater's Surf Ranch with
artificially made waves, Lemoore, California. Opposite: Grain Surfboards, Amagansett, New York.
Back cover: Jadson André, Brazilian surfer who competes on the WSL World Championship Tour

WAVES

Pro Surfers and Their World

Thom Gilbert

Abrams, New York

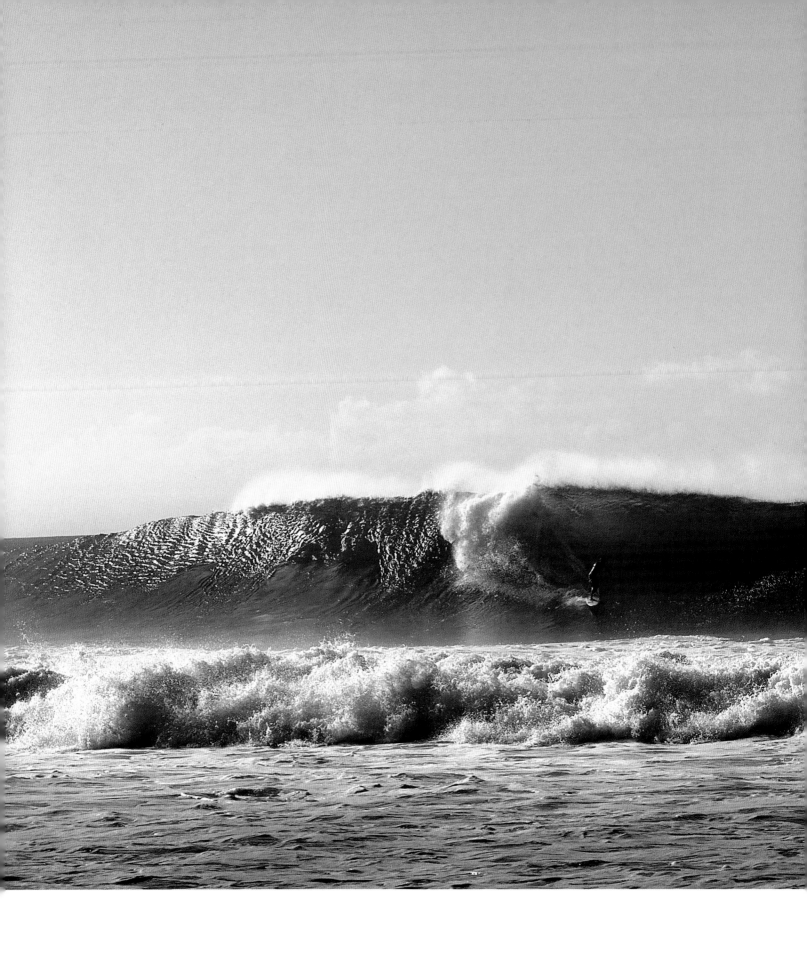

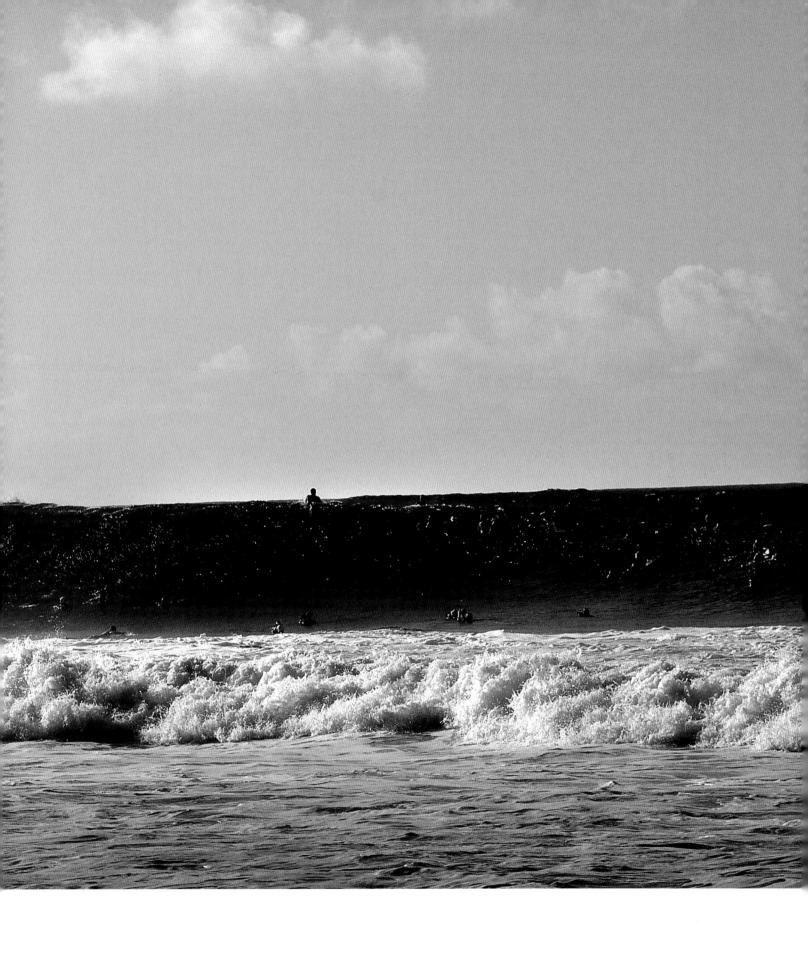

Contents

ROUND 1

HEAT 1
ADRIAN BUCHAN o
HIZUNOME BETTERO w
GLENN HALL b
TORREY MEISTER bk

HEAT 2
AUSTIN WARE o
MATT WILKINSON o
DUSTY PAYNE w
JONATHON GONZALEZ b

HEAT 3
GABRIEL MEDINA o
CORY LOPEZ w
ADAM ROBERTSON b
KEKOA BACALSO bk

HEAT 4
MICHEL BOUREZ o
TRAVIS LOGIE w
BLAKE THORNTON b
EVAN GEISELMAN bk

HEAT 5
DAMIEN HOBGOOD o
RICHARD CHRISTIE w
NATHANIEL CURRAN b
JACK FREESTONE bk

HEAT 6
C.J. HOBGOOD o
TOM WHITAKER w
JOEL CENTEIO b
ROY POWERS bk

HEAT 7
CHRIS DAVIDSON o
KAI OTTON w
LINCOLN TAYLOR b
PEDRO HENRIQUE bk

HEAT 8
TAJ BURROW o
BILLY STAIRMAND w
NIC MUSCROFT b
CONNER COFFIN bk

HEAT 9
PATRICK GUDAUSKAS o
TANNER GUDAUSKAS w
LEONARDO NEVES b
CAIO IBELLI bk

HEAT 10
ALEJO MUNIZ o
DION ATKINSON w
GONY ZUBIZARRETA b
BRIAN TOTH bk

HEAT 11
DANIEL ROSS o
JOSH KERR w
DYLAN GRAVES b
BERNARDO MIRANDA bk

HEAT 12
KELLY SLATER o
MASON HO w
JAY QUINN b
JANO BELO bk

HEAT 13
MICK FANNING o
ARITZ ARANBURU w
MARC LACOMARE b
LUKE DAVIS bk

HEAT 14
RAONI MONTEIRO o
ADAM MELLING w
JOAN DURU b
KOLOHE ANDINO bk

HEAT 15
DANE REYNOLDS o
JESSE MENDES w
SHAUN JOUBERT b
TIM REYES bk

HEAT 16
JULIAN WILSON o
GABE KLING w
KAI BARGER b
SUNNY GARCIA bk

HEAT 17
BEDE DURBIDGE o
JUNIOR FARIA w
MASATOSHI OHNO b
MITCH CREWS bk

HEAT 18
JADSON ANDRE o
YADIN NICOL w
TONINO BENSON b
LUKE STEDMAN bk

HEAT 19
HEITOR ALVES o
GRANGER LARSEN w
HODEI COLLAZO b
ROYDEN BRYSON bk

HEAT 20
JOEL PARKINSON o
BOBBY MARTINEZ w
WIGGOLLY DANTAS b
ROB MACHADO bk

HEAT 21
ADRIANO DE SOUZA o
FREDRICK PATACCHIA w
NAT YOUNG b
DALE STAPLES bk

HEAT 23
MIGUEL PUPO o
WILLIAN CARDOSO w
NATHAN YEOMANS b
STU KENNEDY bk

HEAT 24
JEREMY FLORES o
RICARDO SANTOS w
HEATH JOSKE b
MAXIME HUSCENOT bk

ROUND 2

HEAT 1
HIZUNOME BETTERO o
DUSTY PAYNE w
KEKOA BACALSO b
BLAKE THORNTON bk

HEAT 2
TORREY MEISTER o
JONATHON GONZALEZ w
GABRIEL MEDINA b
EVAN GEISELMAN bk

HEAT 3
RICHARD CHRISTIE o
C.J. HOBGOOD w
PEDRO HENRIQUE b
CONNER COFFIN bk

HEAT 4
JACK FREESTONE o
JOEL CENTEIO w
CHRIS DAVIDSON b
TAJ BURROW bk

HEAT 5
PATRICK GUDAUSKAS o
BRIAN TOTH w
DYLAN GRAVES b
JANO BELO bk

HEAT 6
TANNER GUDAUSKAS o
ALEJO MUNIZ w
JOSH KERR b
KELLY SLATER bk

HEAT 7
MICK FANNING o
ADAM MELLING w
JESSE MENDES b
GABE KLING bk

HEAT 8
ARITZ ARANBURU o
KOLOHE ANDINO w
DANE REYNOLDS b
JULIAN WILSON bk

HEAT 9
BEDE DURBIDGE o
JADSON ANDRE w
HODEI COLLAZO b
WIGGOLLY DANTAS bk

HEAT 10
JUNIOR FARIA o
YADIN NICOL w
ROYDEN BRYSON b
BOBBY MARTINEZ bk

HEAT 11
ADRIANO DE SOUZA o
THIAGO CAMARAO w
MIGUEL PUPO b
MAXIME HUSCENOT bk

HEAT 12
NAT YOUNG w
JOHN JOHN FLORENCE w
NATHAN YEOMANS b
JEREMY FLORES bk

ROUND 3

HEAT 1
DUSTY PAYNE b
JONATHON GONZALEZ w

HEAT 2
HIZUNOME BETTERO b
EVAN GEISELMAN w

HEAT 3
RICHARD CHRISTIE b
JOEL CENTEIO w

HEAT 4
C.J. HOBGOOD b
TAJ BURROW w

HEAT 5
DYLAN GRAVES b
KELLY SLATER w

HEAT 6
PATRICK GUDAUSKAS b
TANNER GUDAUSKAS w

HEAT 7
JESSE MENDES b
KOLOHE ANDINO w

HEAT 8
ADAM MELLING b
DANE REYNOLDS w

HEAT 9
BEDE DURBIDGE b
YADIN NICOL w

HEAT 10
JADSON ANDRE b
ROYDEN BRYSON w

HEAT 11
THIAGO CAMARAO b
JEREMY FLORES w

HEAT 12
MIGUEL PUPO b
JOHN JOHN FLORENCE w

HEAT 1
DUS
EVA
RICH

HEAT 2
TAJ
KELL
TANN

HEAT 3
KOLO
DANE

HEAT 4

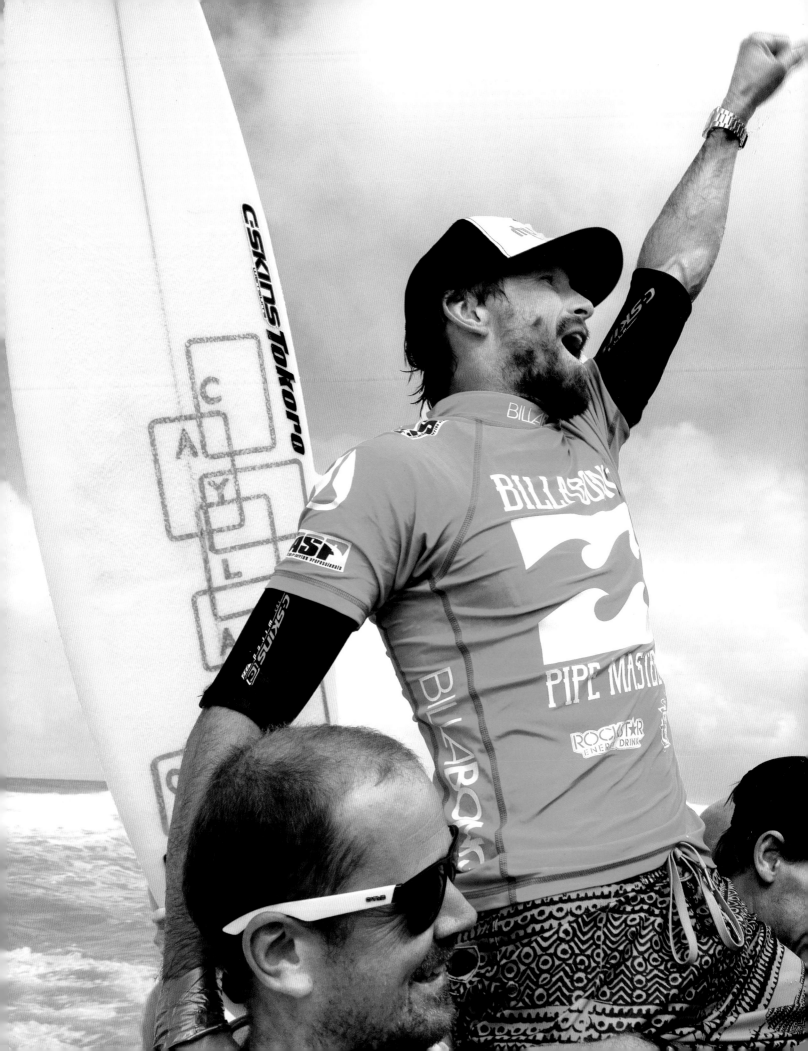

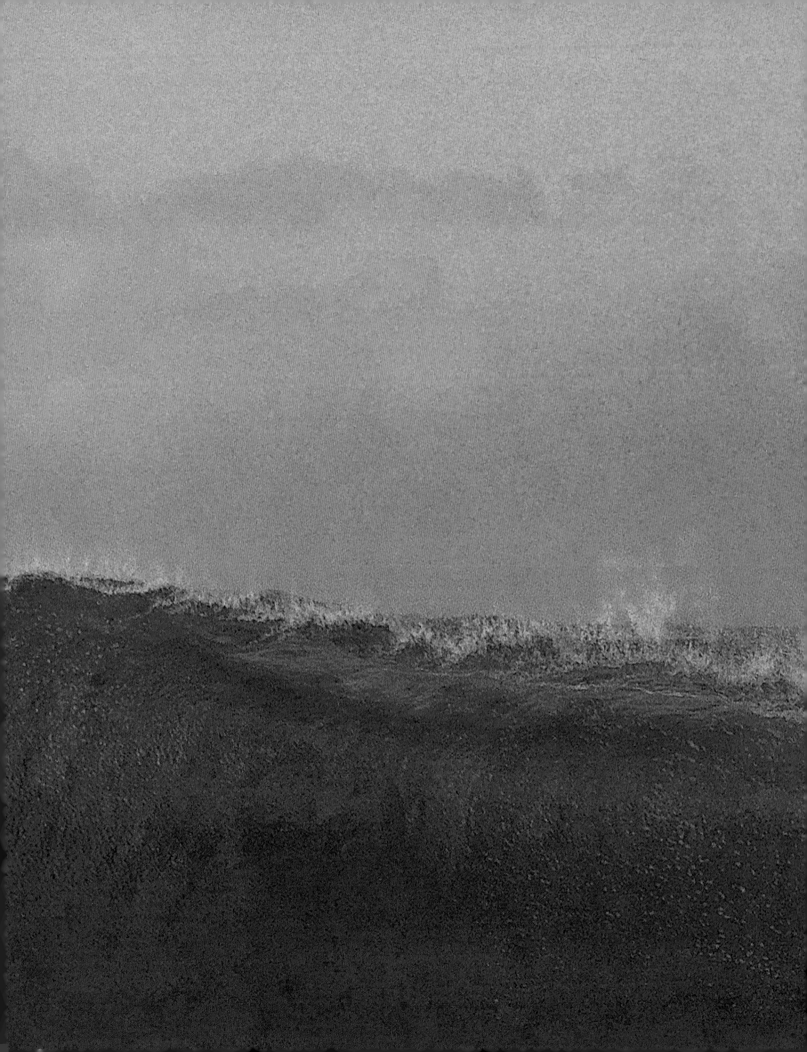

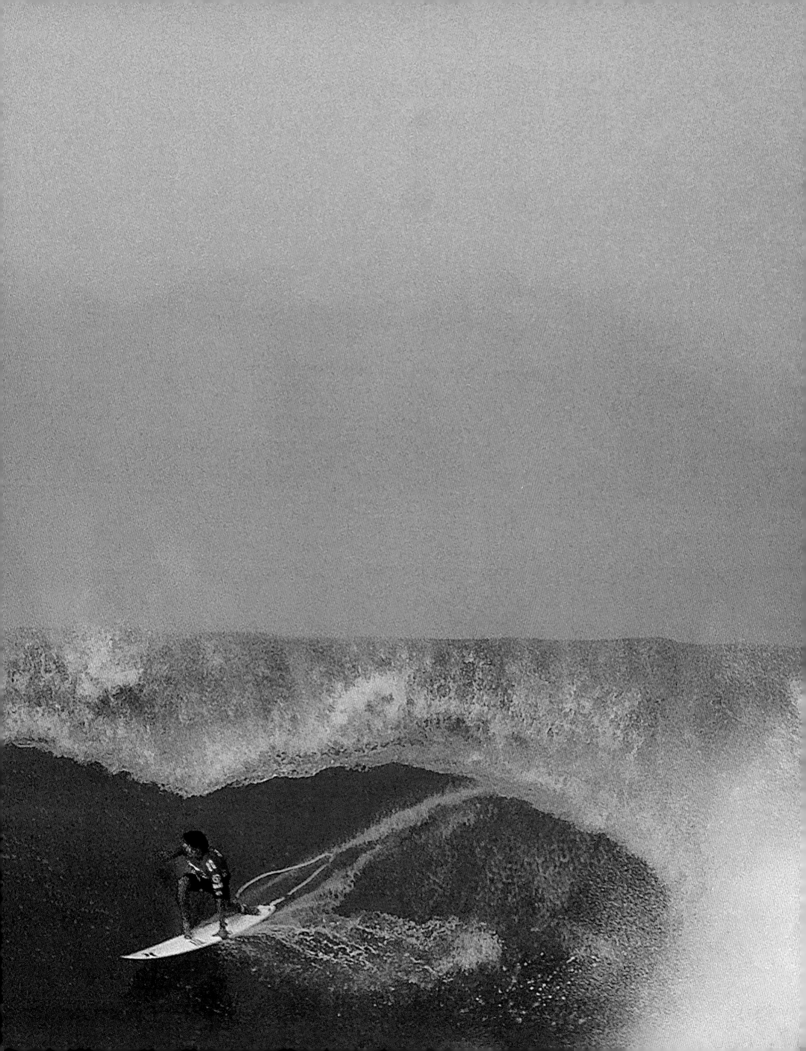

Foreword by

GAR
RE
TT

MC
NAMA
RA

Won world title in 2011 and 2013 for surfing largest wave (Nazaré, Portugal)

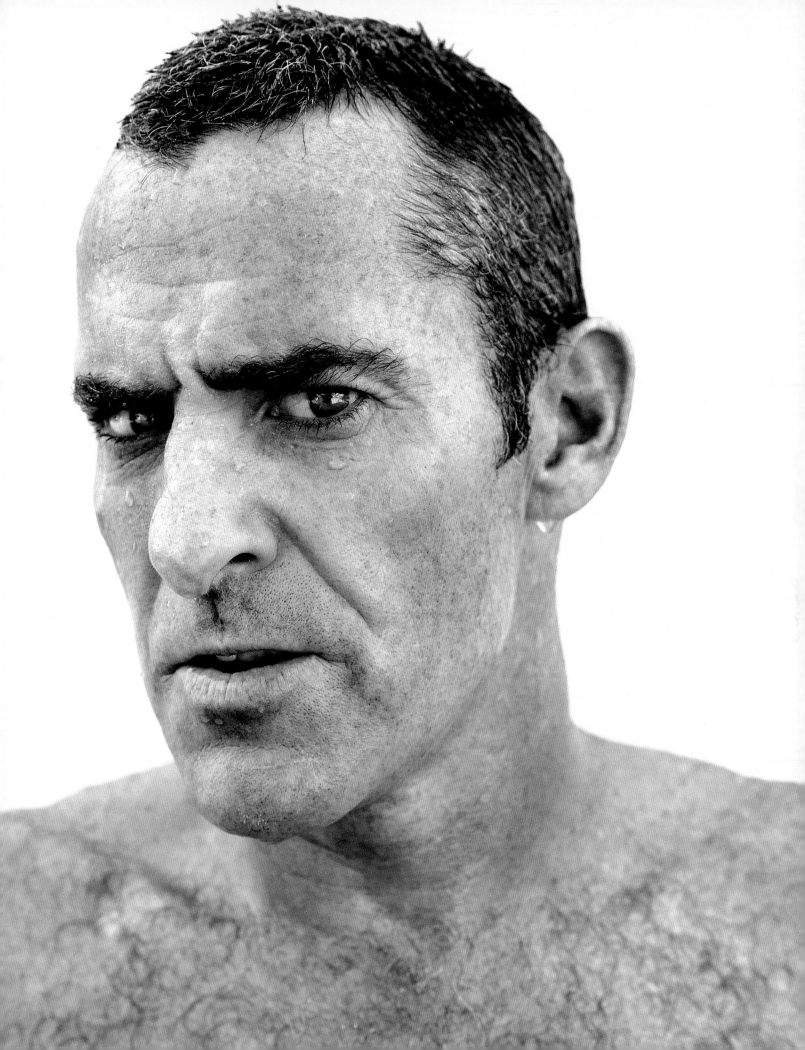

turn to doubt is when you end up in the washing machine. When you're underwater, getting tossed around like a grain of sand, all you can do is enjoy the ride and completely resist the urge to fight back. Just relax and go to your happy place, and before you know it, you are at the surface taking a breath and preparing for the next wave.

In surfing, once you decide you are going, you have to be 110 percent committed; there is no holding back, no hesitation. You must paddle with all your might, and you must know that you are going to make it. The moment you let the mind

Our mind is only responsible for 2 percent of our total body weight, yet for some reason it has the ability to completely control our every move, our every thought, our every decision. Taking control of your mind can truly free your spirit. One thing our mind is responsible for is our ego, our self-worth—our self-esteem. The greatest challenge I have found in big-wave surfing is to leave the ego aside and listen to my heart, asking myself what my spirit truly wants. When I first started surfing big waves, it was the opposite of ego. I would paddle out to the outer reefs to be on my own, away from the crowds. I was also living for the rush of adrenaline that big

waves give you. Then surfing became a way for me to support myself and my family. It required me to sell myself to companies, brands, et cetera. Why me versus the other guy? Around this time, I lost the rush. I no longer felt adrenaline on these big waves. So why did I keep doing it? I love riding big waves even without the rush, but why keep searching for bigger and bigger waves? I suppose I am searching for a big enough wave to get the rush back—but why? My wife has admitted that every time I go out there, I do it for my spirit and not my ego. I do it because I love surfing. I love being on these giant moving canvases of water. I make sure I am not out there

just because someone else is or to beat some record. When I surf because of ego, I don't have a good session—when I surf for me and for the pure love of surfing, then magic happens. It truly is an everyday battle between ego and spirit, especially with social media contributing to the fear of missing out, which can creep in and cause me to make decisions based on ego. You have to keep yourself in check with meditation, reading, and goal-setting.

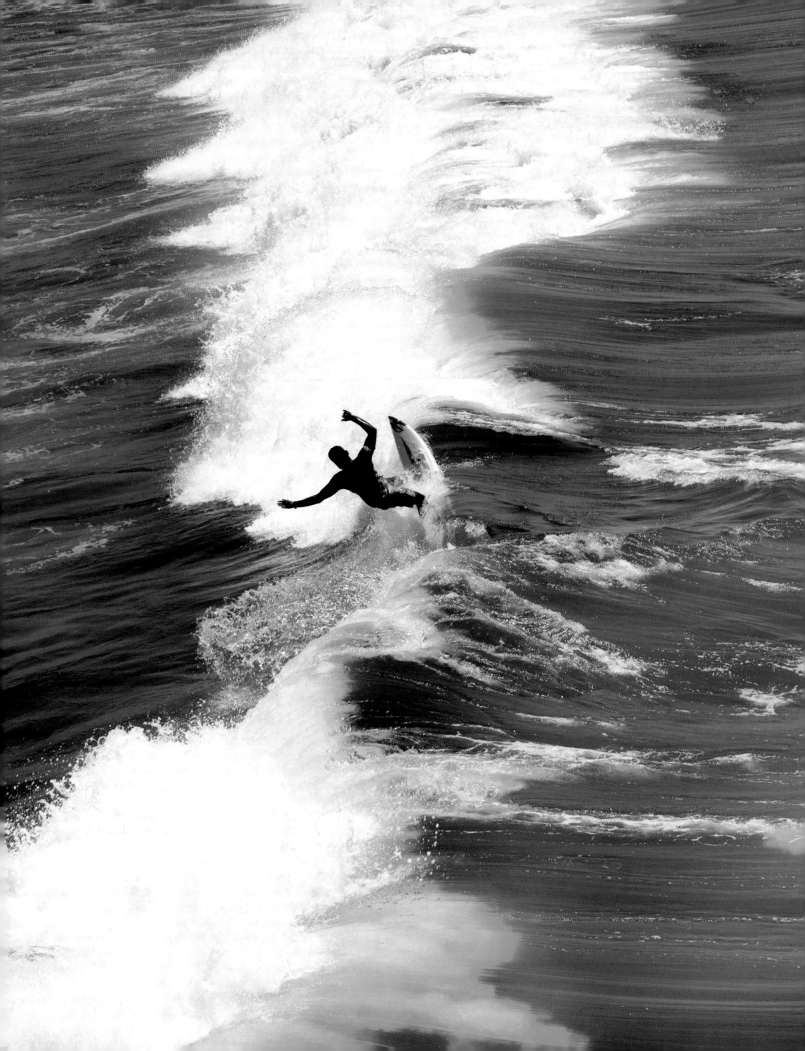

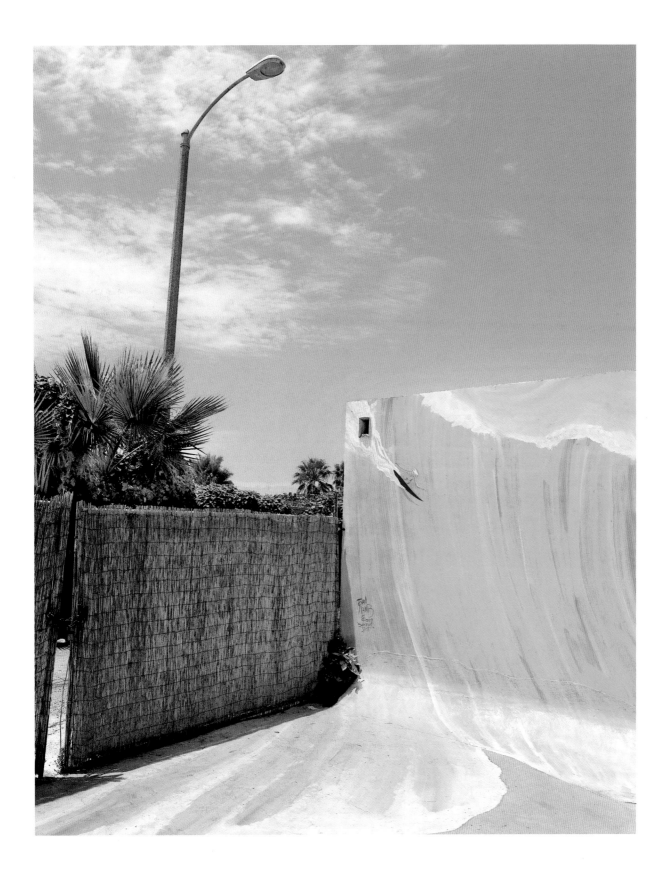

INTRO DUC TION

Basketball, baseball, football, and tennis are just a few sports that we love and enjoy playing and watching. They take place on surfaces that are built synthetically and arranged in areas where they are needed. This is a vastly different situation from the playing areas that surfers have and need. Theirs are not built, nor are they strategically placed; they exist where they have been for millions of years—on the oceans of the world. As a result, it's easy to understand the appreciation these individuals express for their playing fields and the quasi spirituality they derive from them. The ocean can be daunting and downright menacing, but after being immersed in the world of surfing for seven years and having a kid who surfs around Long Island, I've learned the common maxim among all those who successfully ride its waves: "Respect the sea and you will be rewarded." The great thing is we can learn to adapt that idea to other challenges in life, and the rewards of that lesson are ultimately limitless.

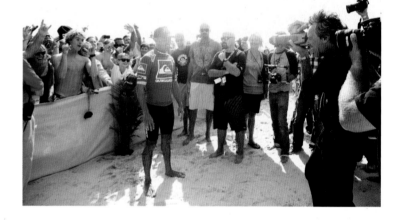

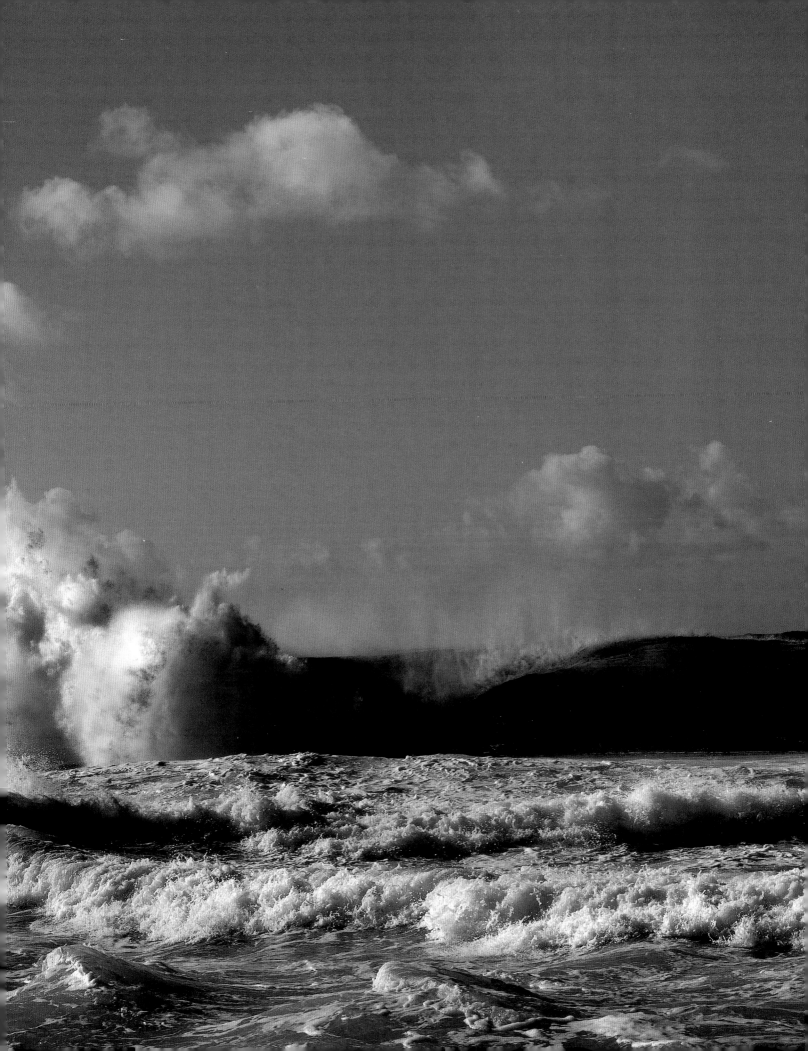

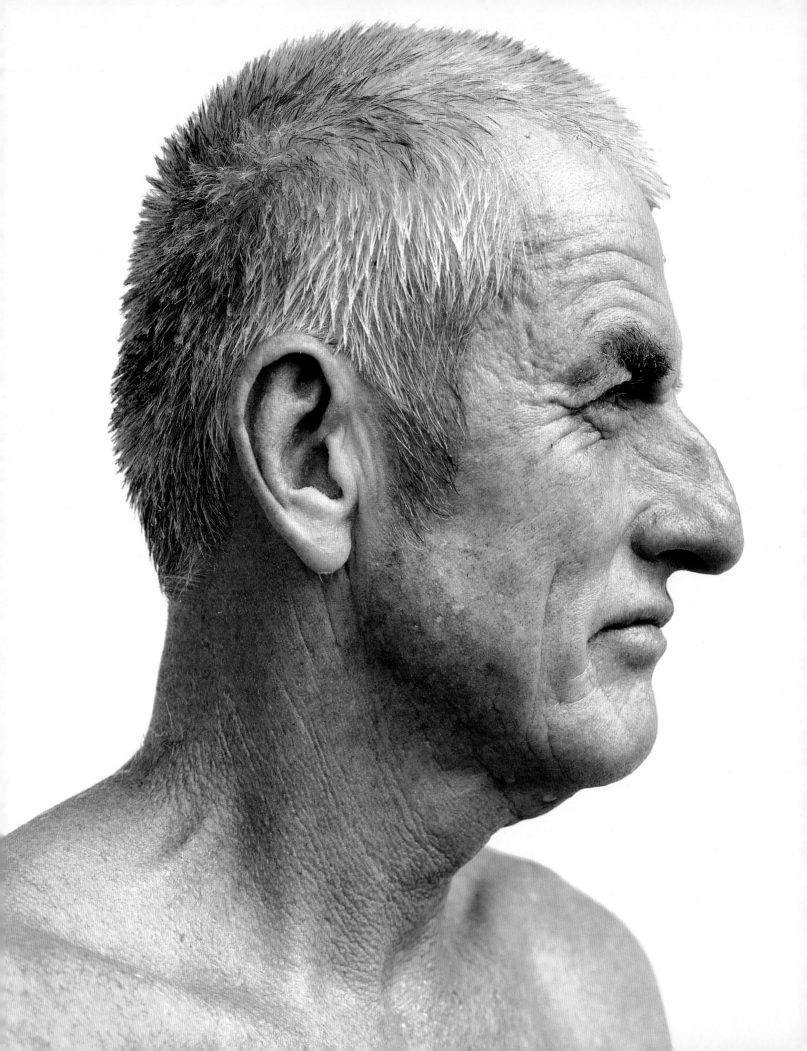

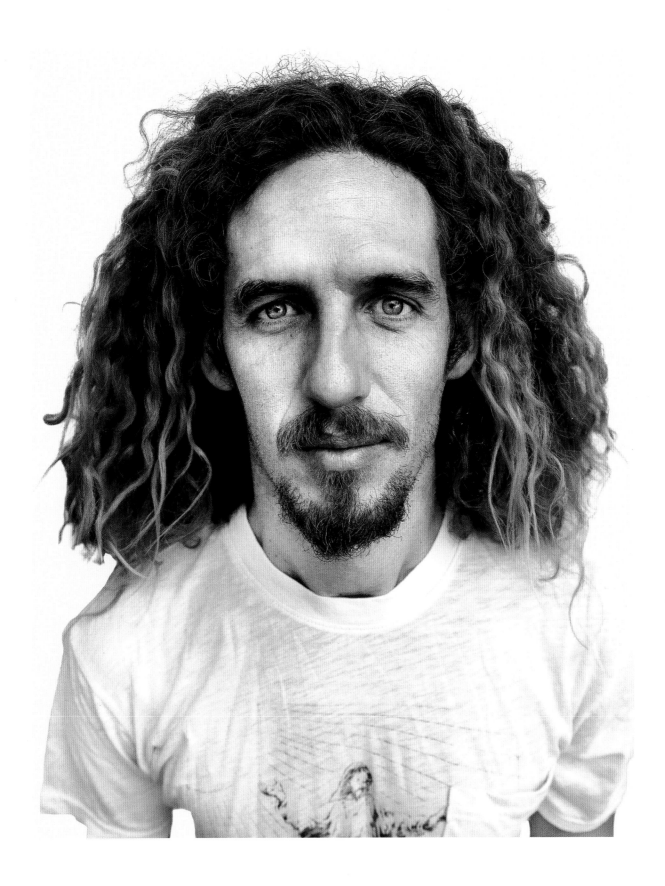

Opposite: Mark Cunningham, top body surfer in the world
Right: Rob Machado, winner of 2000 Pipe Masters

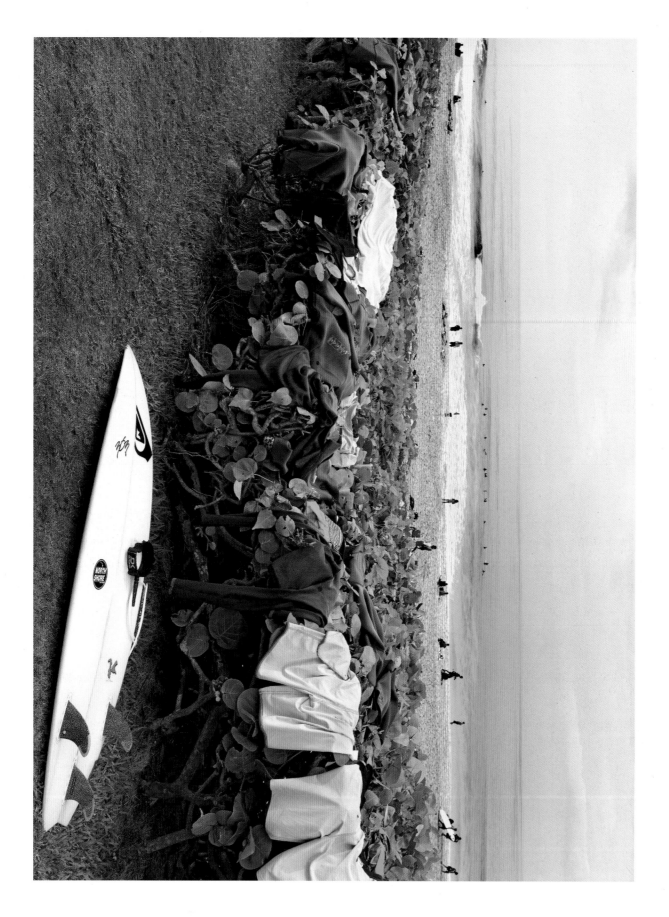

Left: Surf company team house, Oahu

Opposite: Early morning surf briefing, France

22

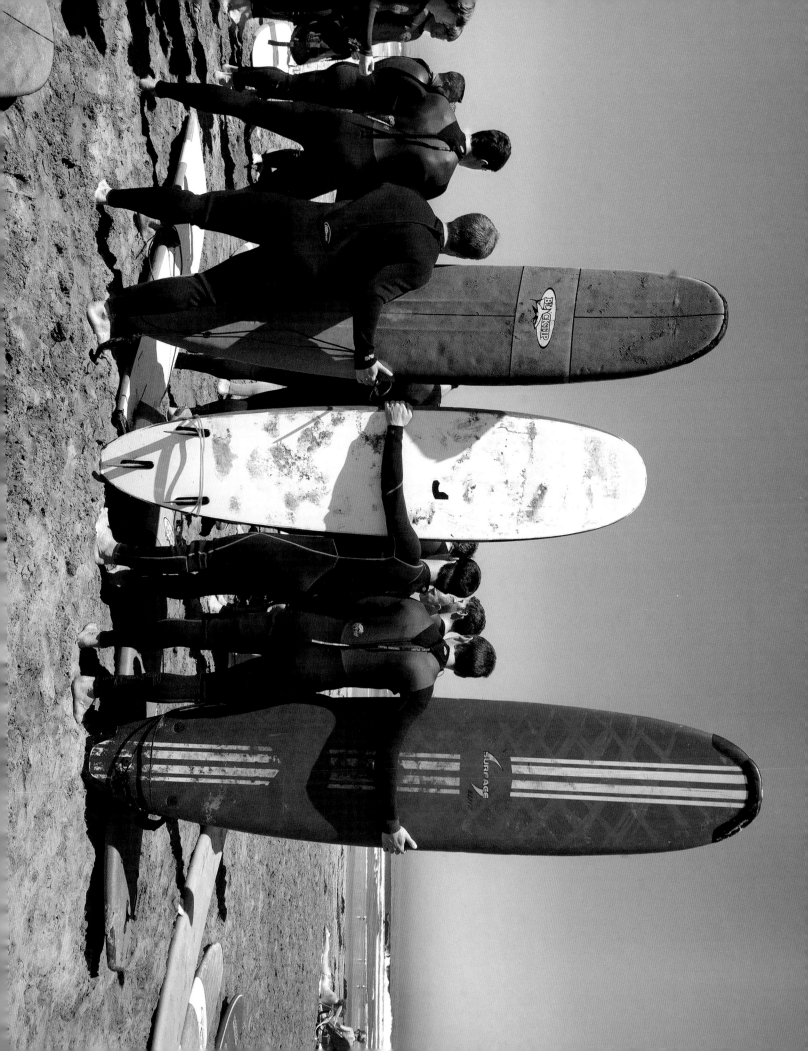

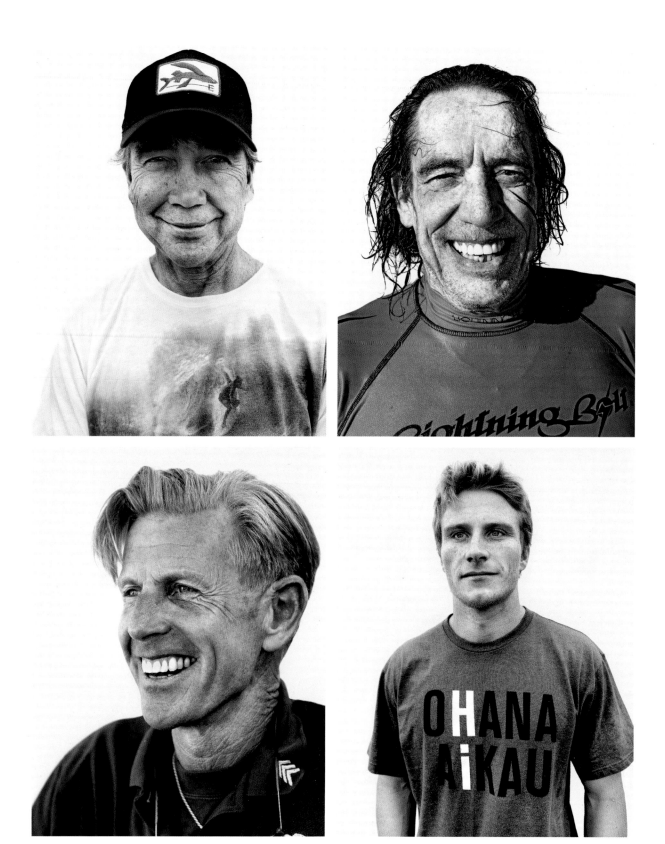

Top left: Jerry Lopez, 1972 and '73 Pipe Masters winner and master surfboard maker

Top right: Rory Russell, famed veteran North Shore surfer and shaper for Rory Russell Surfboards

Bottom left: Robert Veria, longtime head lifeguard at Encinitas's major surf beach, California

Bottom right: Mark Healey, pro big-wave surfer

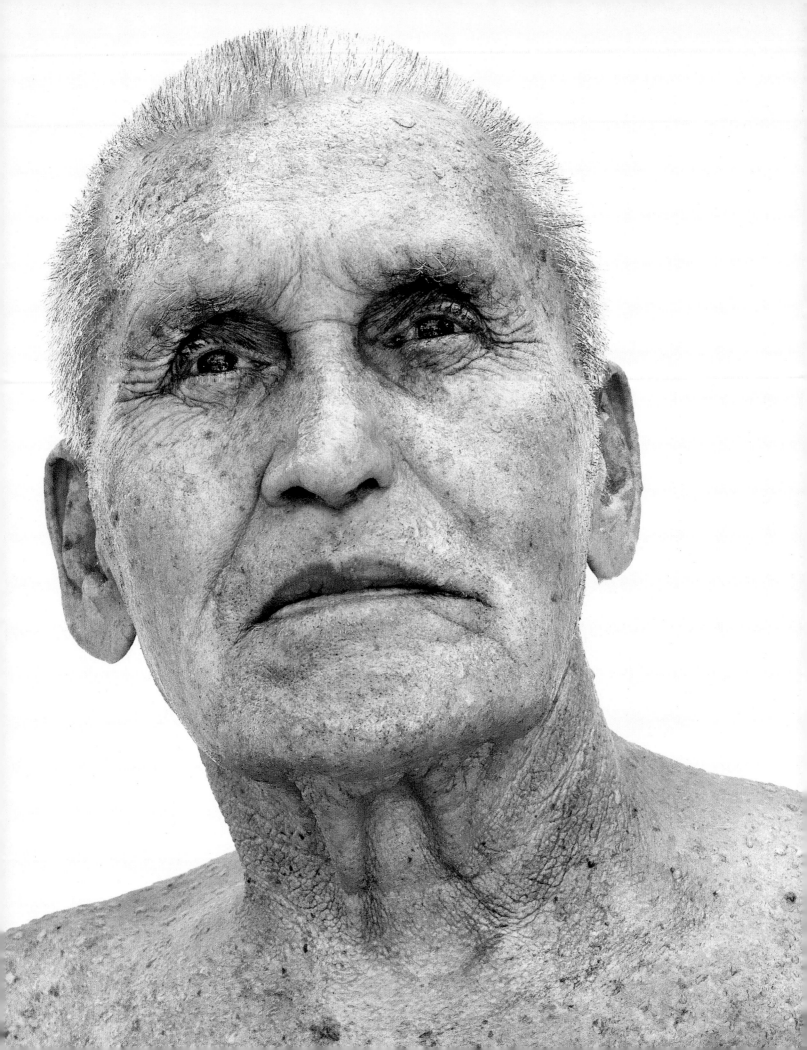

Opposite: Rabbit Kekai, surfing legend and original innovator of modern surfing; dominant master of the sport in the 1930s, 1940s, and 1950s. Right: Kamalei Alexander, Hawaii; competed in Billabong Banzai Pipeline Masters and Billabong Teahupoo PRO; one of the pioneers of international surfing

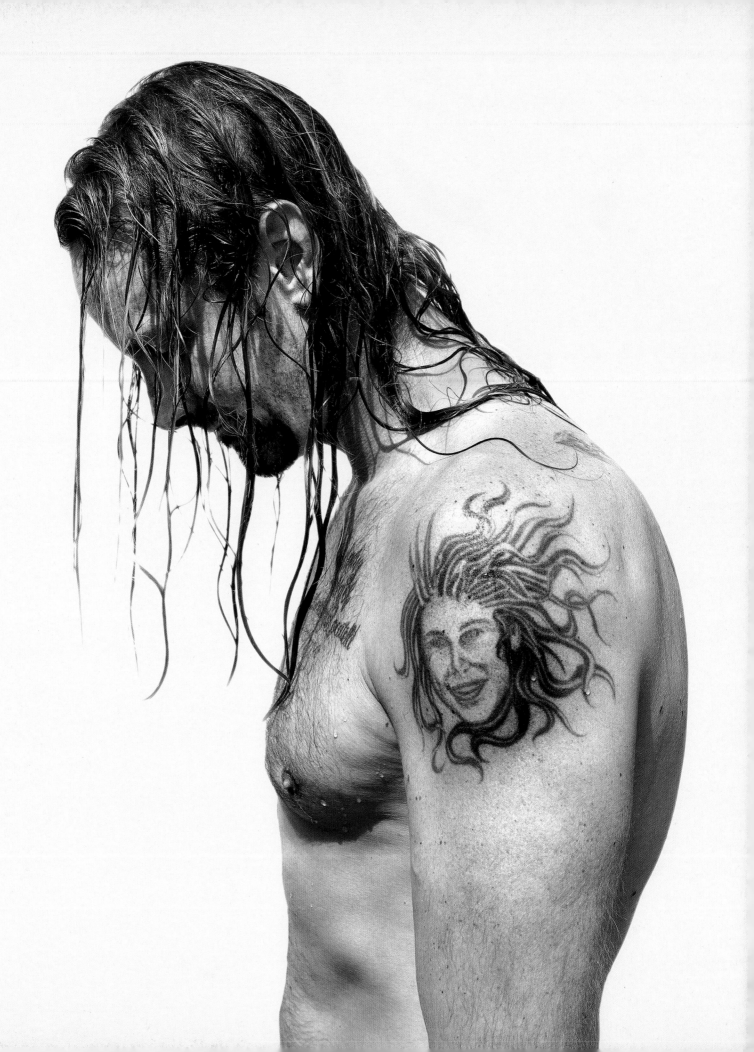

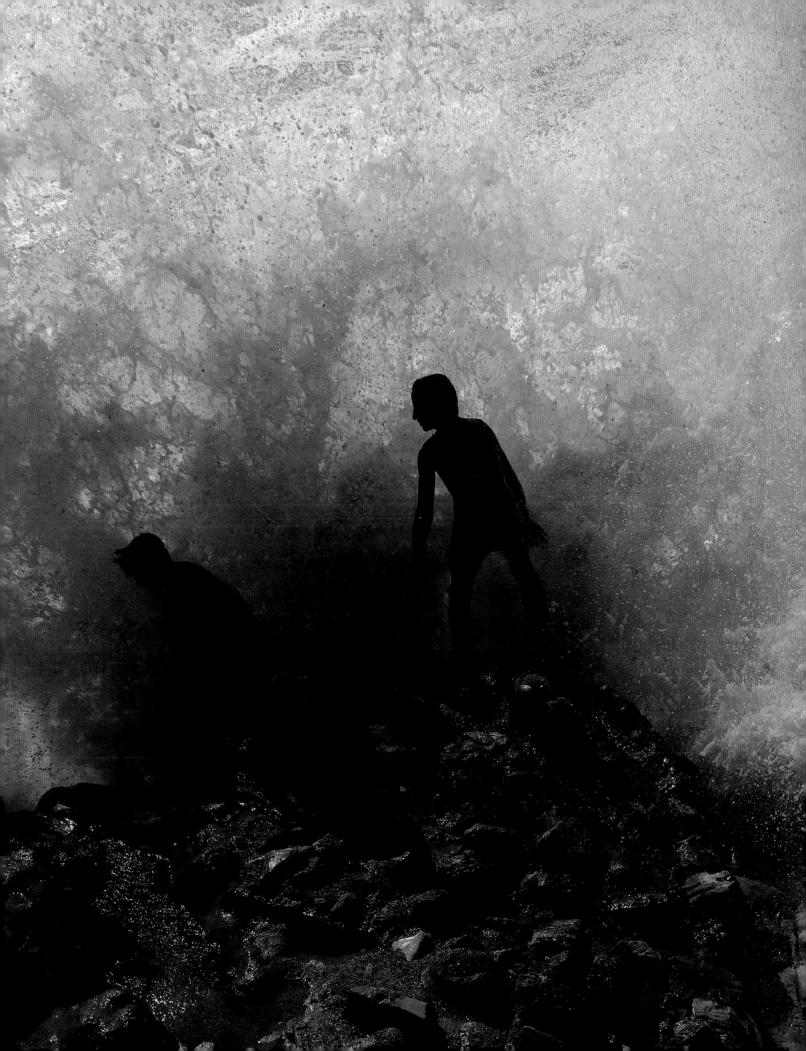

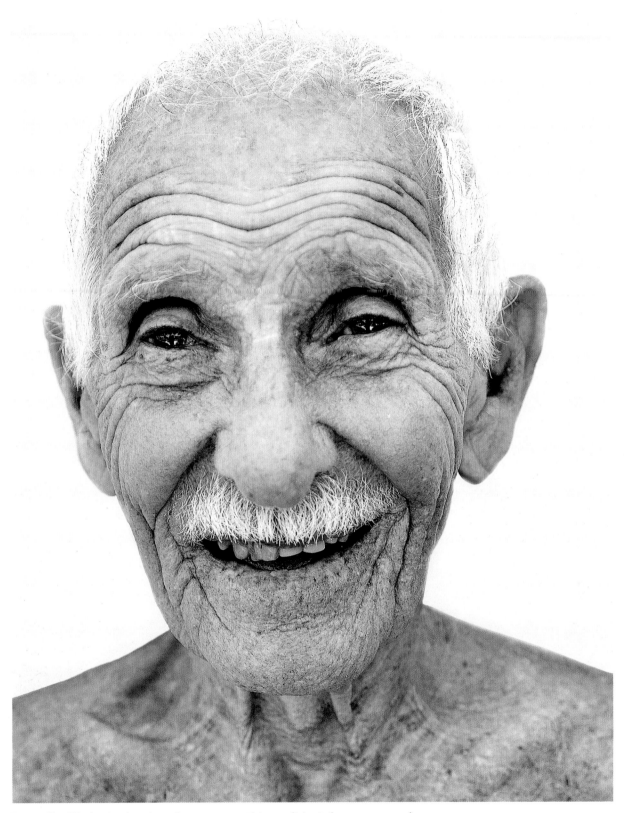

Opposite: Matt "Rocky" Rockhold, Santa Cruz

Dorian "Doc" Paskowitz, American who gave up practicing medicine to become a pro surfer. In 1972, he founded a surf camp with his family. Most notably, in 2007, Doc founded Surfing for Peace. His efforts, beginning with delivering surfboards to surfing communities in Gaza, have given underprivileged surfers who could not afford surfboards a chance to have one and connect with surfing and the sea.

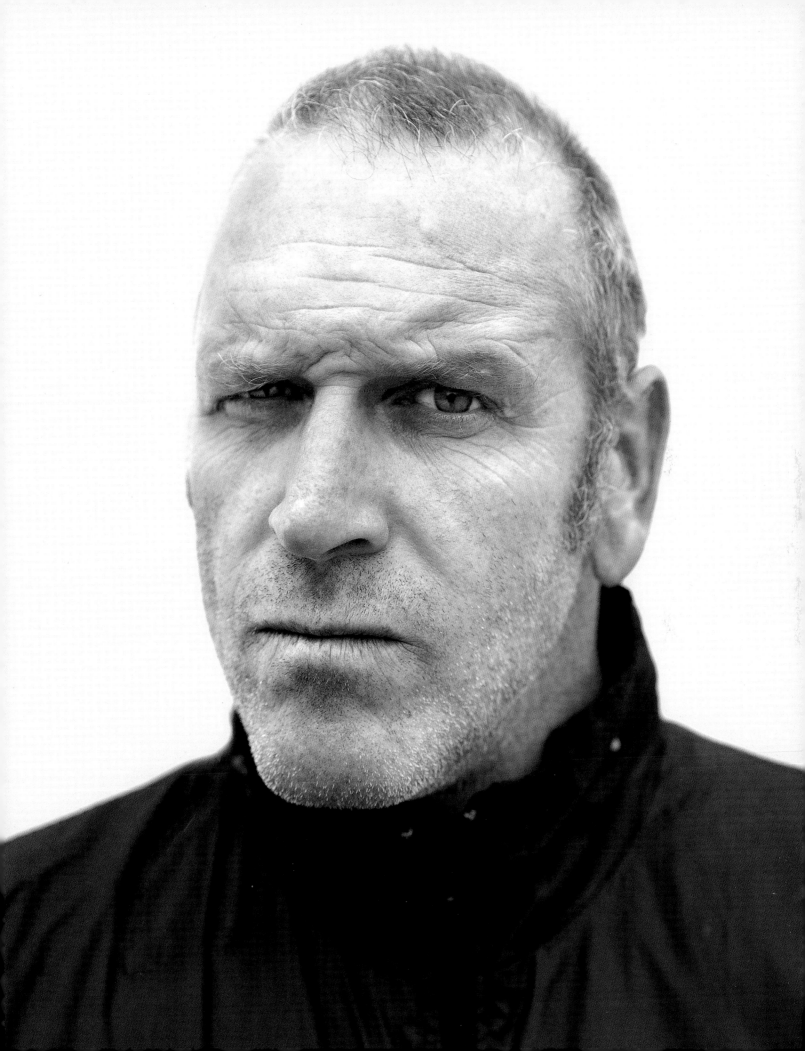

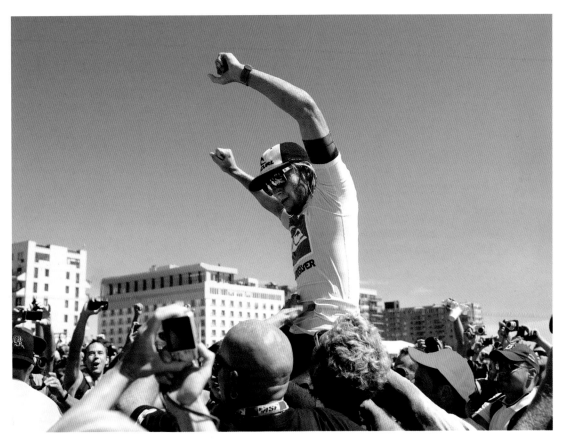

"Victory": Owen Wright, Quiksilver Pro, New York City, 2011

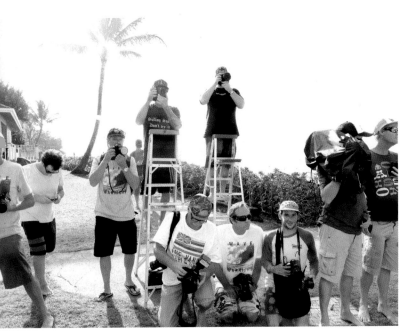

Press pool for Herbie Fletcher's annual "Wave
Warriors" event, Oahu

Gabriel Medina, 2016 Pipe Masters, Oahu

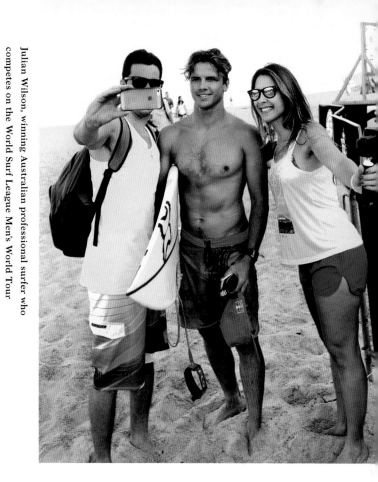

Julian Wilson, winning Australian professional surfer who competes on the World Surf League Men's World Tour

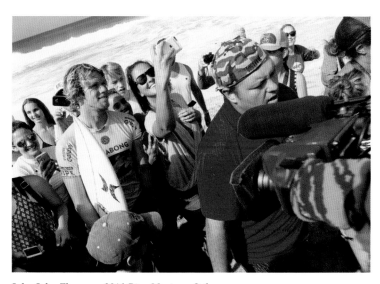

John John Florence, 2016 Pipe Masters, Oahu

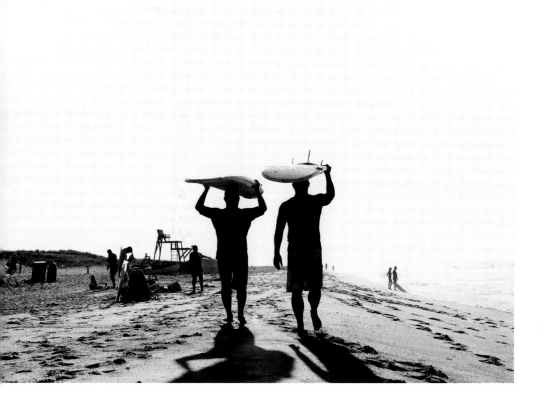

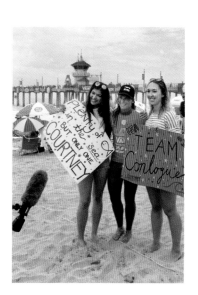

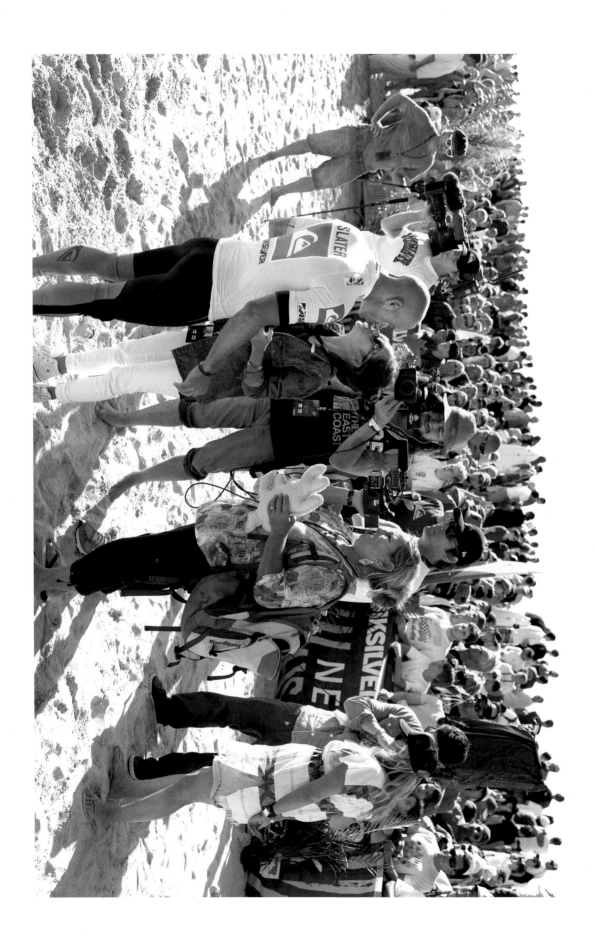

Left: Kelly Slater and girlfriend Kalani Miller, New York

Opposite: North Shore Pipeline, Oahu

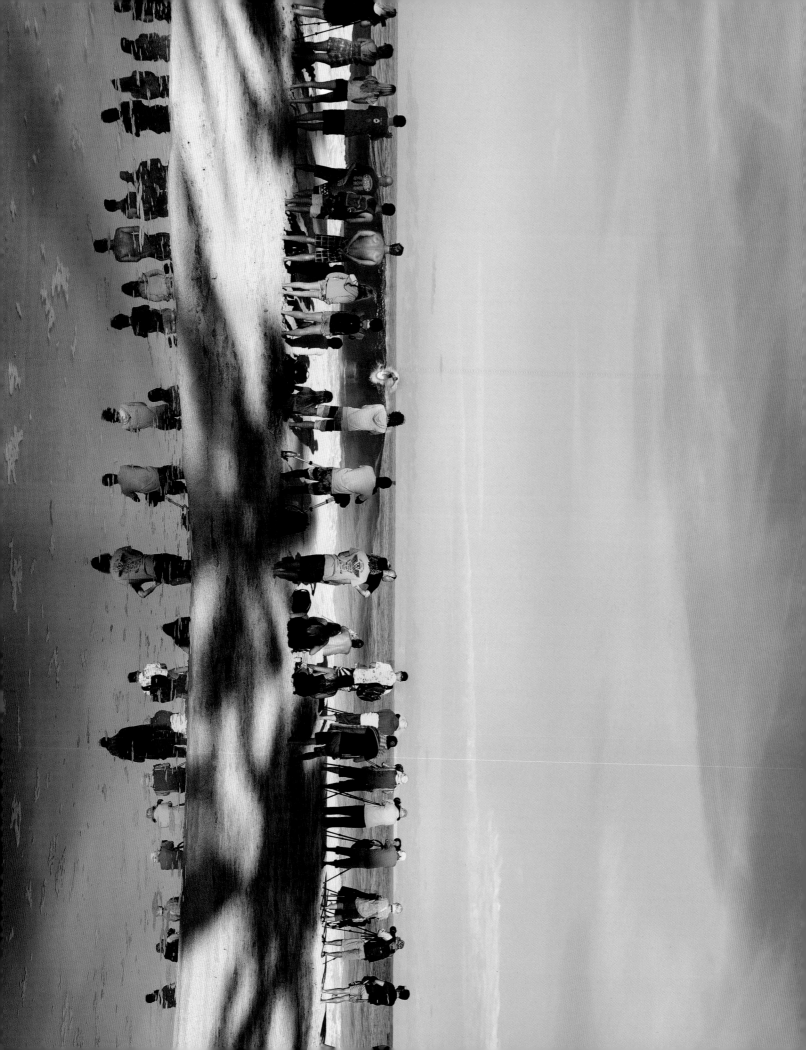

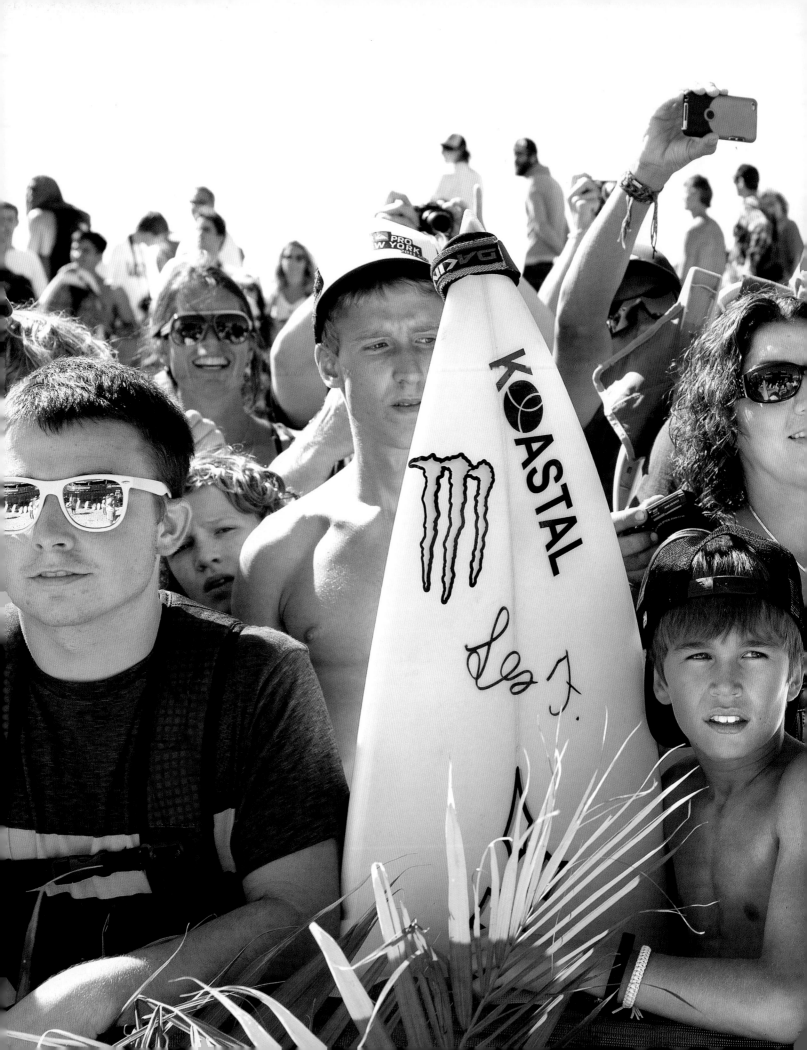

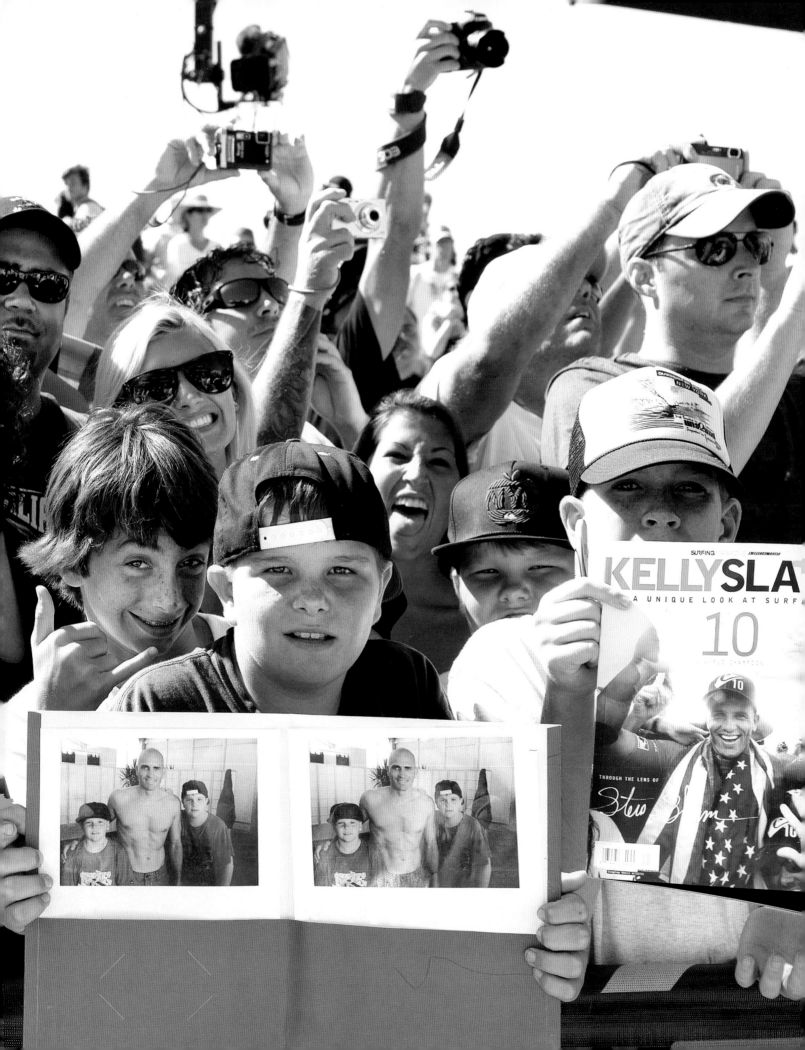

Opposite: North Shore, Oahu

Previous spread: "Slater Mania"

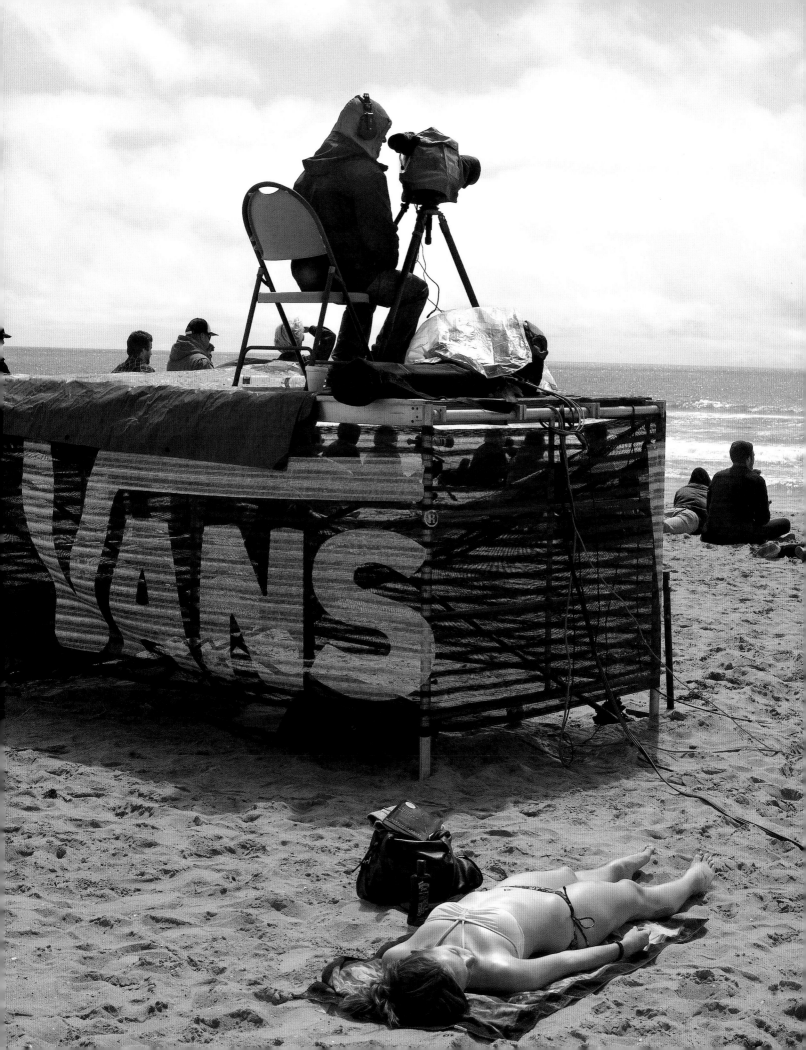

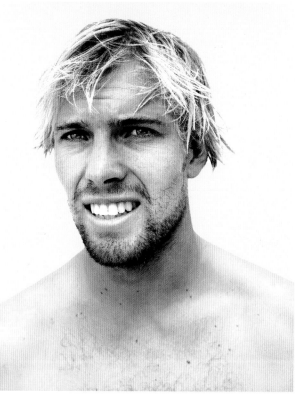

Top left: Nathan Curren, pro surfer and son of Tom Curren. Top right: Paul Fisher, Australian internet surfing reporter/host. Bottom left: Buzzy Kerbox, big-wave surfer; best known for codeveloping tow-in surfing with Laird Hamilton, Dave Kalama, and a handful of other surfers in the mid-1990s. Bottom right: Pat Gudauskas, winner, 2008 O'Neill Sebastian Inlet Pro

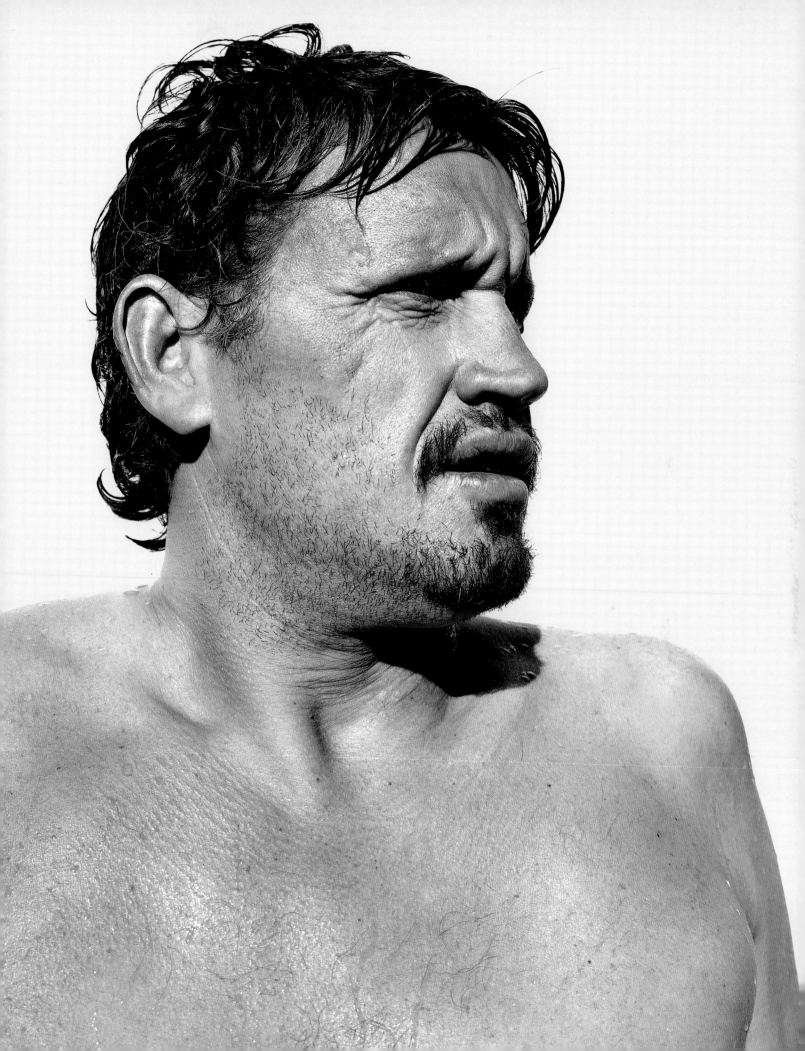

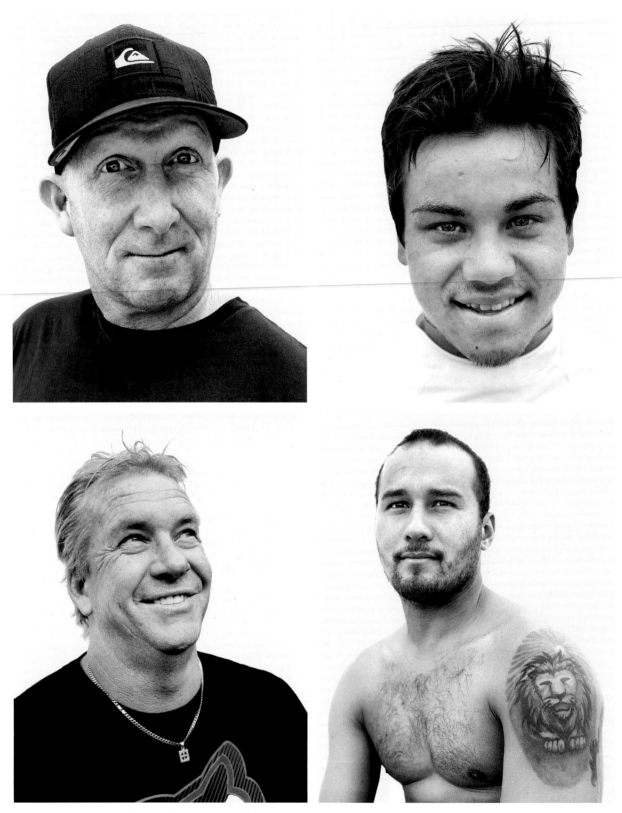

Top left: Steve "Belly" Bell, pro surfing coach. Top right: Keanu Asing, Hawaiian surfer who competes in the World Surf League and debuted on the World Championship Tour of 2015. Bottom left: Gary Elkerton, known as "Kong"; Australian three-time World Masters champion; two-time Hawaiian Triple Crown champion. Bottom right: Fred Patacchia, retired from the World Surf League after a perfect 10 at the Hurley Pro at Lower Trestles in 2015

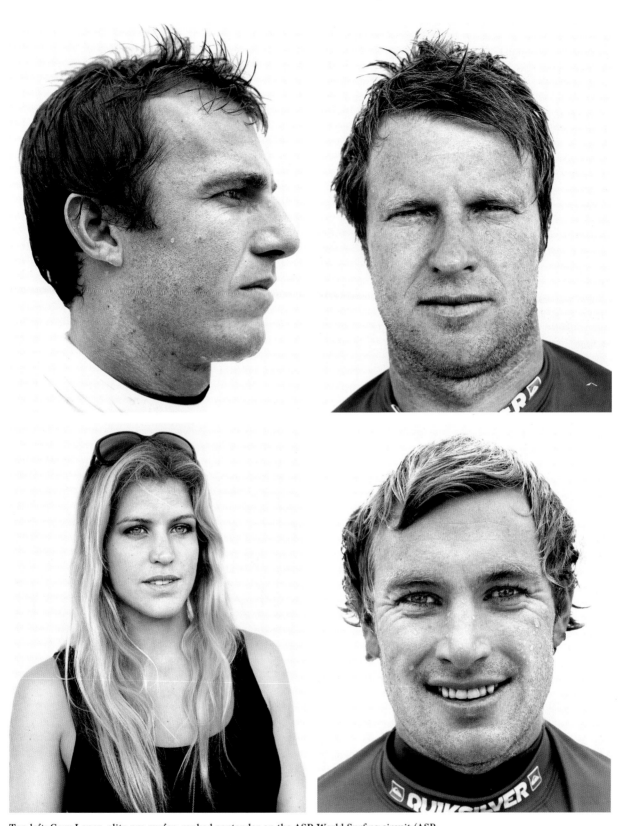

Top left: Cory Lopez, elite pro surfer; ranked contender on the ASP World Surfing circuit (ASP World Tour) for multiple years and considered one of the best "Free Surfers" on the planet. Top right: Taj Burrow, Australian retired pro surfer; many major wins, including Billabong Pro Jeffreys Bay and 2009 Pipeline Masters. Bottom left: Rosy Hodge, South African pro surfer and regular on-camera sportscaster for WSL. Bottom right: Adrian Buchan, Australian pro surfer; won 2008 Quiksilver Pro France and 2013 Billabong Pro Teahupoo

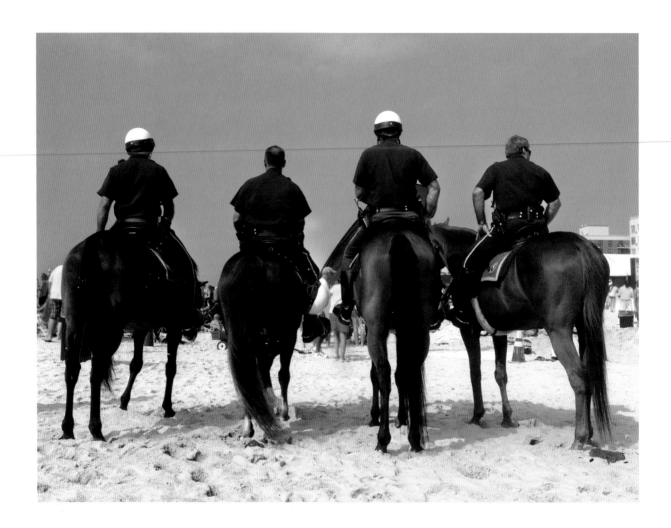

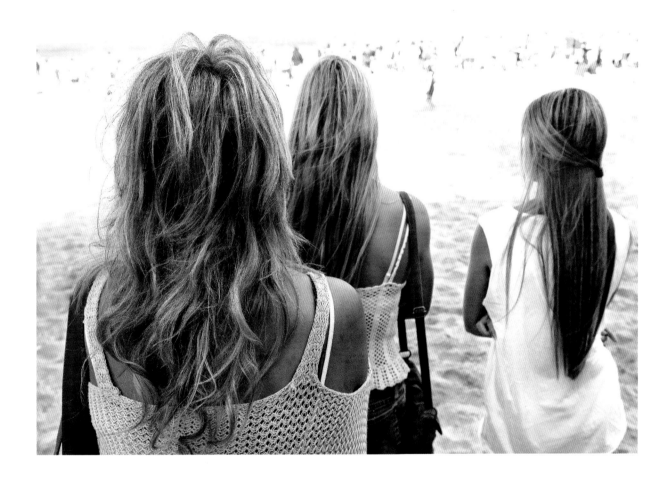

Following spread, left: Cori Schumacher, three-time Women's World Longboard
Champion. Right: Sunny Garcia, Hawaii; ASP WCT World Champion in 2000;
holds six Triple Crown of Surfing titles

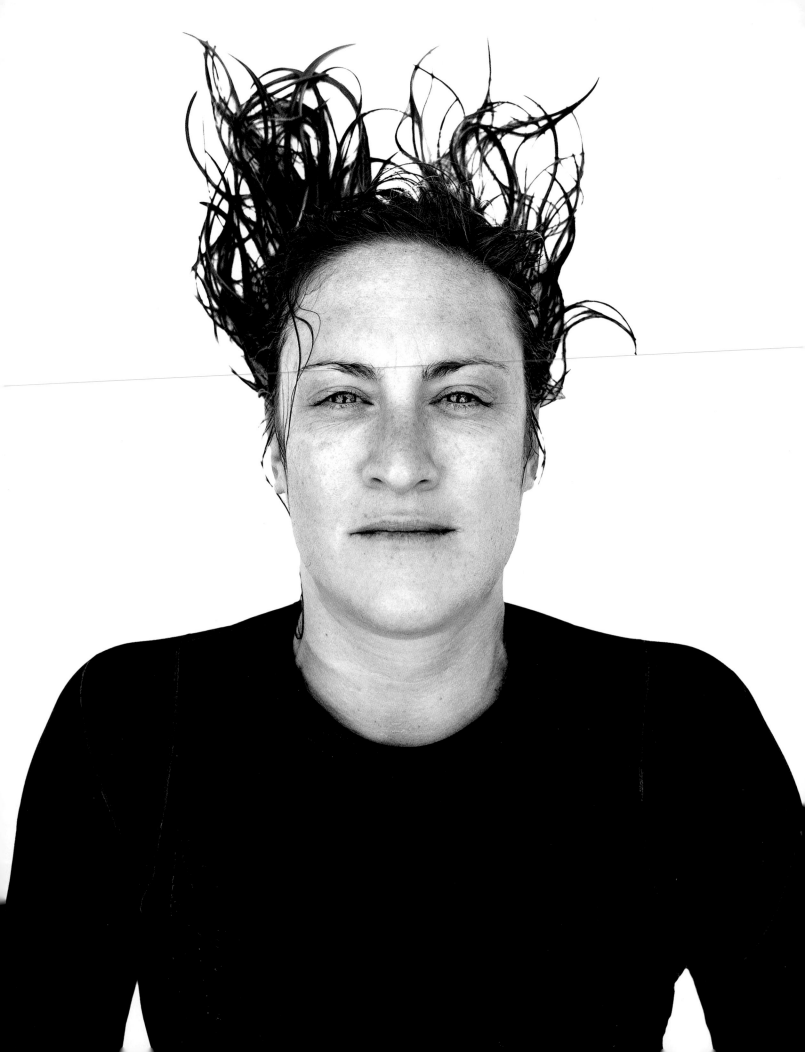

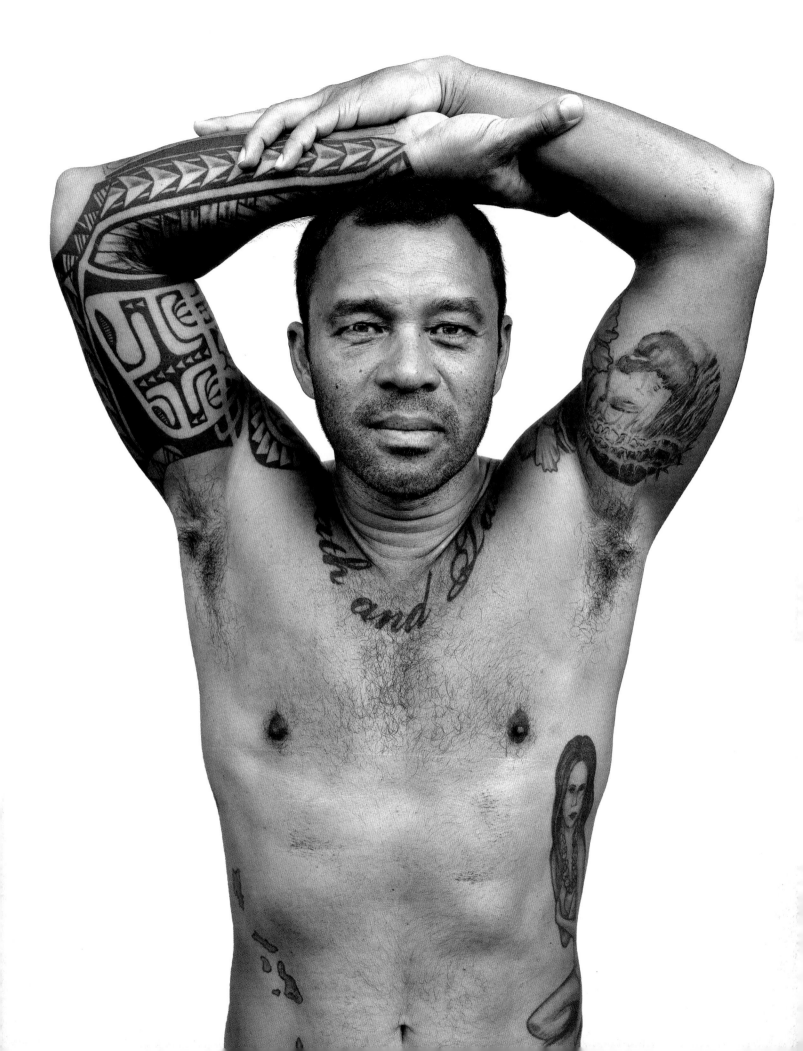

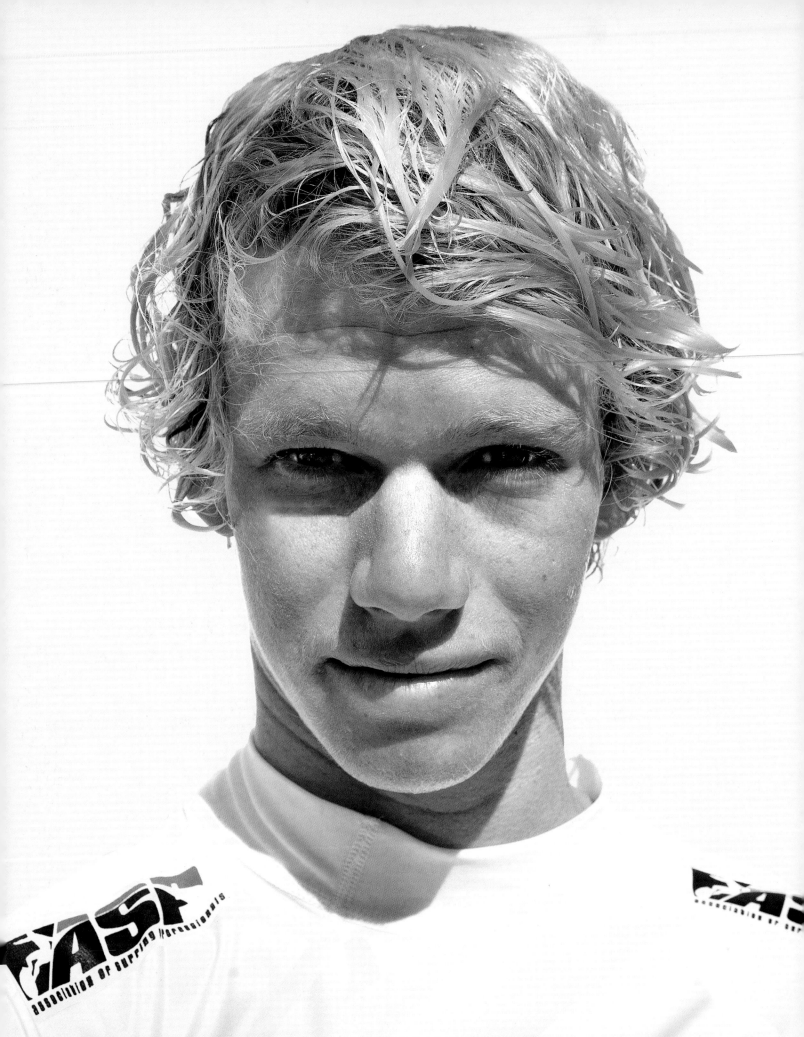

Opposite: John John Florence, 2012

Right: John John Florence, Hawaii; one of the new breed of champion surfers; grew up surfing the forceful waves of Pipeline; won the title of 2017 World Surf League Men's Champion, ranking him #1 in the world; continues to win many prestigious titles on the pro surfing circuit

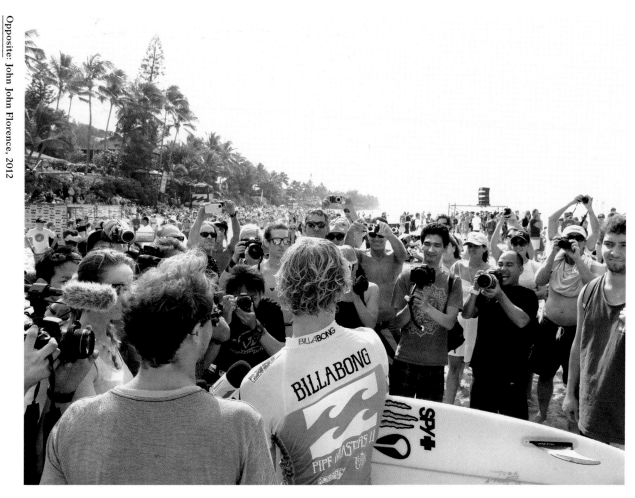

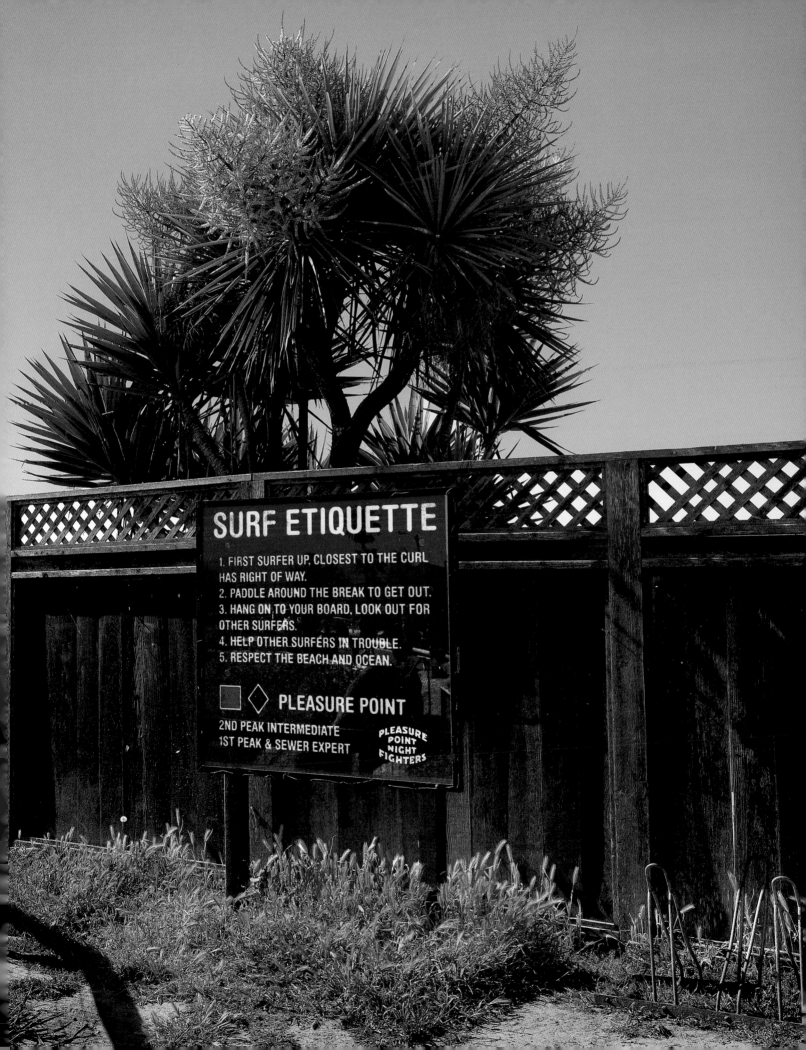

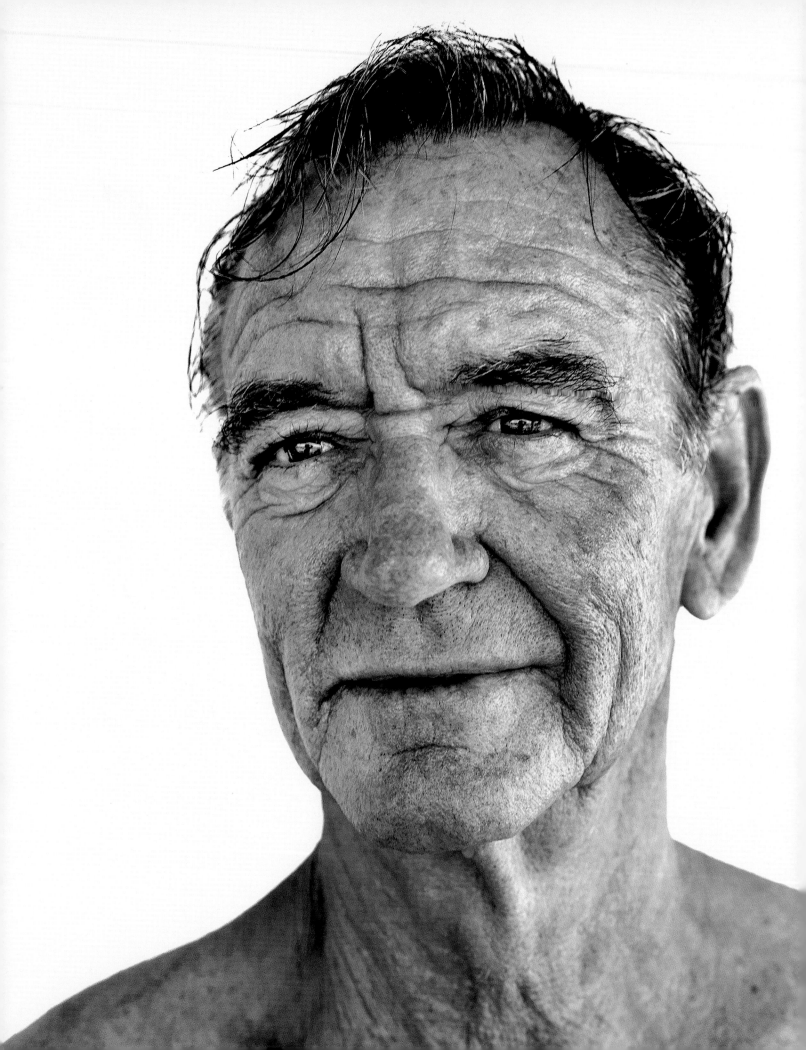

An interview with Robert August,
star surfer of *The Endless Summer* (1966)

I WAS A LUCKY KID

53

Thom: What and how were the components of The Endless Summer *pieced together to accomplish such a groundbreaking achievement by surfing the world in the sixties?*

Robert: My dad surfed, and he was one of the first California guys when Duke Kahanamoku came over. I surfed on a piece of wood when I was a little boy. Then my father made one paddleboard. When they discovered balsa wood, I remember the first person to make anything with it was Greg Noll in his mom's garage in Manhattan Beach, as well as Hobie [Hobart "Hobie" Alter, founder of Hobie Surfboards] in a garage in Dana Point. My dad got balsa boards for each of us. That's when I was seven years old, in 1953. That year, my dad decided we should travel to places like Mexico, and we kind of pioneered Baja, California, camping out. We never saw anyone else surfing. Then my parents decided to take me to Hawaii, when I was eight years old. We flew from Burbank to San Francisco, then went from San Francisco to Honolulu on a propeller plane. Seventeen hours of freezing vibration. I got to surf Waikiki, and my mom was in an outrigger taking pictures of me. I was a lucky kid. We lived right on the beach in California, and all the older guys were hanging around our house because my dad was a surfer. John Severson, who started *Surfer* magazine, lived in a little back apartment in our house. He was going to school at Long Beach State when he was a kid. Bruce Brown [director of *The Endless Summer*] was also hanging out at our house among other guys. Our house was the center of activity. When Bruce Brown started making surf movies, I ended up in all his films before *The Endless Summer*. I would also be in other guys' surfing movies and got to travel with them, and at a young age, I was good at it. They told me what to do. They would show the films in high school auditoriums. It was 16 mm crank-up stuff. They would project them on a screen and narrate them with a little microphone. We had a turntable too for music. This was the only communication there was about our sport. There would be posters on telephone poles around town that said "Surf movie—Saturday night— Newport Harbor High School." We all went because it was something cool to do. Anyway, I was in all of Bruce's movies, and then he had this idea to travel the whole world. He told me the whole process and what we needed to do. He mentioned we would be gone for eight months. I said, "Sure, I'll go."

Would you consider this the beginning of modern surfing?

No one was traveling to find waves beyond their backyards?

Getting back to this idea of the invention of modern surfing: Weren't your travels a defining moment for this transition?

That's how he started making that amazing movie that pretty much spread the sport around the world.

Definitely. Ours was a whole adventure. We went to so many countries where there was no surfing culture. Like Singapore, Ghana, and Nigeria. There were no surfers anywhere. There were a few of them in South Africa who we met down there at Cape Town and Durban, but there just wasn't anybody else. They were just learning how to stand up. That was it until we got to Australia. There were no flights that went across the Indian Ocean. We had to go from South Africa to Kenya to Saudi Arabia to Yemen to India to Sri Lanka to get across to Australia.

Right. People then were just getting a board and learning how to stand up. They were already pretty advanced in Australia, though. Guys knew how to surf down there.

Oh, yeah. The movie ended up showing in all the theaters across America. Bruce Brown was so successful just doing the narration onstage. Then it got distributed worldwide, where everyone got to see it. People had no idea what surfing was about. They didn't necessarily go buy a board, but at least it got people to want to go somewhere. Two older ladies tracked me down not too long ago in Costa Rica. They said they were from the Midwest, and once a week, years ago, they would have one movie come to their town and everyone went 'cause there was nothing else to do. One week there was a movie about riding waves and traveling. They said: "We went and saw it, and then we went again the next night and saw the movie a second time. Actually, we saw it every time it played until it was finished. After seeing it so many times, we just decided we wanted to go somewhere. We didn't necessarily surf because neither one of us was very much athletic. We did our research and got to this little airport down the road that could get us to a major airport that would get us anywhere in the world. We saved our money for a couple of years and decided to go to Europe. We went and I ended up teaching English in Spain, and my friend ended up marrying a guy in France. Our whole lives really changed dramatically 'cause we saw that movie

about traveling and surfing." Man, stories like that really reached my heart.

Can you explain what it was like mentally and spiritually for you when you first left on the trip and what it was like when you returned?

The trip had a major impact on me because we saw so many different kinds of people and the different ways they lived. When we were in South Africa, apartheid was still happening. That was kind of uncomfortable. We also went to India, and they confiscated everything at the airport, including our surfboards and the cameras, because of the class system there. They treated the lower-level people [caste], the untouchables, like dirt. It was horrible. You had to have a special permit to do any type of photography. That was their reason for all this confiscation. We were there about ten days and found our way to the coastline. Right there were beautiful waves. Bruce said he would go back to the airport and make a payoff to get our stuff. Well, he did it and got it all back. We finally ended up in Hawaii. We also visited New Zealand, Tahiti, Samoa, and Fiji. When we got back, after having such a great experience for eight months, it really changed my thoughts about surfing and my whole life. This all had such a major impact on career, family, and everything.

Did anything happen during this adventure that turned out to be way above your expectations and might have led you to live your life by a different set of rules?

I did mention my fabulous upbringing with my wonderful mom and dad.

I was prepared for a giant experience like that, but also overwhelmed at how amazing it was. When I got back, my brain was wondering what in the world we just did.

Surfing is the people you meet and the exhilaration of the ocean and the effect it has on you. I found out through others, as well as my own experience, that there is something in that water that heals. I think those waves have a thing that goes on called reverse osmosis. Over a period of my life and whatever is going on, if I can just get to the ocean and catch a few waves and get washed around in that white water, things seem to just get better. Somehow, I feel good. I think that's why so many people get hooked on it. They just got to get their waves.

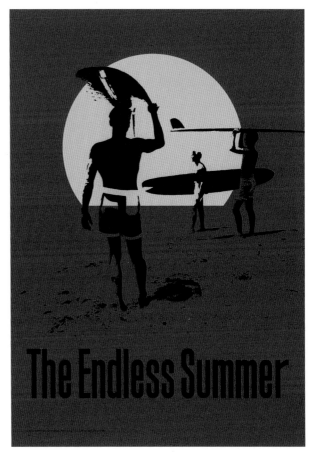

The Endless Summer

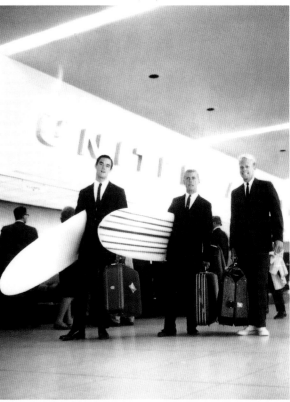

Top: Official 1966 *Endless Summer* movie poster
Bottom: Robert August, Mike Hynson, and director Bruce Brown leaving for their historic worldwide surfing journey

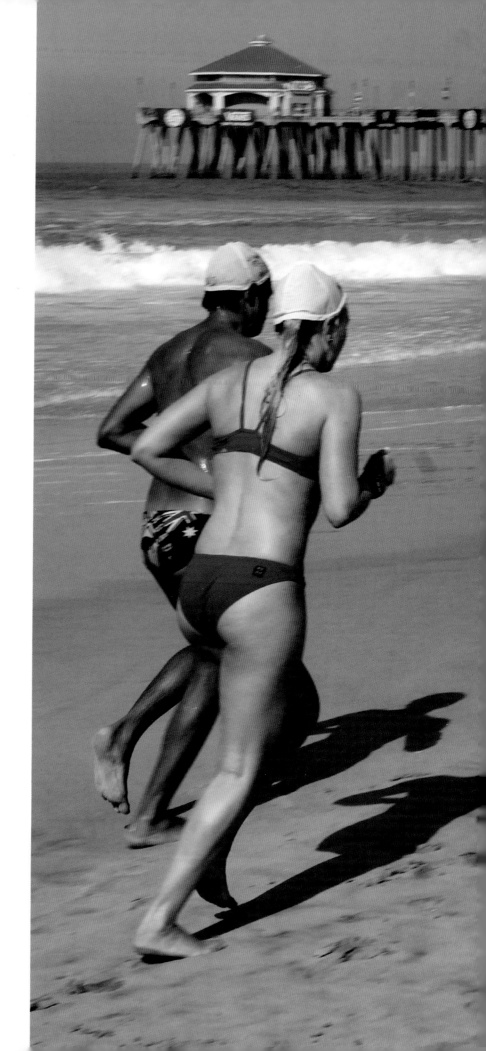

Huntington Beach, California: Junior Lifeguard training

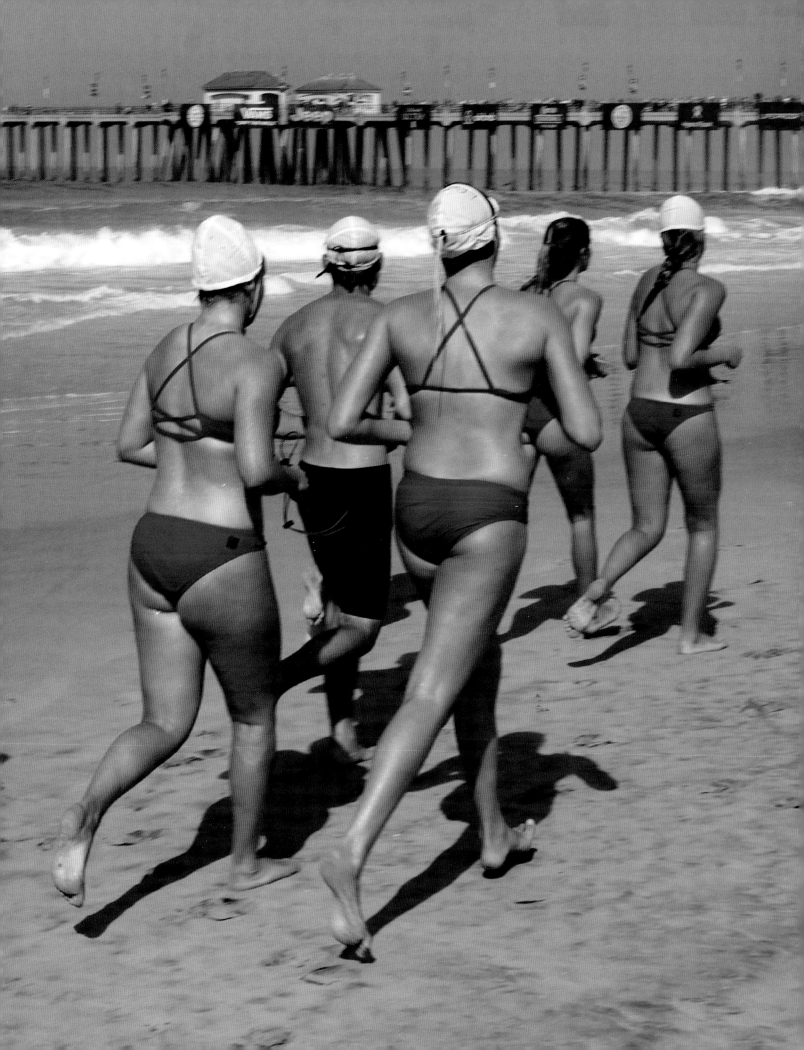

Following spread, left: Kanoa Igarashi, Huntington Beach; finalist in 2016 Billabong Pipeline Masters. Following spread, right: Simon Anderson, 1981 Pipe Masters winner and inventor of the three-fin surfboard

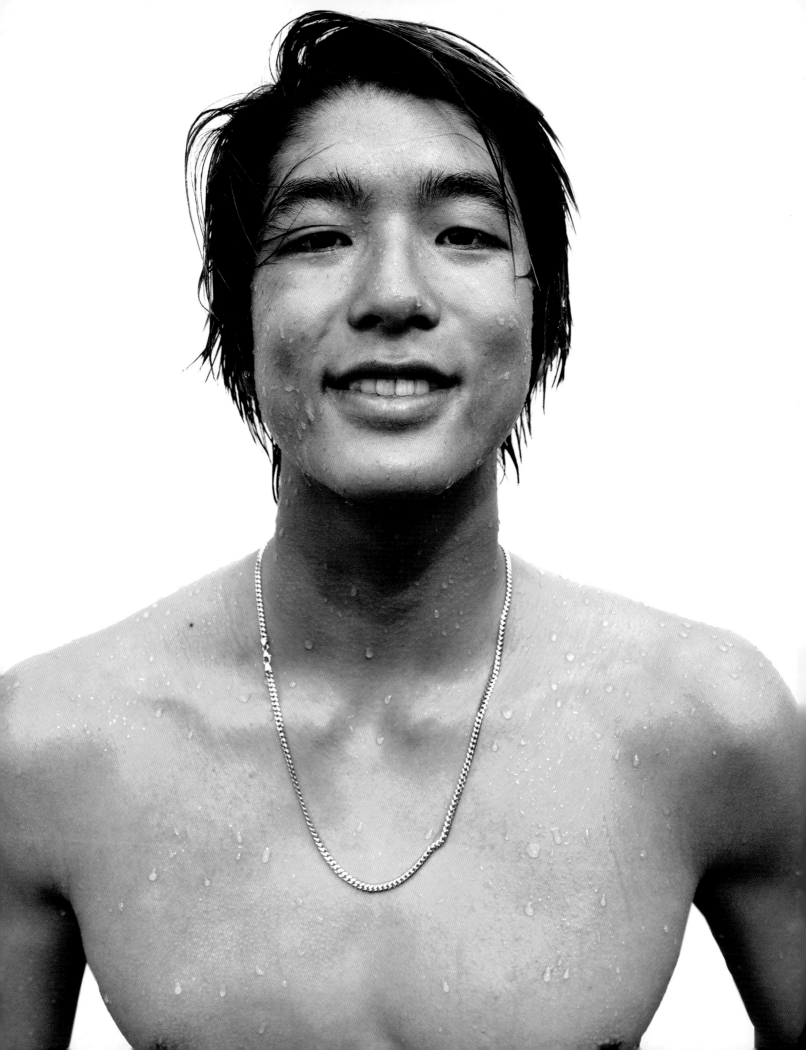

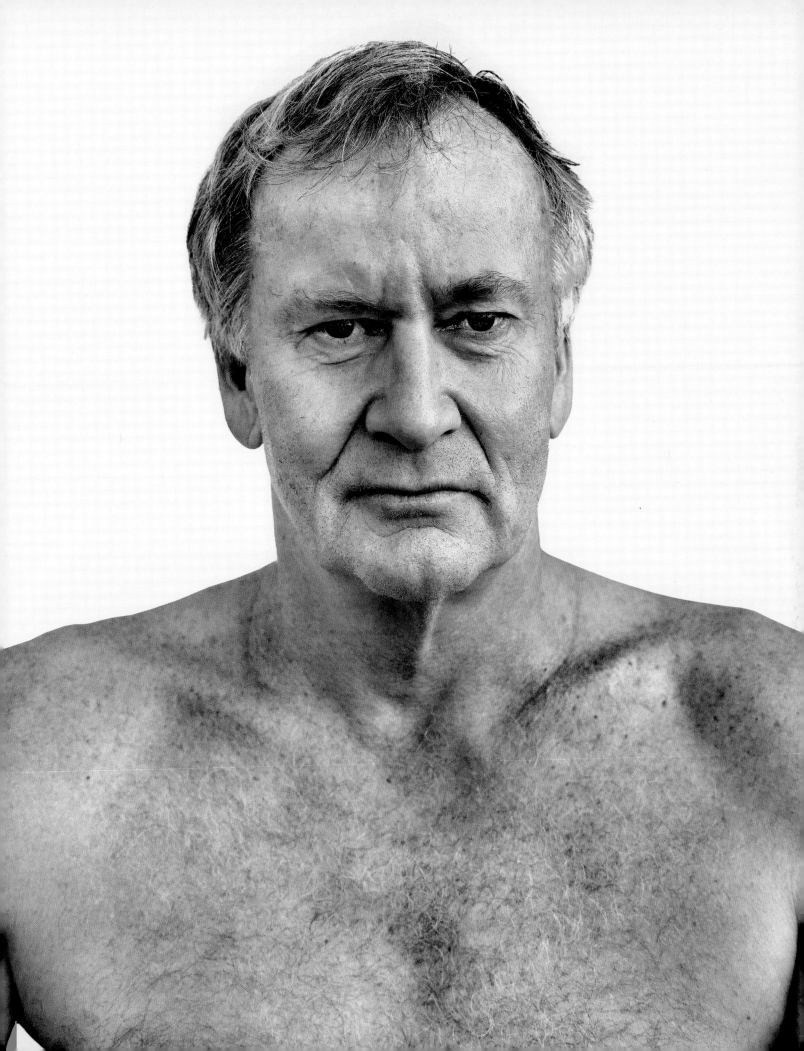

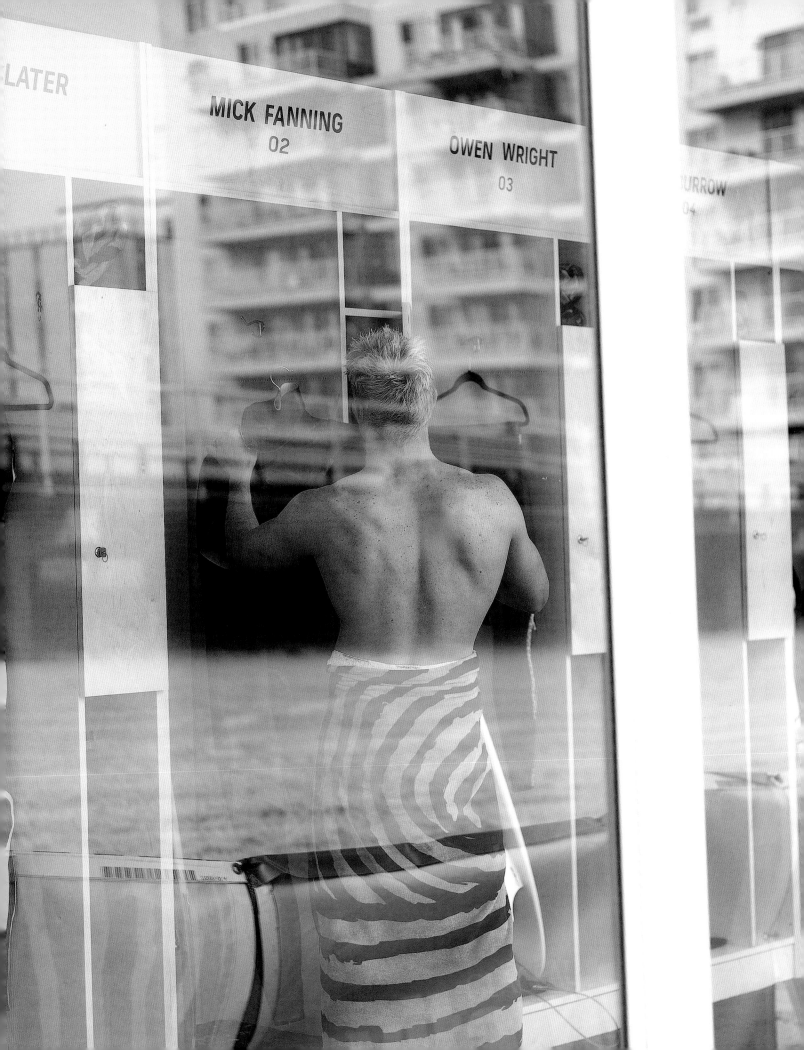

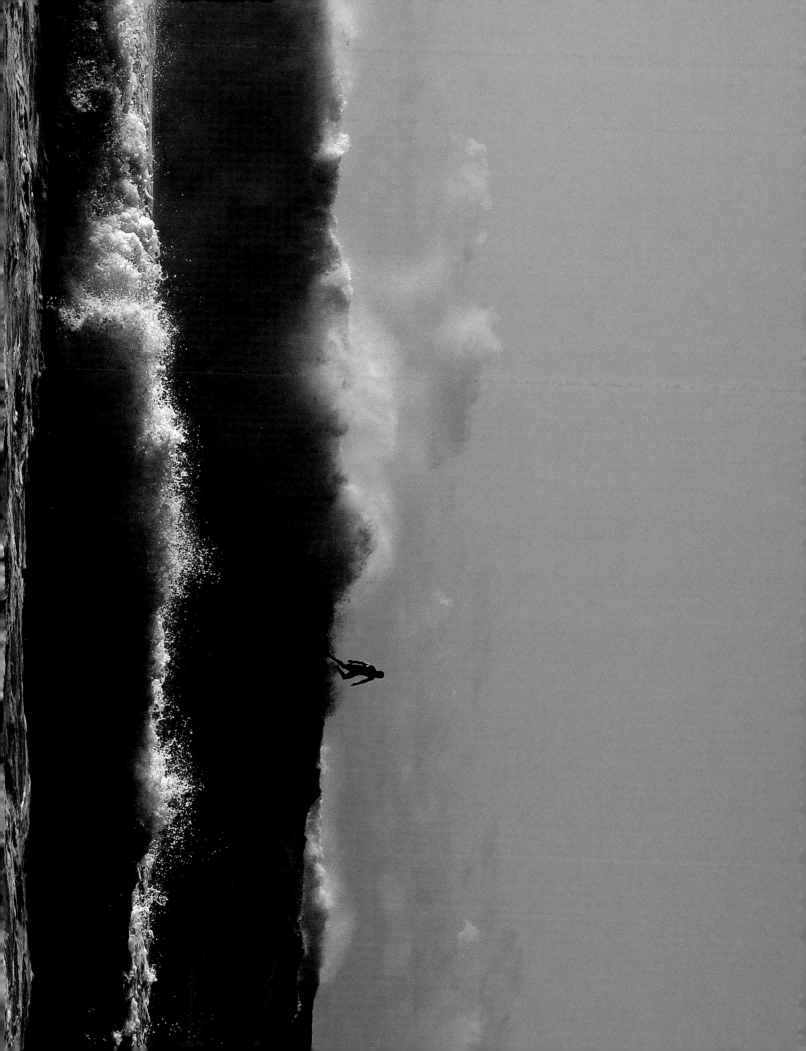

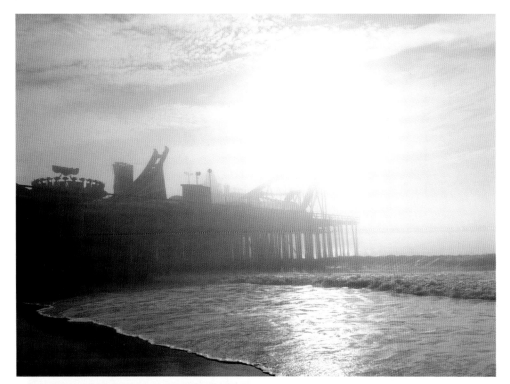

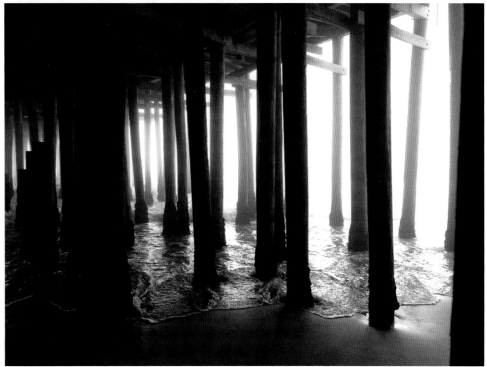

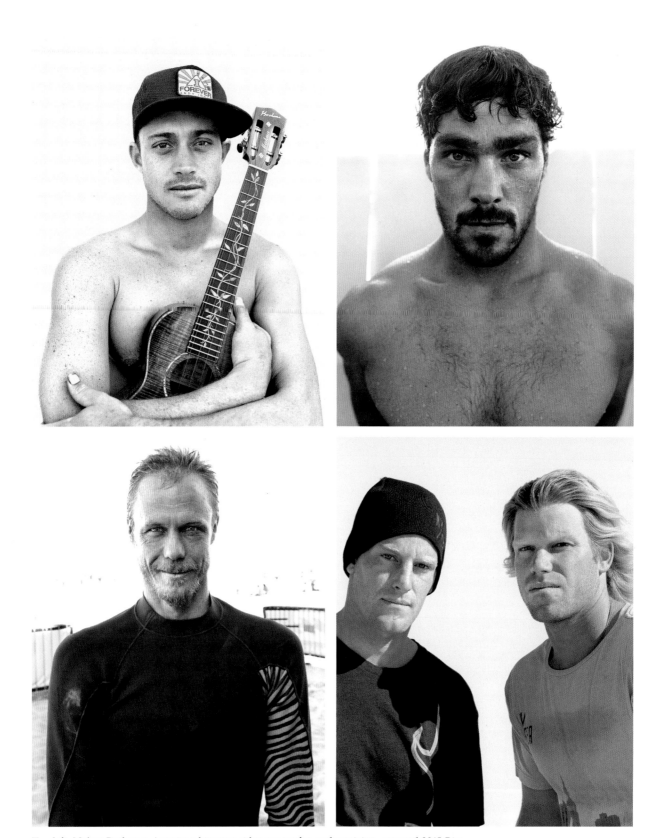

Top left: Makua Rothman, American big-wave rider, pro surfer, and musician; crowned 2015 Big Wave World Champion in the World Surf League's (WSL) first sanctioned Big Wave World Tour; son of surfer Eddie Rothman. Top right: Jay Davies, regarded as one of the most exciting and dynamic free surfers in the world. Bottom left: Gavin Beschen, pro surfer who competes on the Volcom team. Bottom right: Brothers Will and Cliff Skudin, pro big-wave surfers from Long Island and founders of Surf and Surf for All, a nonprofit organization

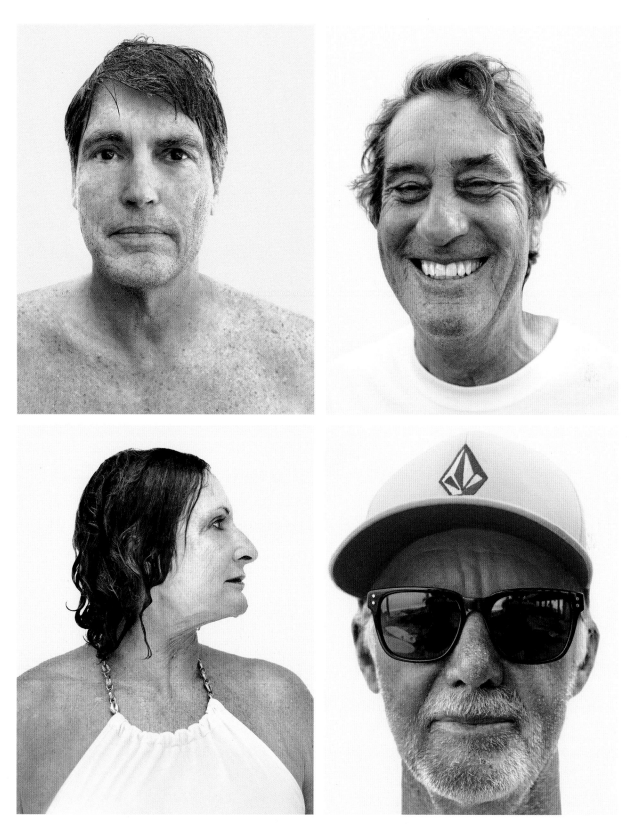

Top left: Jeff Divine, pro surf photographer and photo editor for *Surfer* and *The Surfers' Journal* for thirty-five years. Top right: Steve Lis, creator of the "fish" design surfboard. Bottom left: Jericho Poppler, world champion longboarder. Bottom right: David Riddle, Volcom team manager

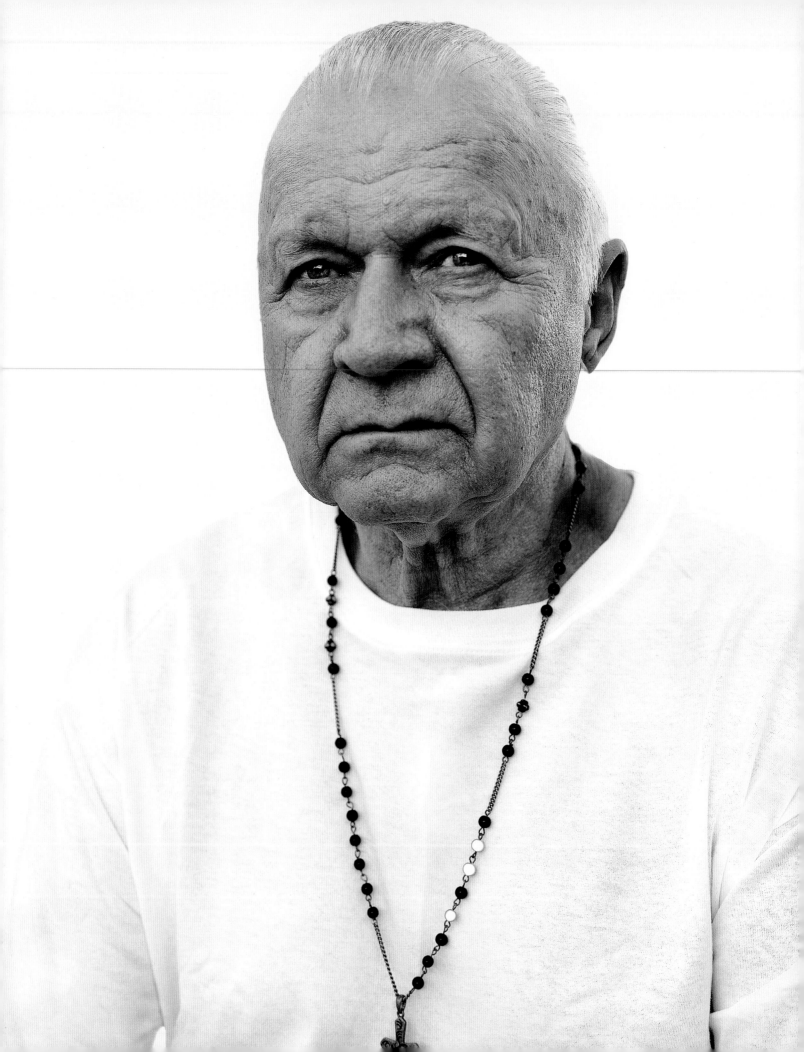

Opposite: Dick Dale, king of the surf guitar
Right: Peter Joli Wilson, pro surfing photographer

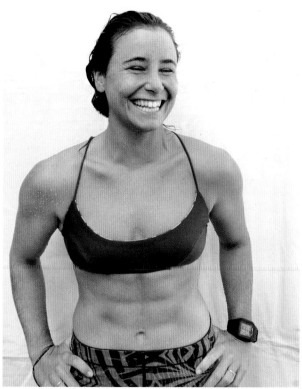

Opposite: Tatiana Weston-Webb, Brazilian American; ranked #4 in the world in 2016 and will participate in the 2020 Olympics

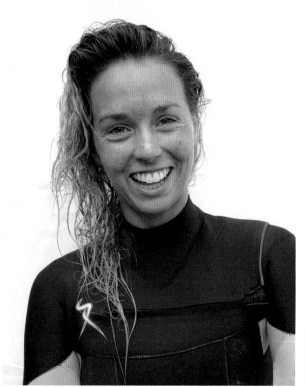
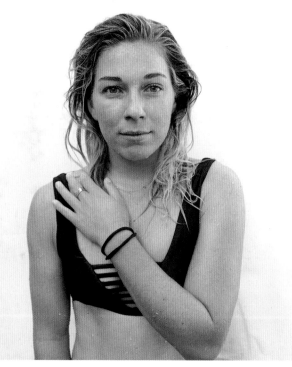

Top left: Courtney Conlogue, American pro surfer; won 2018 Hurley U.S. Open of Surfing at Huntington Beach. Top right: Johanne Defay, France; ranked #5 in the world in 2016. Bottom left: Sally Fitzgibbons, Australian pro surfer; has won Billabong Pro, Roxy Pro, and Fuji Pro events through 2015. Bottom right: Coco Ho, Hawaiian pro surfer from the famous Ho surfing family; won more than twenty-five surfing awards

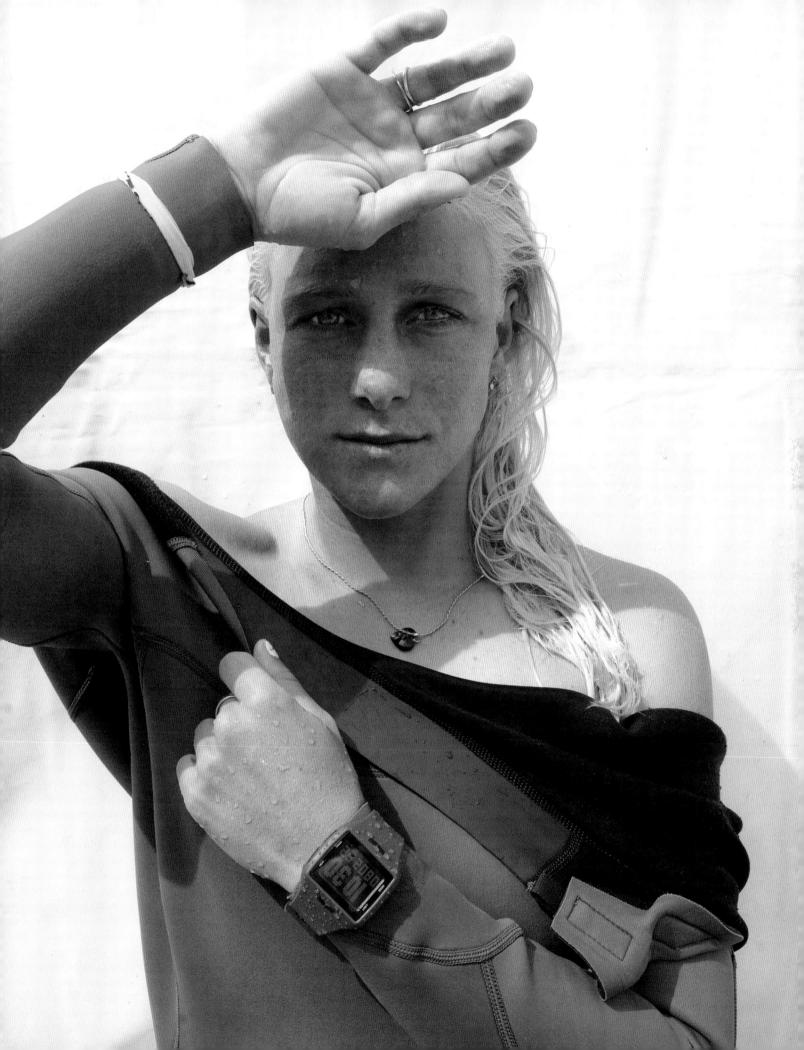

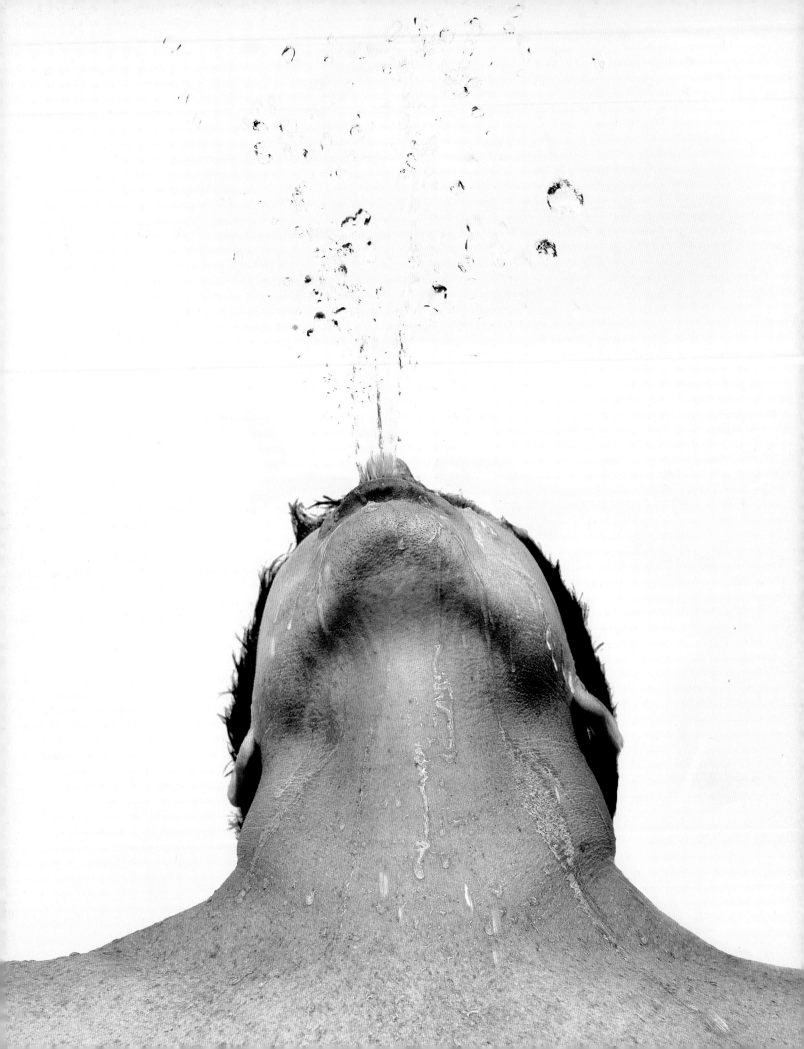

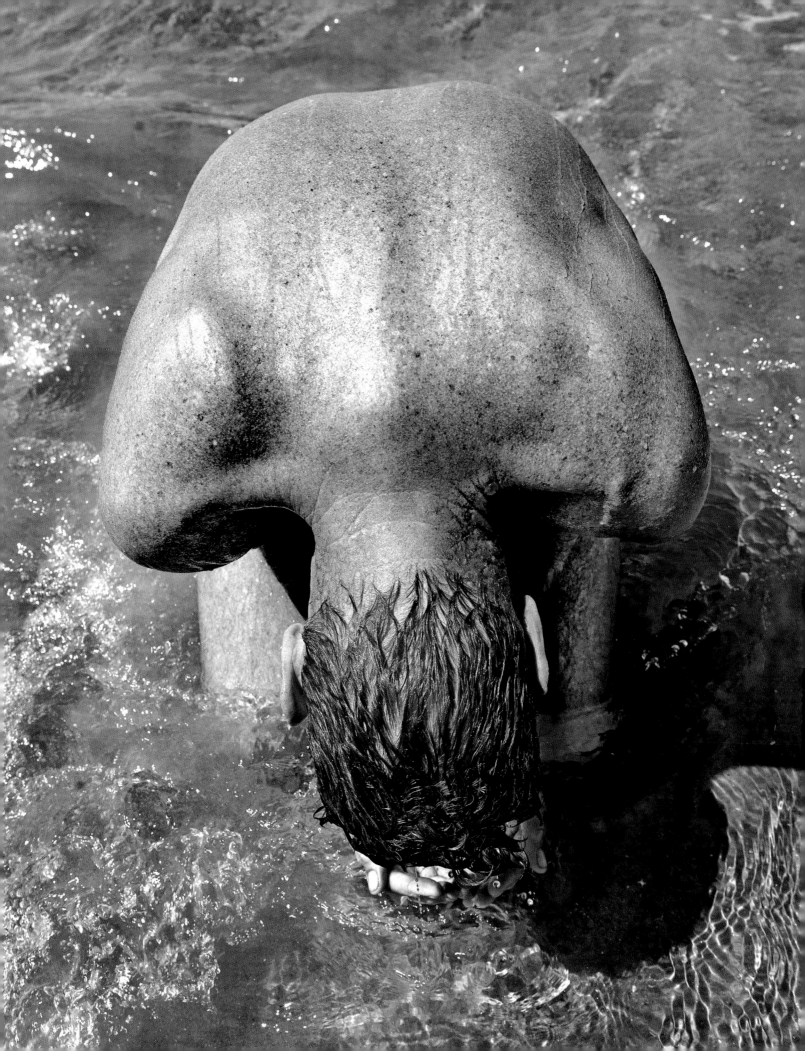

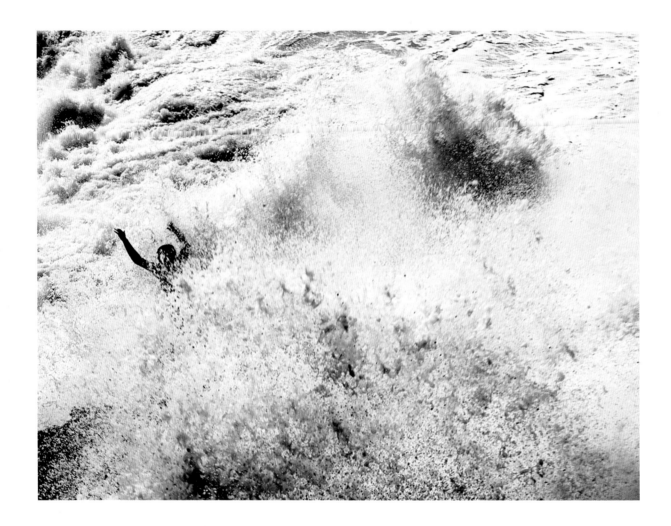

Previous spread, left: Dave Wessel

Previous spread, right: Grant Caradine, surfer, waterman, and well-known fashion model

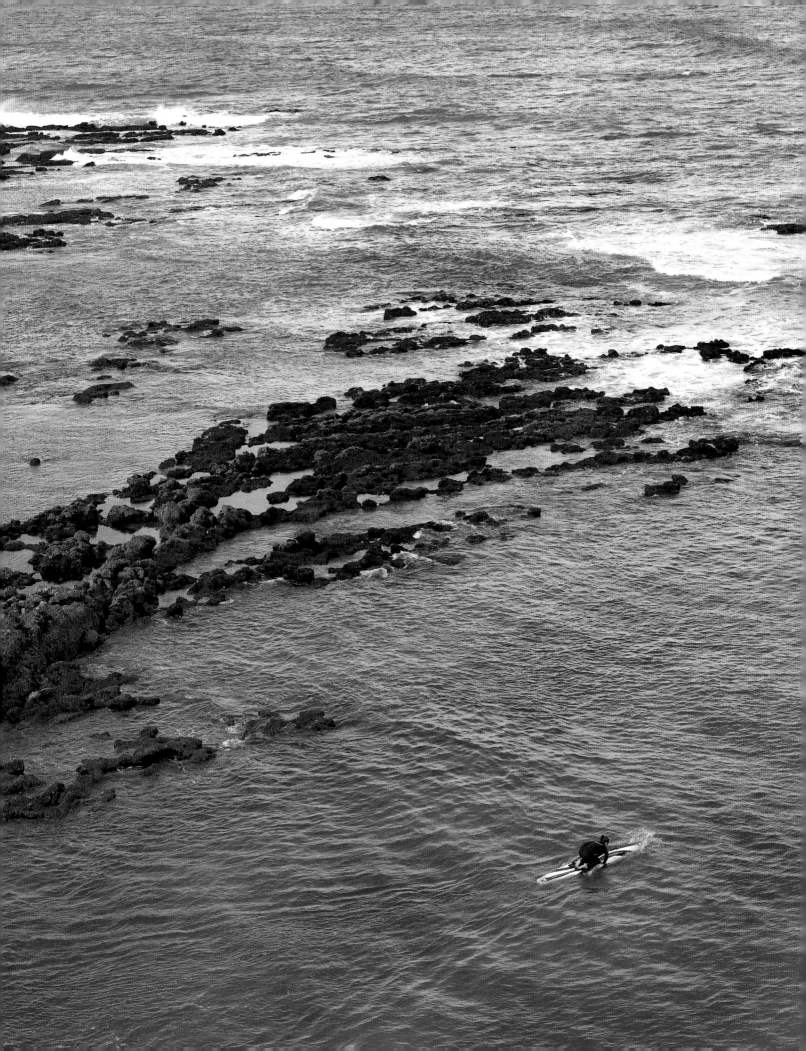

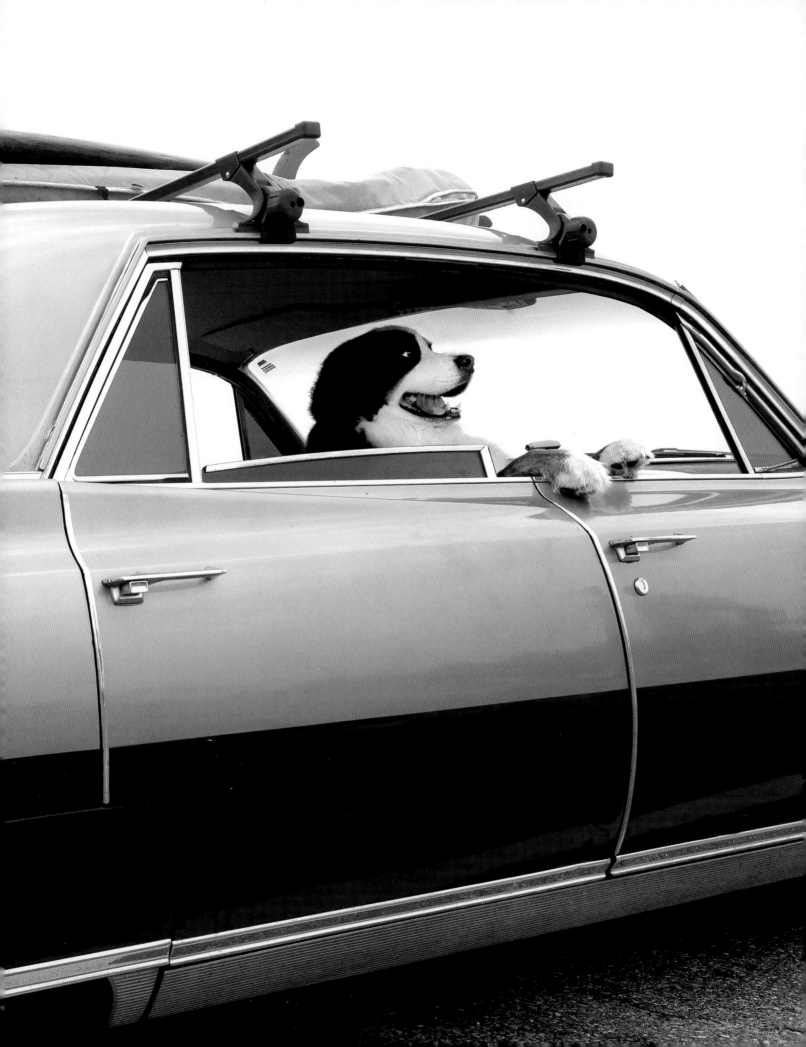

VW "The Thing," Manhattan Beach

Torrey Meister's surfboard arsenal, Oahu

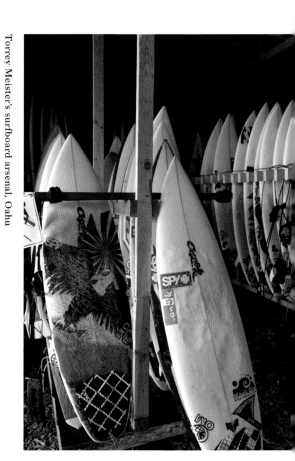

Montauk, Long Island

Joel Parkinson's broken board during competition

78

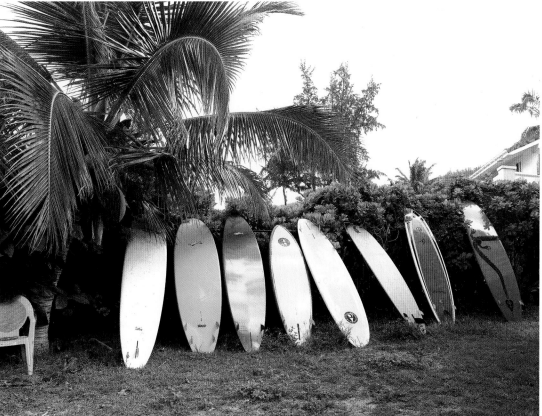

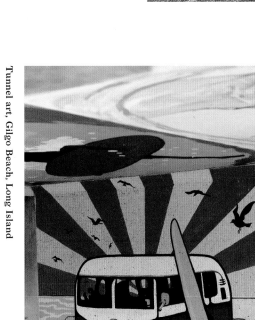

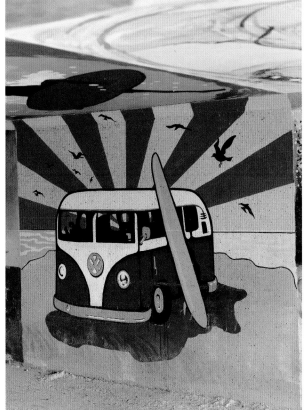

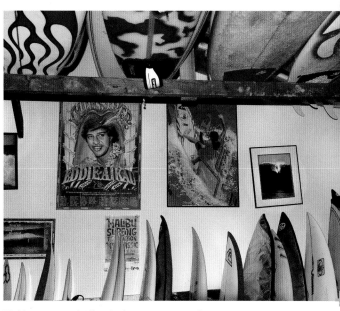

Malibu garage of Allen Sarlo, American surfer
prominently known as one of the original members
of the Z-Boys surf and skateboarding team

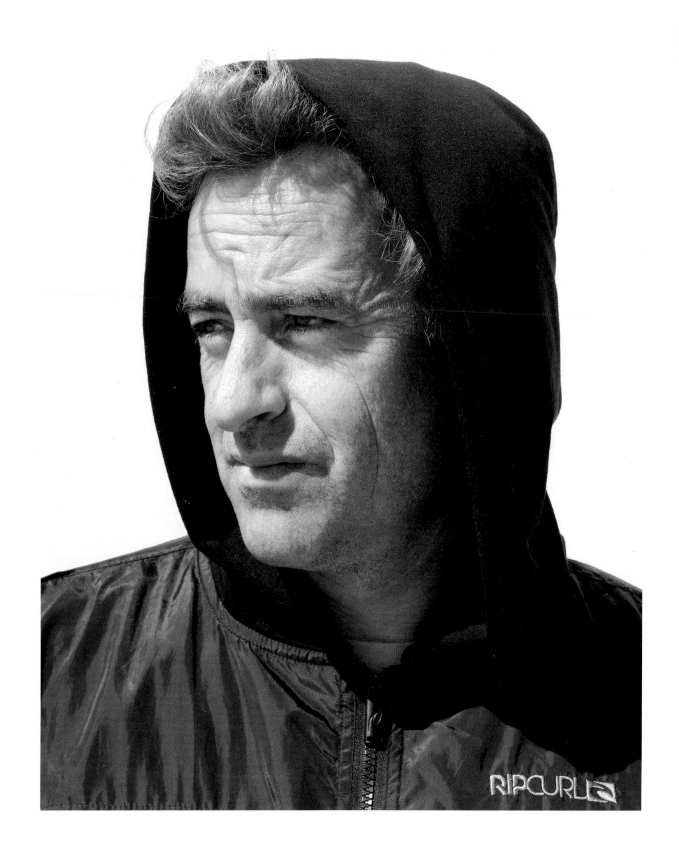

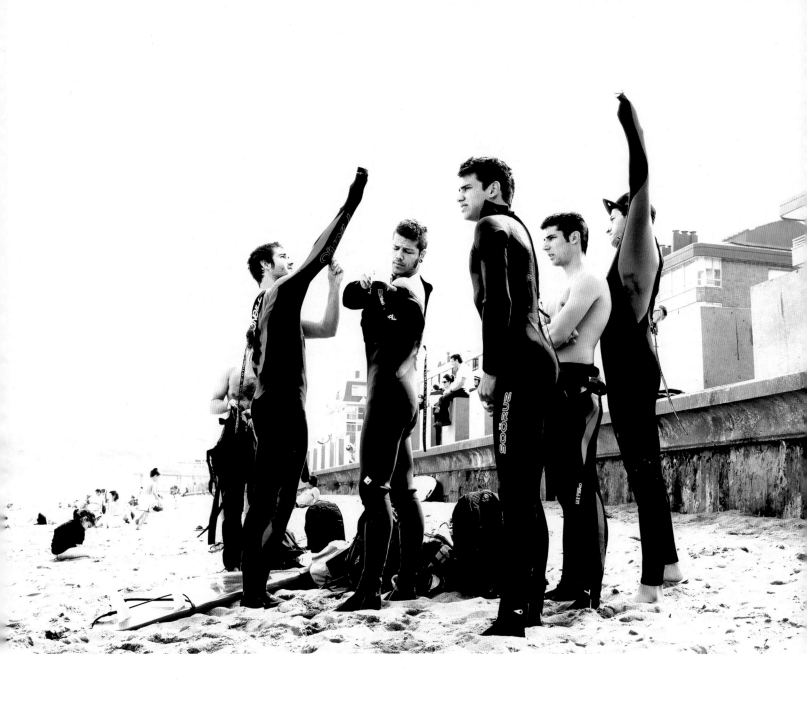

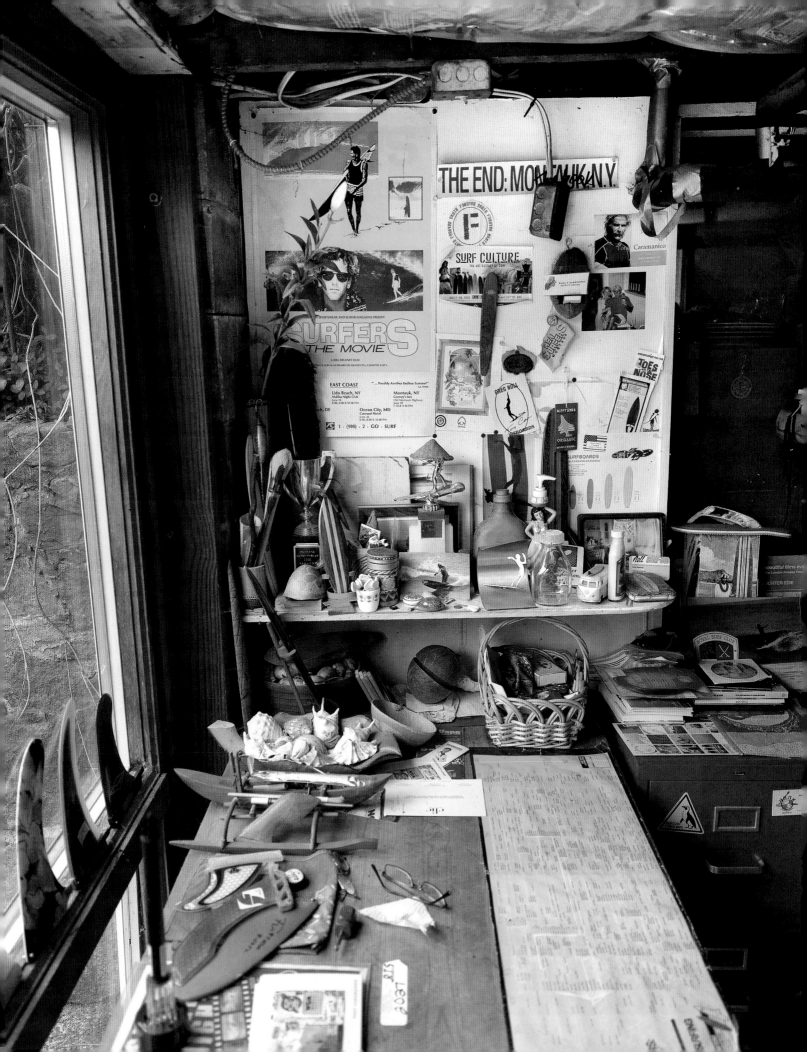

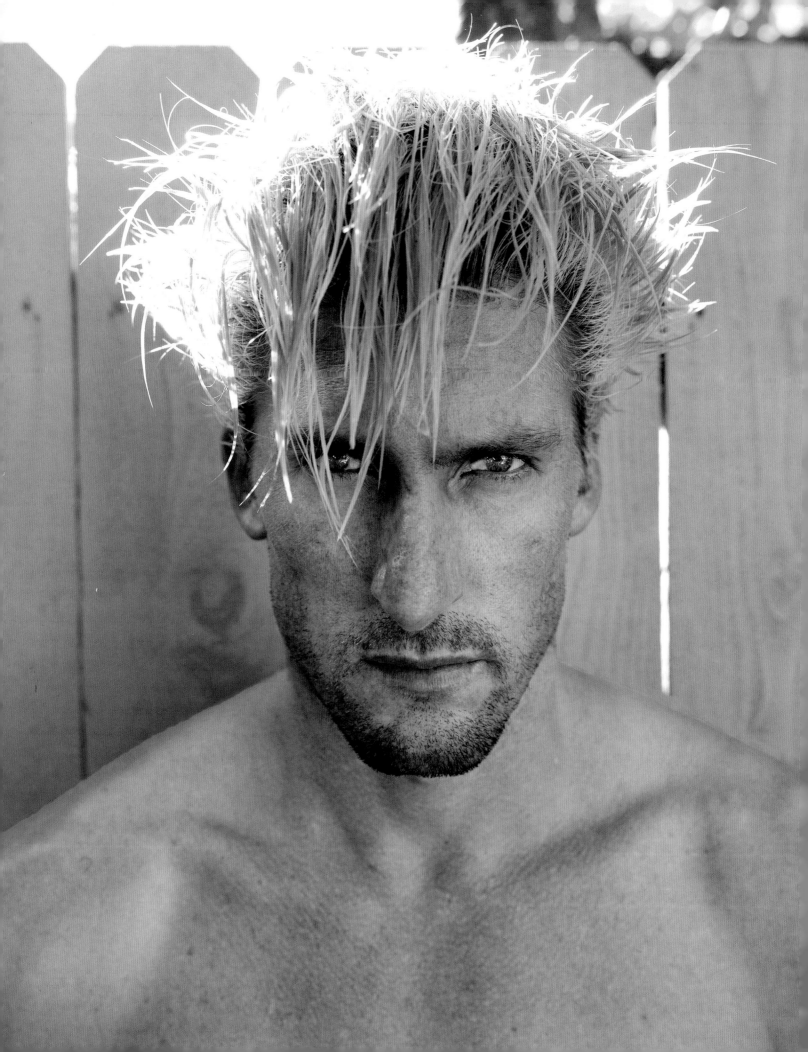

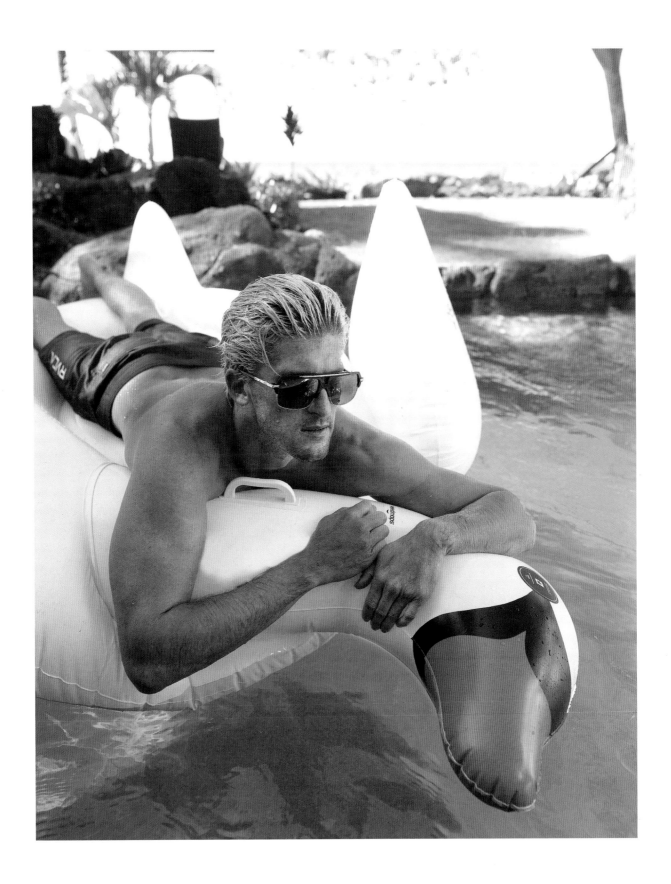

Right and opposite: Bruce Irons, known for radical aerial maneuvers and fearless tube-riding abilities; younger brother of three-time world champion Andy Irons

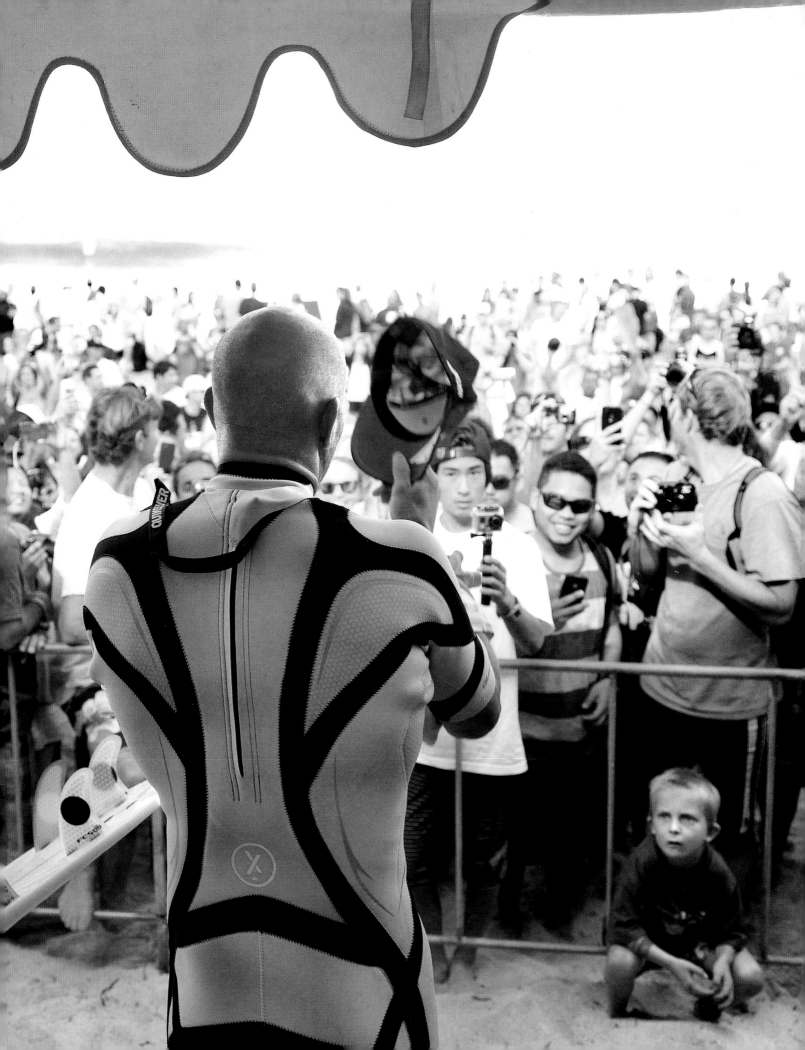

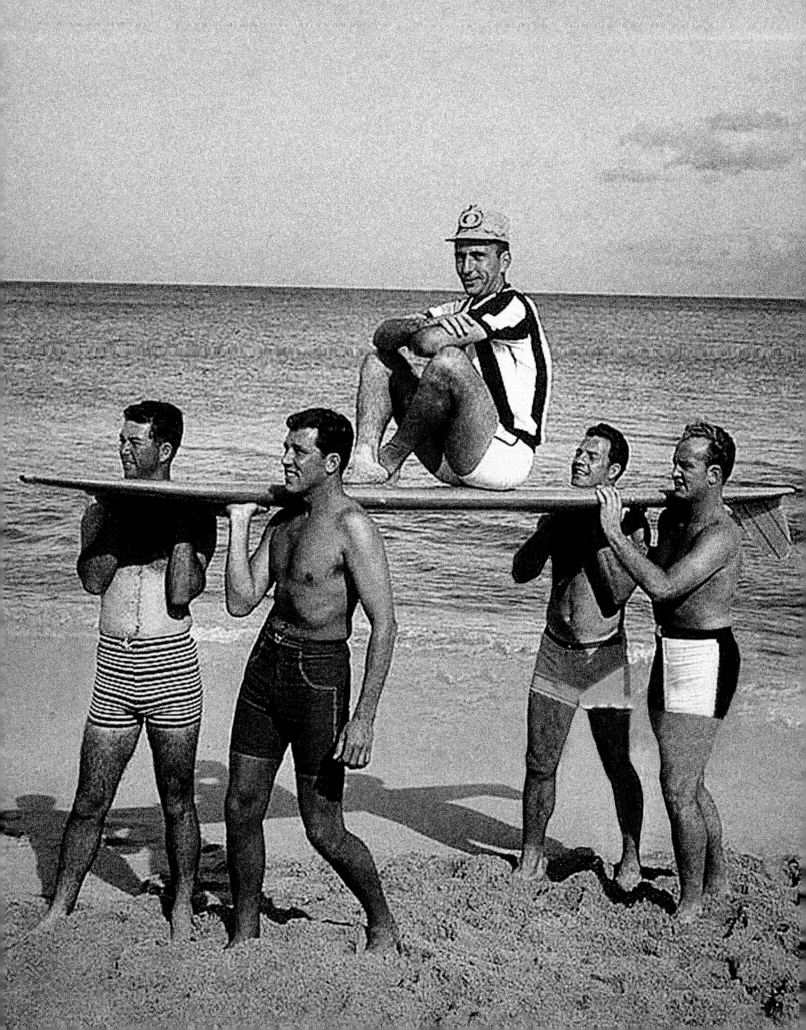

American basketball player Bob Cousy sitting on top of a surfboard carried by four fellow sportsmen in swimming trunks at the beach, circa 1965. The board-bearers are (left to right) golfer Ken Venturi; John Severson, founder of *Surfer* magazine; and NFL players Frank Gifford and Paul Hornung.

JOHN SEVERSON

By Mat Arney

I like to feel that surfing is a little more artistic and light, with a sense of humor, because of Surfer magazine.

—John Severson, in an interview for his 2011 Surfer Poll Lifetime Achievement Award

"Before John Severson, there was no 'surf media,' no 'surf industry' and no 'surf culture'—at least not in the way we understand it today."

—Sam George, former executive editor of Surfer magazine

John Severson was one of the founding fathers of surf media and one of surfing's great cultural custodians. He was born in December 1933 and grew up in Altadena and Pasadena, in northeast Los Angeles. In 1945, when he was thirteen, the Severson family moved to San Clemente and John discovered surfing. As a gifted artist intending to make a living from art and teaching, he majored in art education at Long Beach State but was drafted to the army in 1956 almost immediately after graduating. He was posted to Oahu to work as a draftsman, putting his artistic skills to use making maps, and "assigned" to the army surf team: "I had orders to practice every afternoon at Sunset Beach and Makaha. Yes, sir!"

While based in Oahu, Severson shot film footage, which he combined with footage captured at home in California, to produce his first surf film, *Surf* (1958). Following his discharge in 1958, he went on to produce *Surf Safari* (1959) and established himself as a surf filmmaker alongside such names as Bud Browne, Bruce Brown, and Greg Noll. To help promote his third film, *Surf Fever*, in 1960, Severson

struck upon the idea of producing a booklet—rather than a handbill—that could be sold to his audience. He titled the landscape-format booklet "The Surfer," and it proved very popular, with surfers lining up to buy copies from surf stores. Severson's intention was to produce a follow-up the next year to promote another film, but he had turned enough of a profit that he decided instead to publish a quarterly magazine (printed in portrait format and briefly named *The Surfer Quarterly*), which was to become *Surfer*—a seminal publication that has now been in print for more than fifty-five years.

In early editions of his publication, Severson not only produced the editorial content but also created logos and artwork for his advertisers in order to entice them to buy space. He was soon able to employ staff, though, and assembled an iconic team in the form of photographer Ron Stoner, cartoonist Rick Griffin, and writers and editors Bev Morgan, Drew Kampion, and Steve Pezman. Throughout these early years of *Surfer* magazine, Severson continued to paint and produce surf films. By the 1970s, the magazine had a readership of around 100,000, but Severson was feeling disconnected from the lifestyle that he desired; he felt that he was "evolving into a desk-ridden businessman," on top of which he was facing restrictions upon both access to his favorite local

surf break, Cotton's Point in San Clemente, and his personal privacy—thanks to President Richard Nixon moving in next door to his home. So he sold up and moved his family to Maui to get back to surfing and painting.

John Severson was a surfer and an artist; he wanted to share a true image of the sport he loved and counteract what he saw as the negative image of surfers portrayed by Hollywood through the Gidget and Beach Party series of movies of the early 1960s, promoting a purer relationship with surfing. He did this through his paintings and films and, most enduringly and with the greatest impact, through *Surfer* magazine. Severson's own relationship with surfing is best described in his own words: "In this crowded world the surfer can still seek and find the perfect day, the perfect wave, and be alone with the surf and his thoughts . . ."

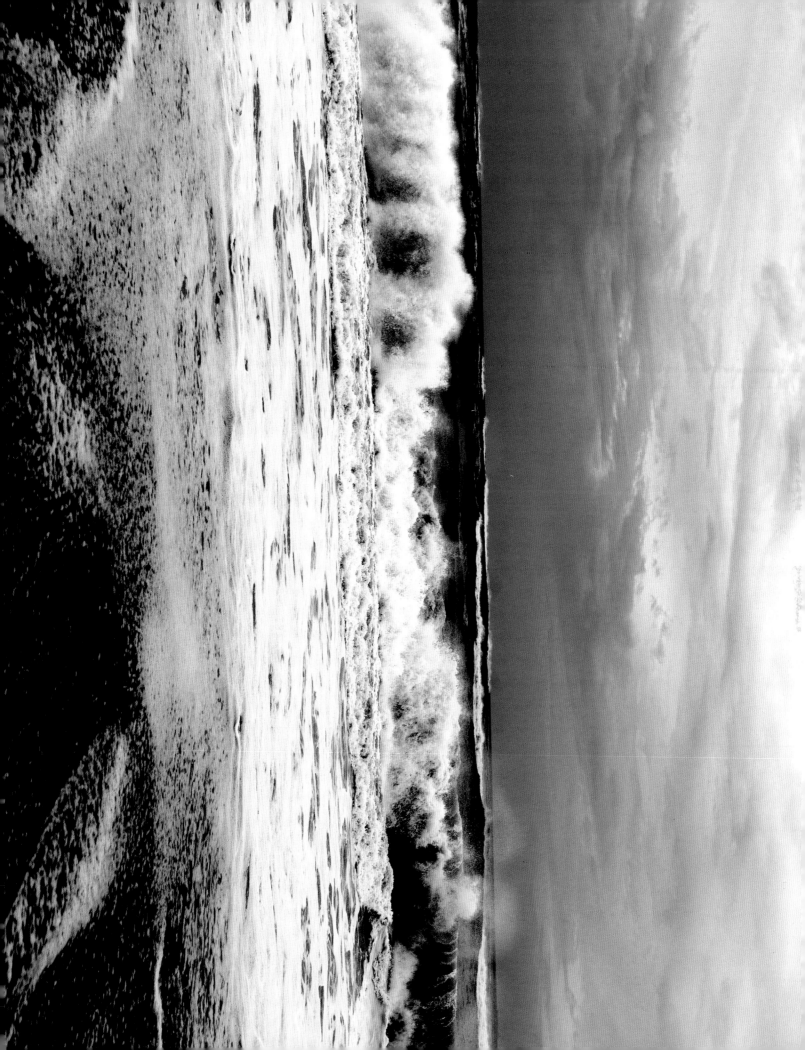

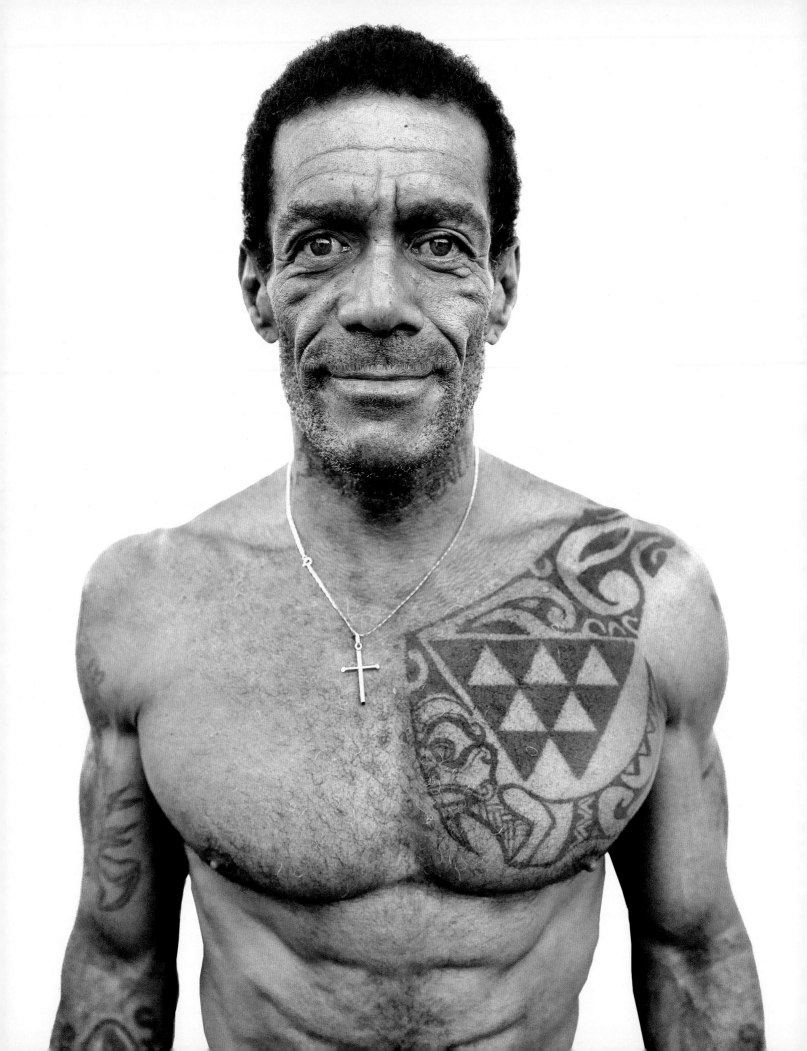

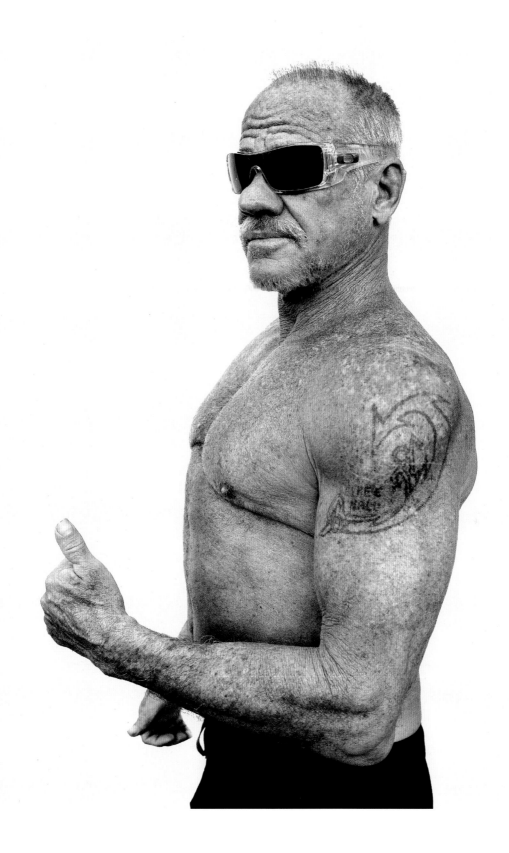

Opposite: **Buttons Kaluhiokalani**, pro surfer and instructor; described by *Surfer Today* as a surf legend. **Right: Eddie Rothman**, founder in the 1970s of **Hui O He'e Nalu**, a club to keep surfers in Oahu more organized while surfing; also known for his surf brand

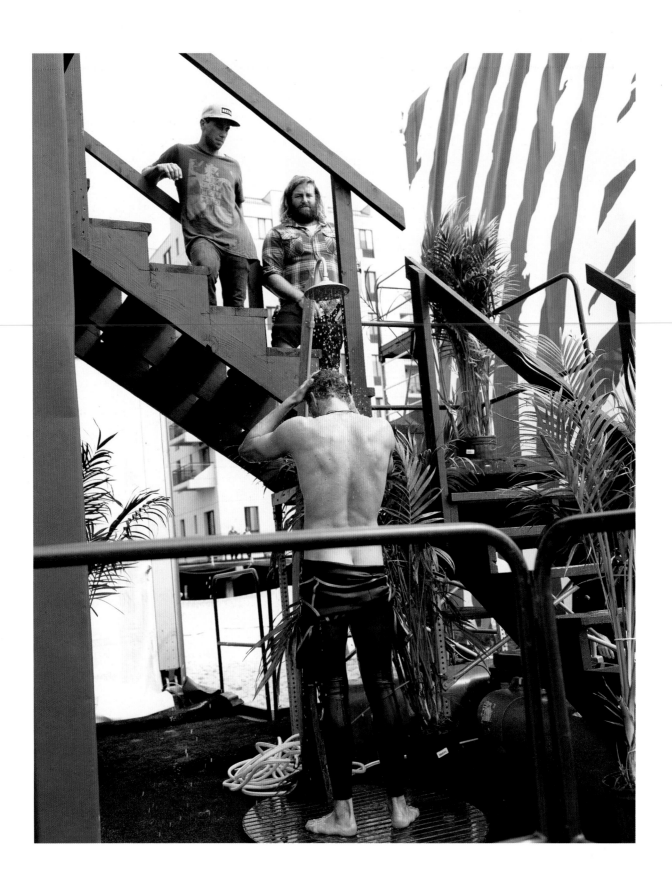

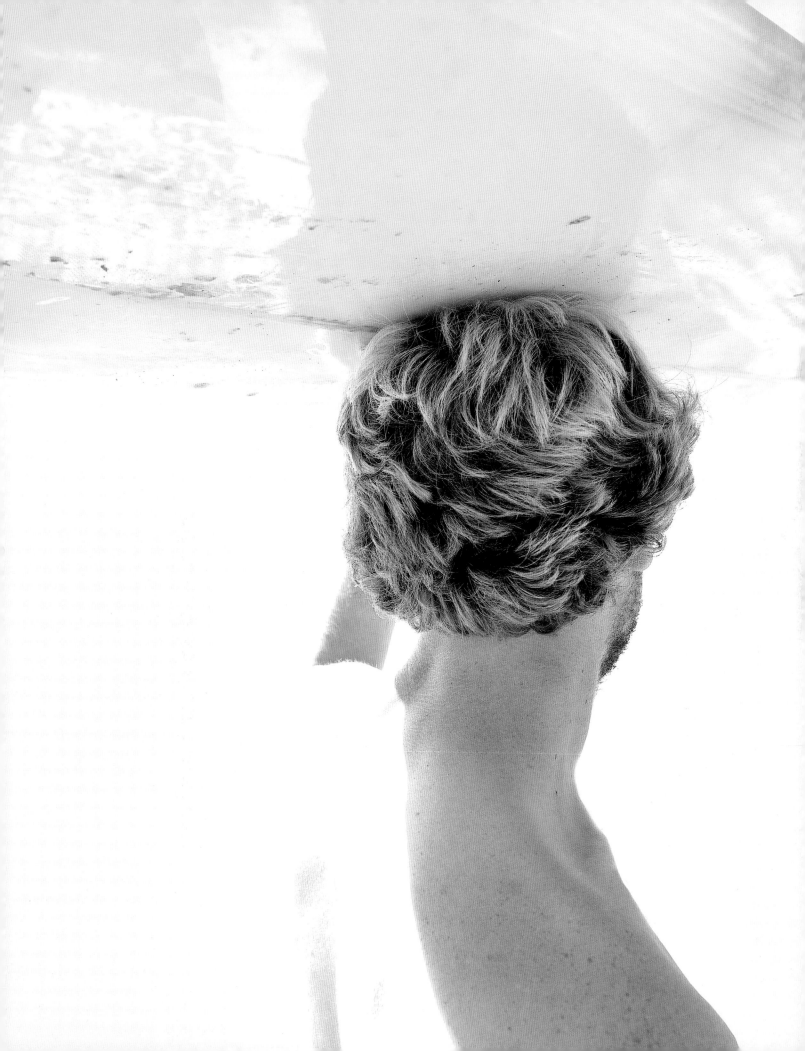

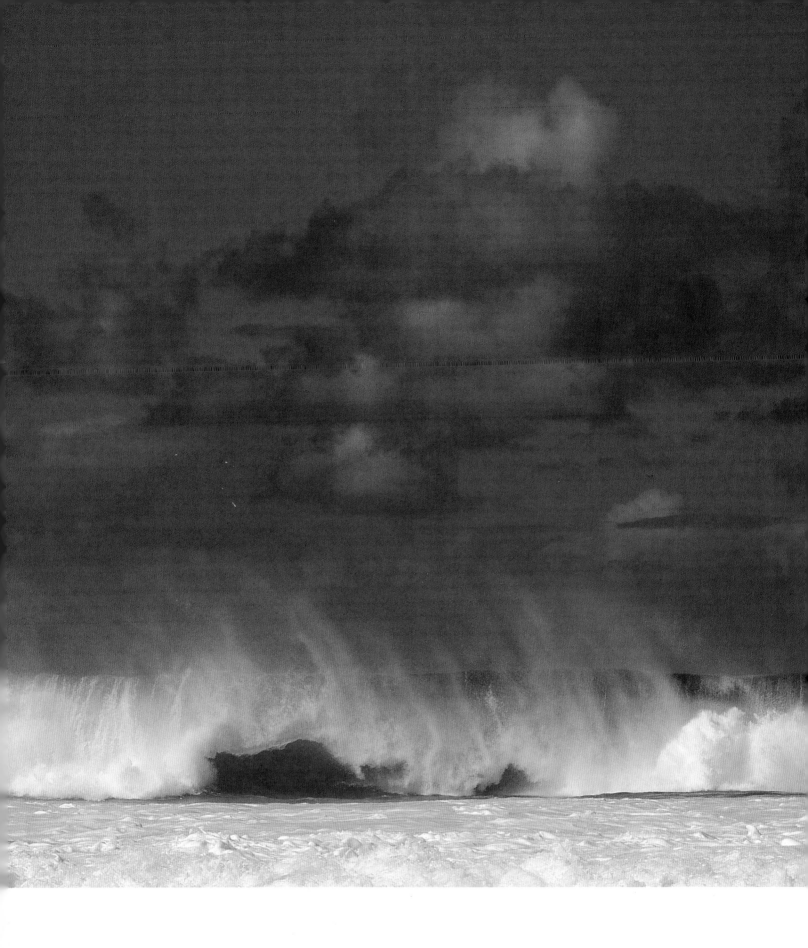

North Shore, Oahu

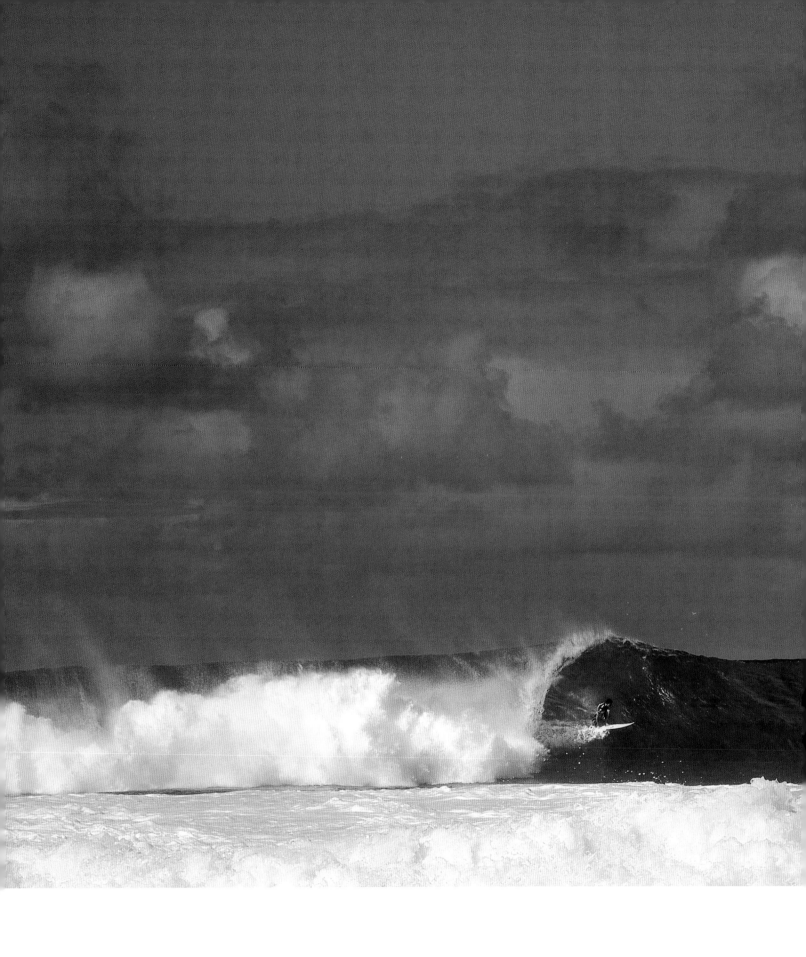

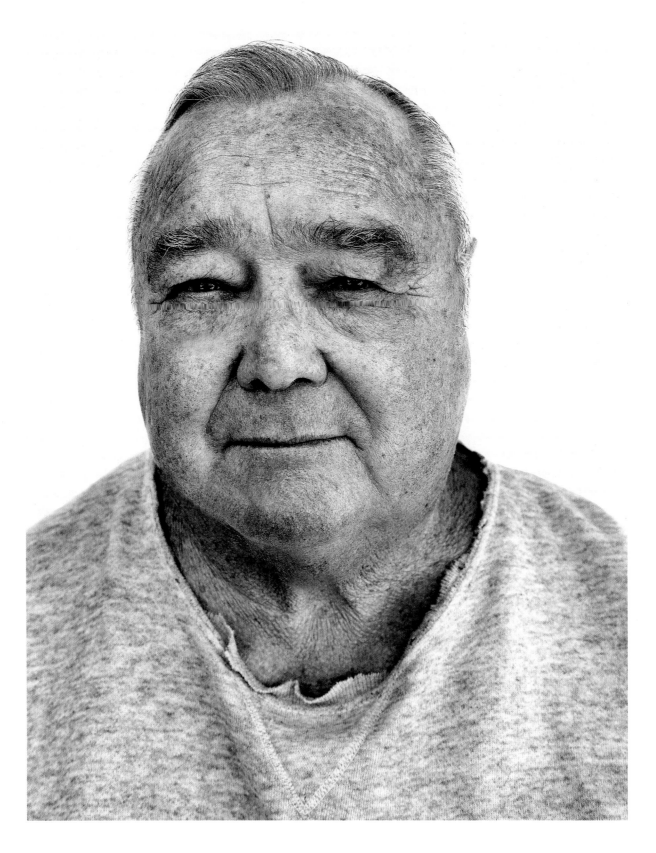

Left: Greg "Da Bull" Noll, pioneer of big-wave surfing and prominent longboard shaper
Opposite: William "Stretch" Riedel, owner of Stretch Surfboards, Santa Cruz

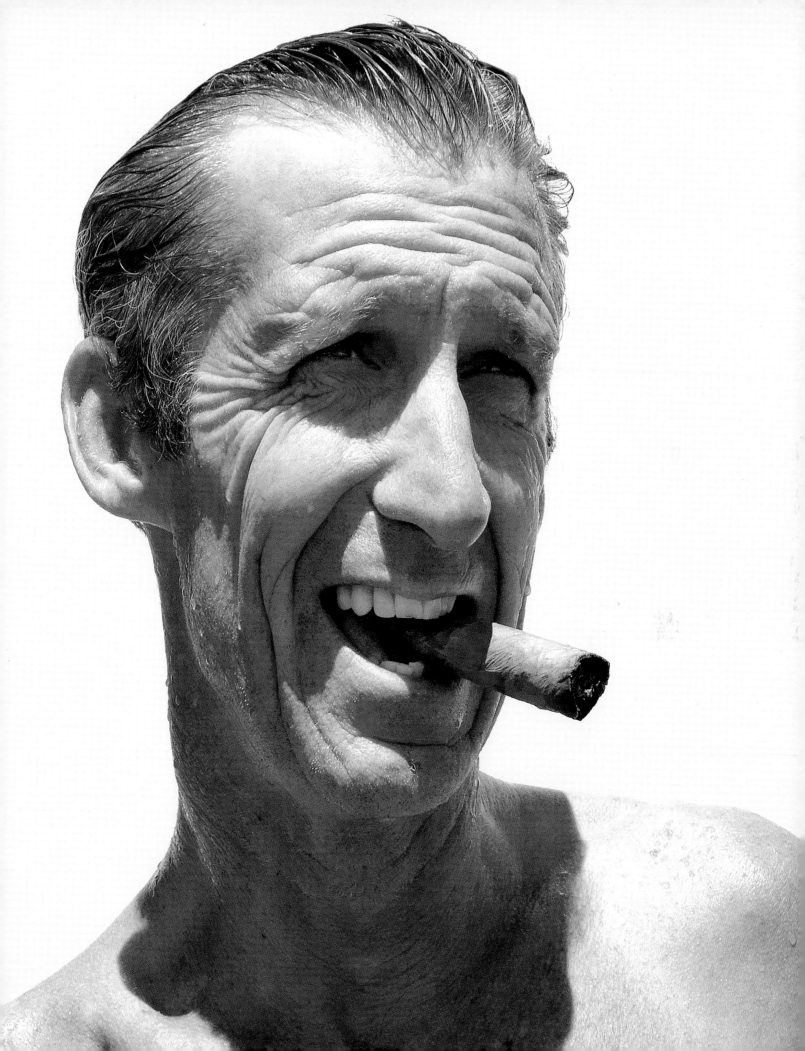

Left: Shaper's art concept room, Oahu
Opposite: Kaimana Henry, longtime Oahu surfer; in charge of the Volcom company house for team surfer

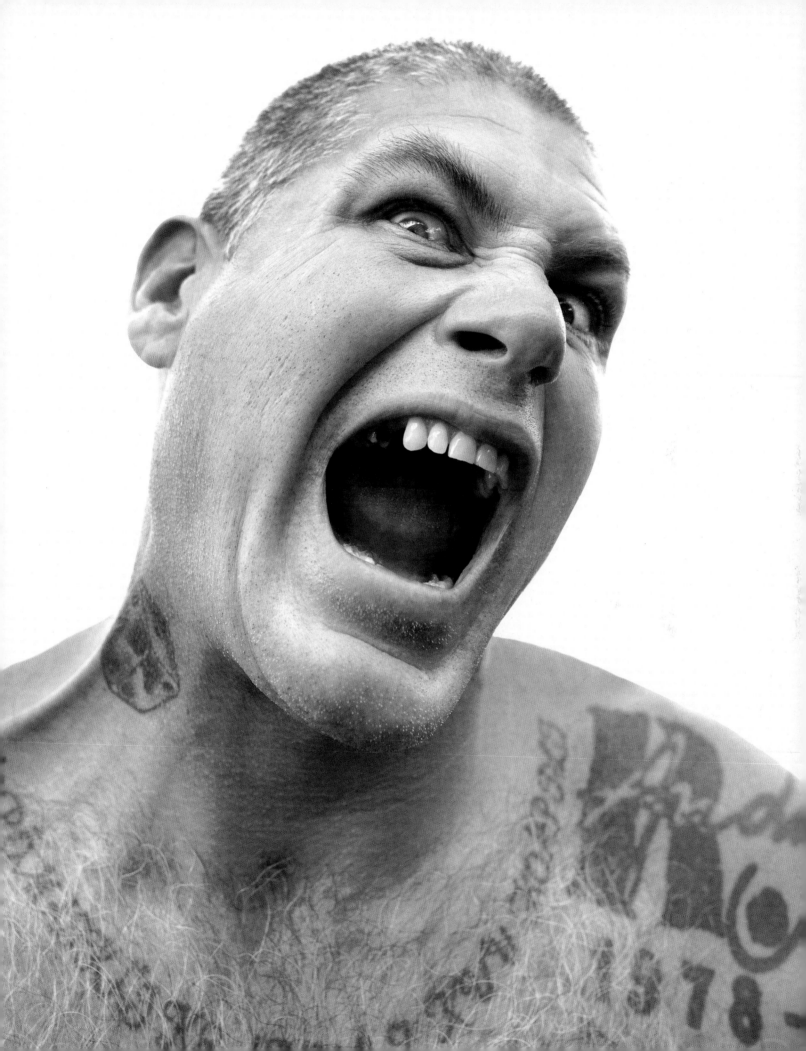

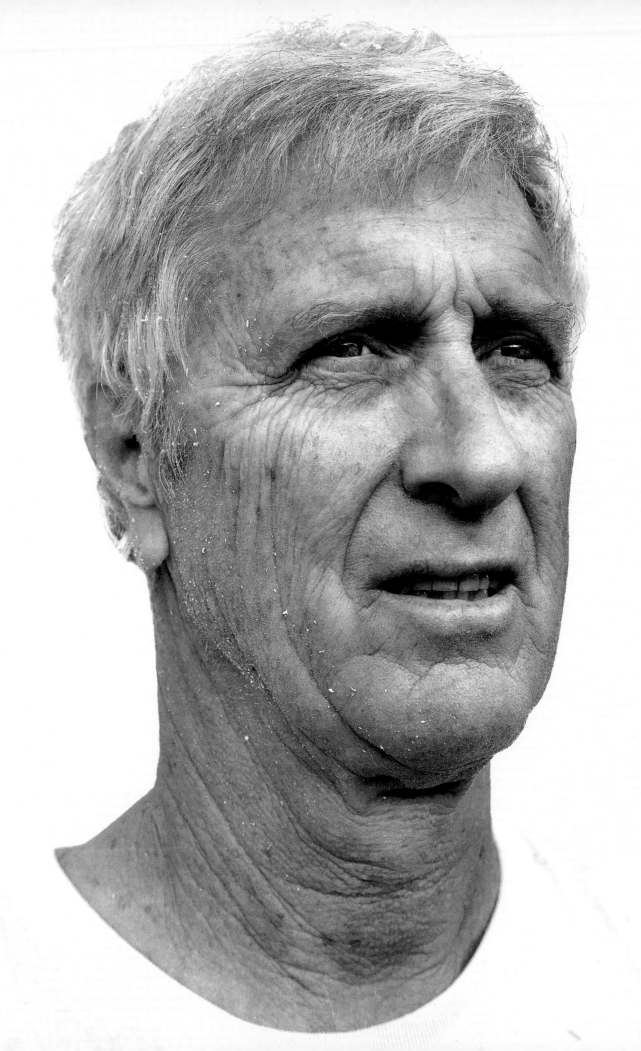

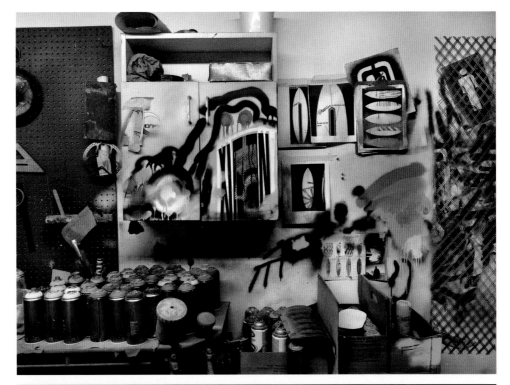

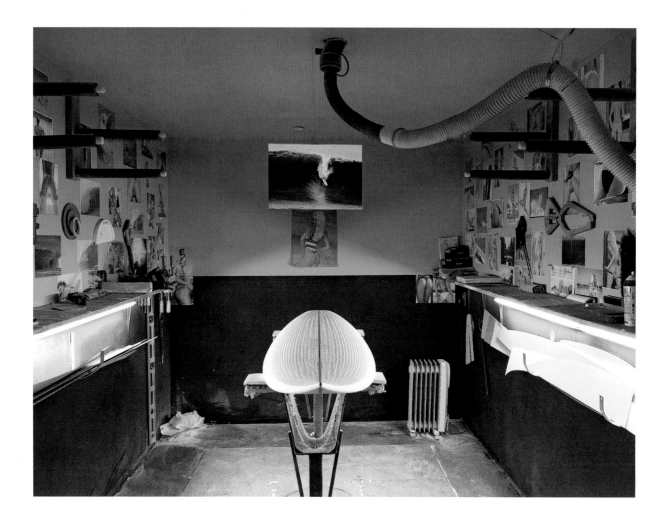

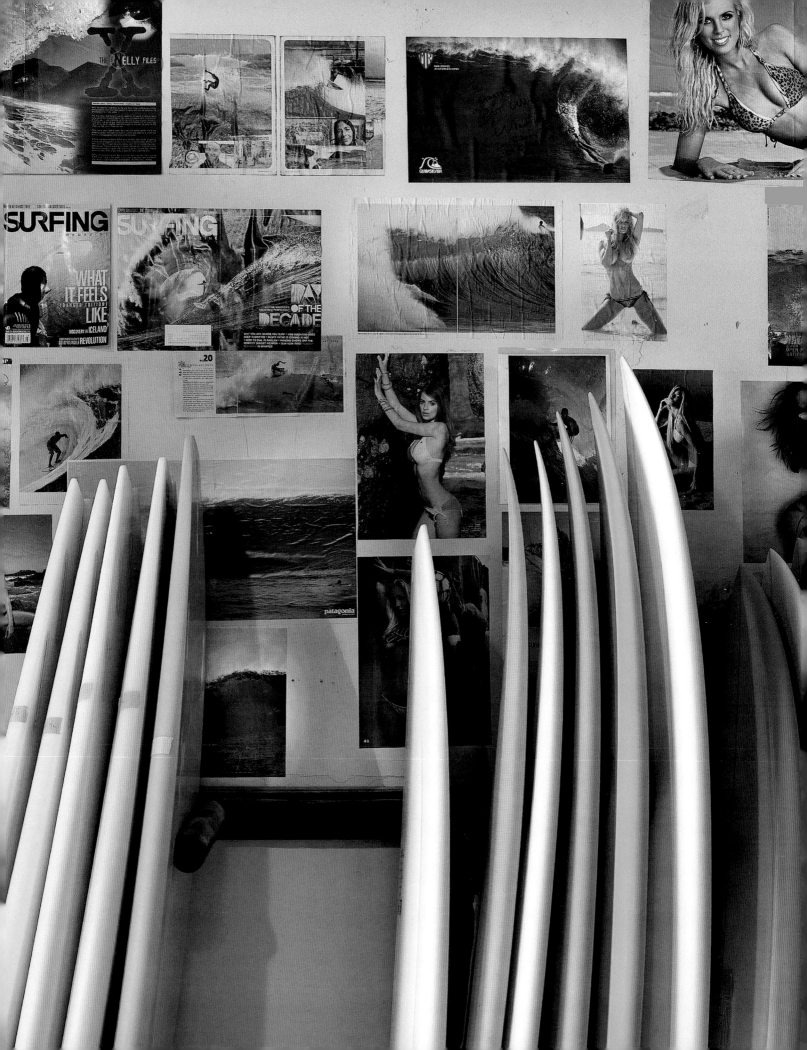

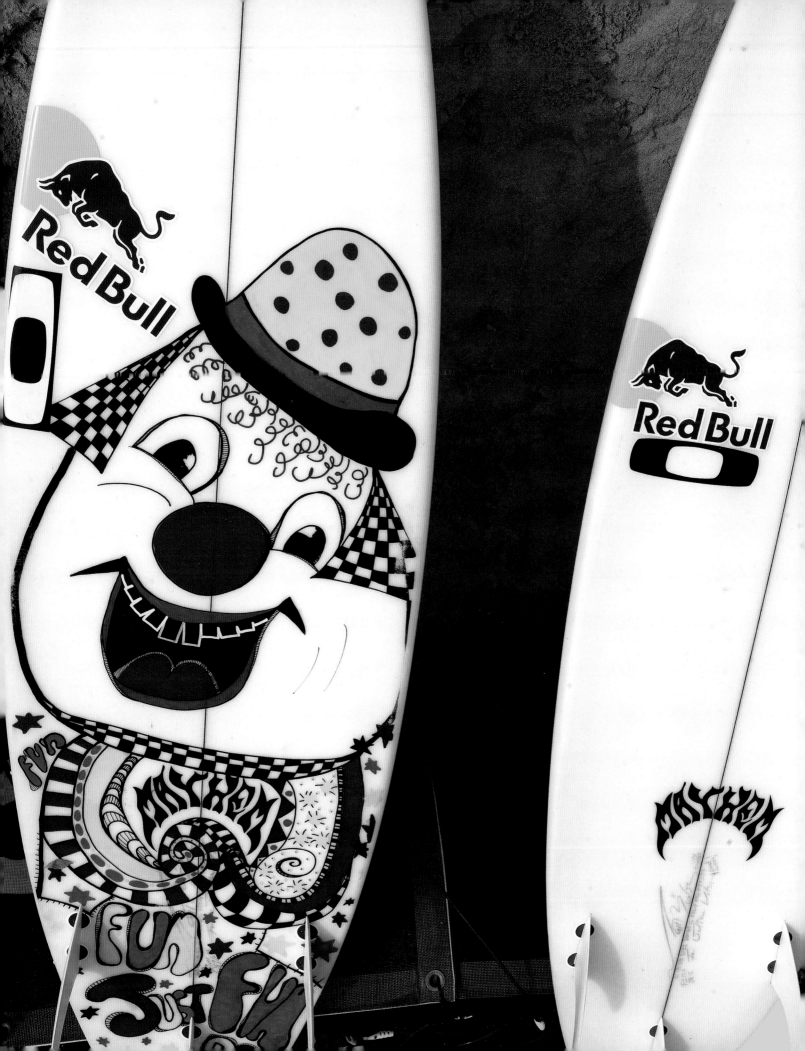

Right: Dustin Barca, pro surfer and accomplished MMA fighter

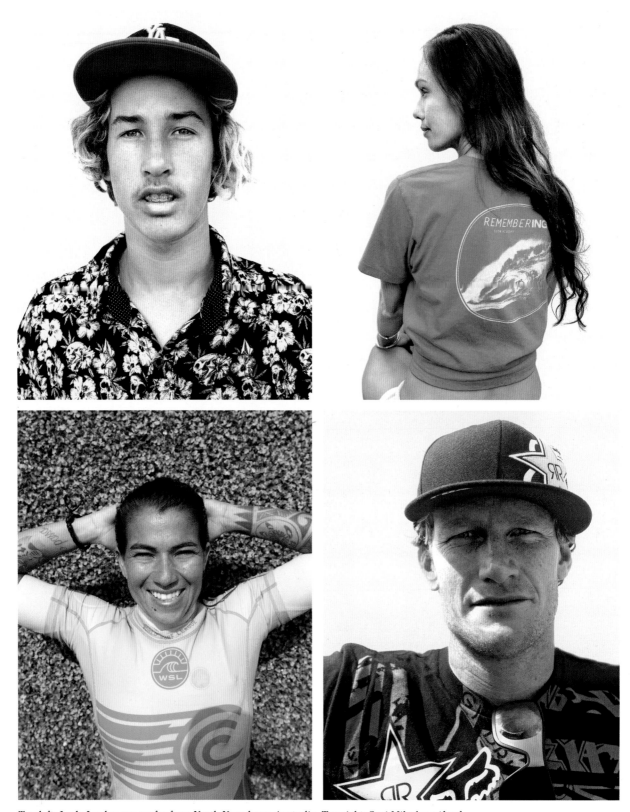

Top left: Jordy Lawler, pro surfer from North Narrabeen, Australia. Top right: Suzi Milosky, wife of Sion Milosky, who died surfing at Mavericks; he is famous for catching the biggest wave ever paddled into. Bottom left: Silvana Lima, Brazilian pro surfer; on the ASP World Tour, placed 9th in 2006, 3rd in 2007, runner-up in 2008 and 2009, 4th in 2010, and 5th in 2011. Bottom right: Bebe Durbridge, Australian pro surfer, winner of 2007 Pipeline Masters

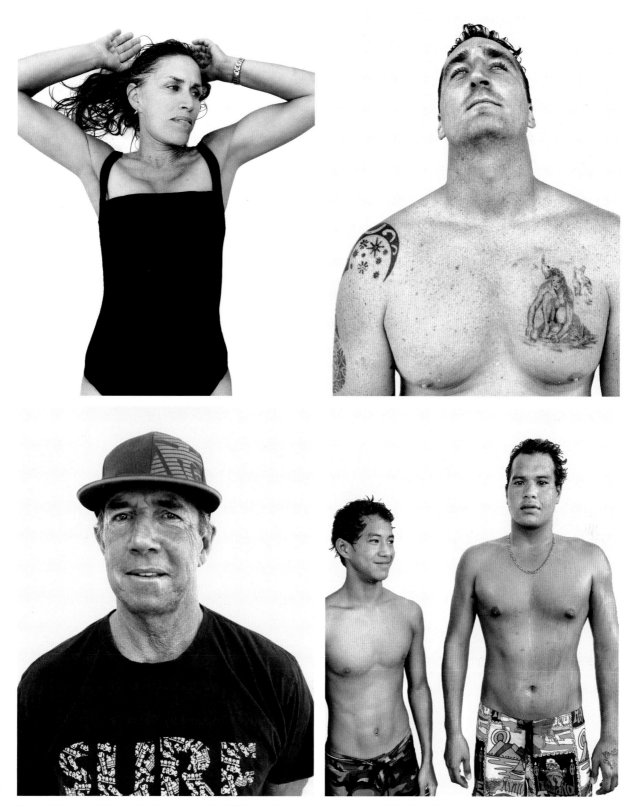

Top left: Jeanette Schumacher Top right: Ben Wilkinson, big-wave surfer. Bottom left: Rich Chew, 1960s pro surfer and winner for WSSA; lifeguard with more than a thousand rescues; inducted into Surfing Walk of Fame, 2003. Bottom right: Seth and Micah Moniz

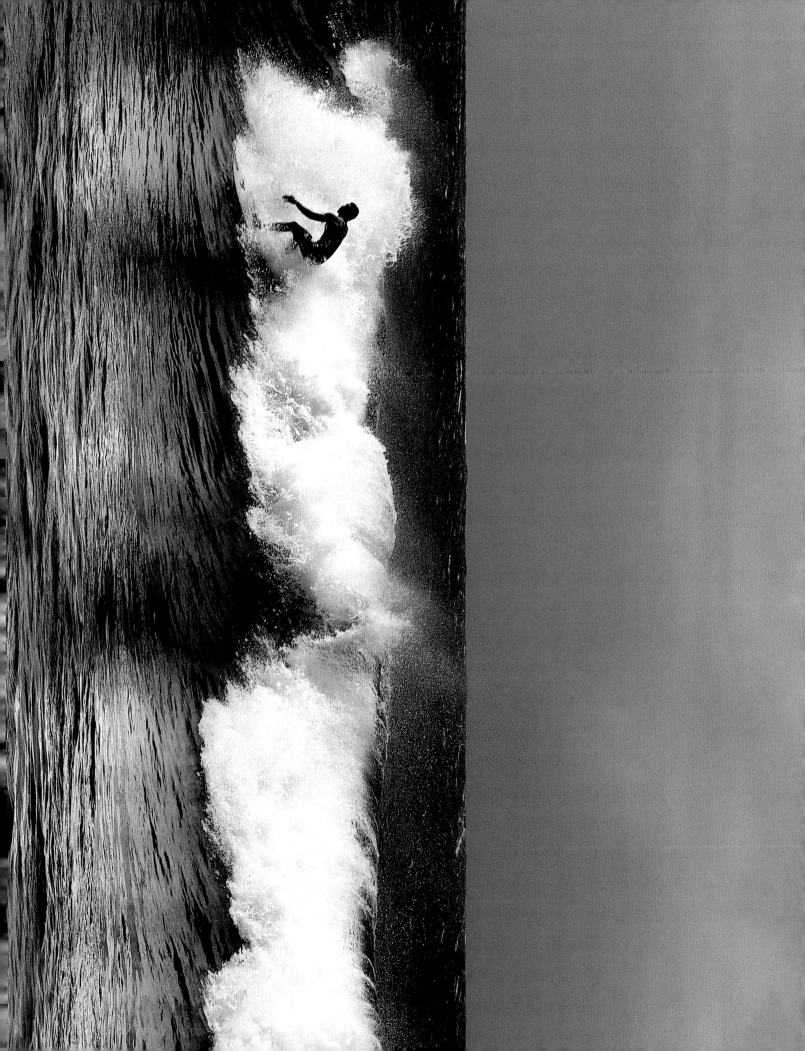

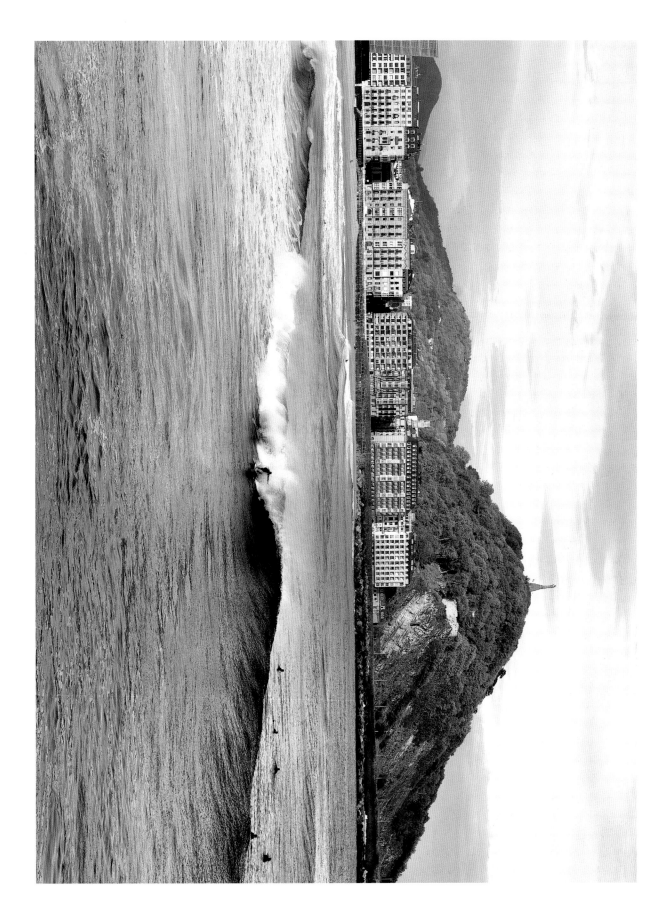

Opposite: "Classic Pose," Hawaii
Right: "1st Wave," San Sebastian, Spain

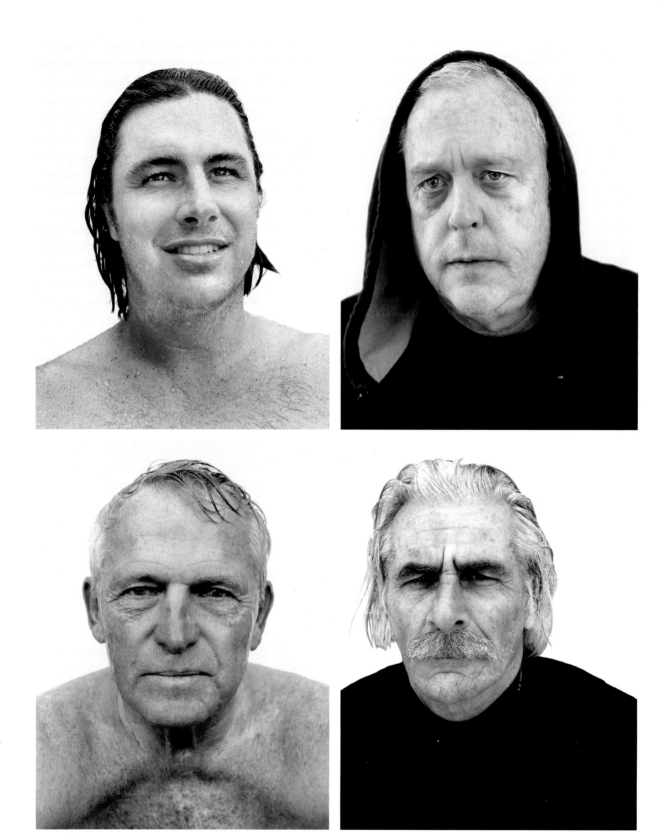

Top left: Reef McIntosh, pro surfer; runs the Quiksilver beach house at Pipeline, housing team riders Top right: Dick Brewer, pro surfing photographer, La Jolla. Bottom left: Steve Walden, known as the "father of the modern longboard"; prolific longboard shaper Bottom right: Artist/surfer Tony Caramanico, Montauk, Long Island

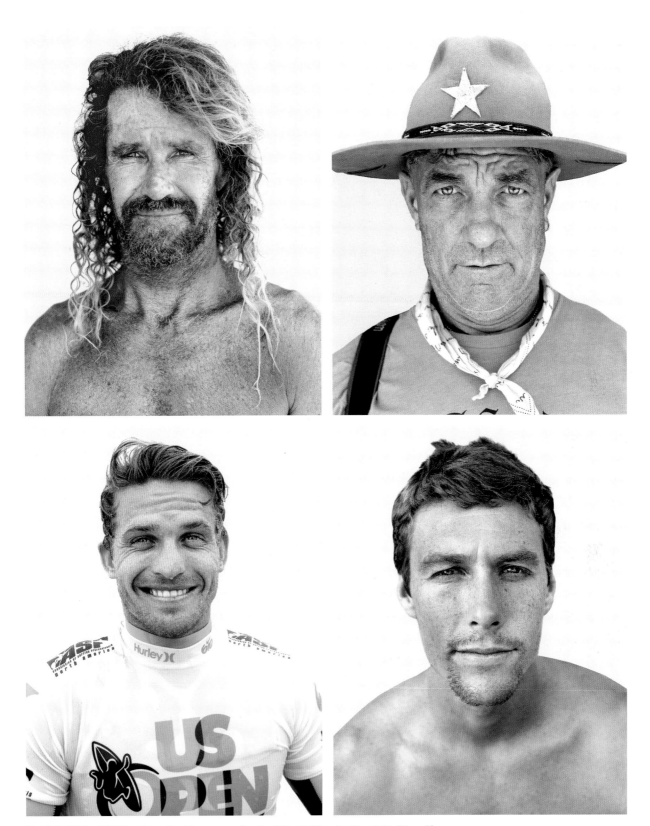

Top left: Michael Willis, champion big-wave surfer, La Jolla, California. Top right: Steve Sherman, veteran pro-surfing photographer. Bottom left: Yadin Nicol, Australian pro surfer; placed 2nd in 2012 U.S. Open. Bottom right: Ian Wallace, big-wave surfer

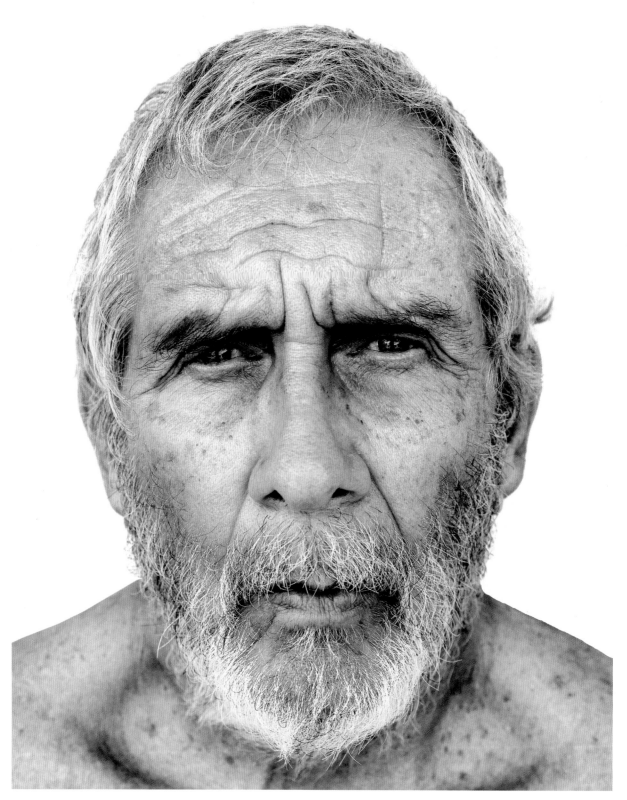

Left: Kimo Hollinger, legendary Hawaiian surfing big-wave pioneer

Opposite: Leonardo Fioravanti, Italian surfer who holds a 2014 QS ranking of #24 and holds #11 with WSL ASP

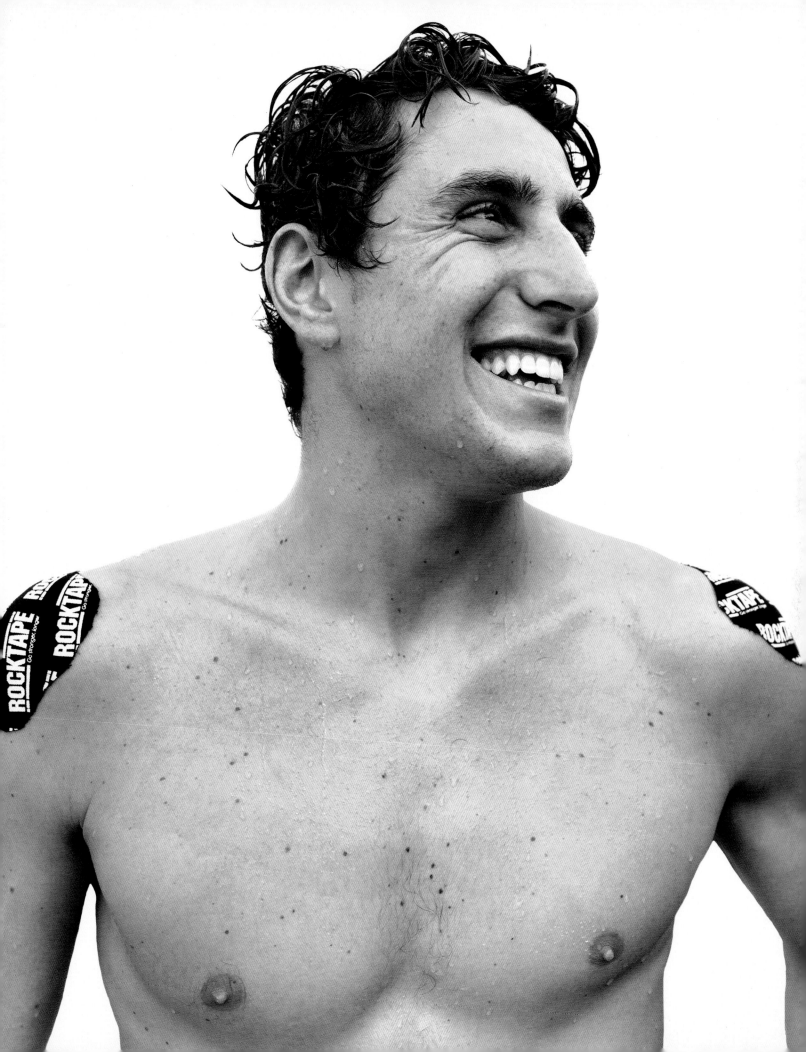

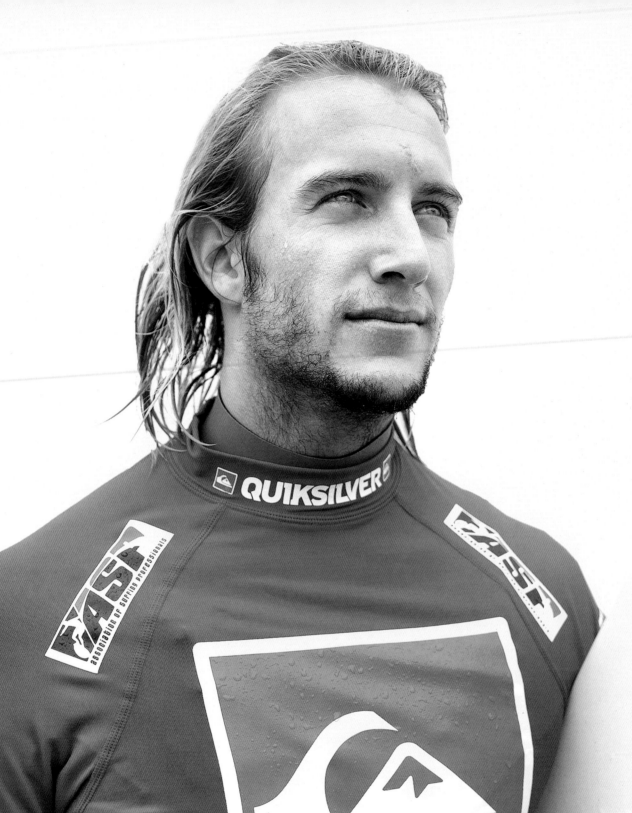

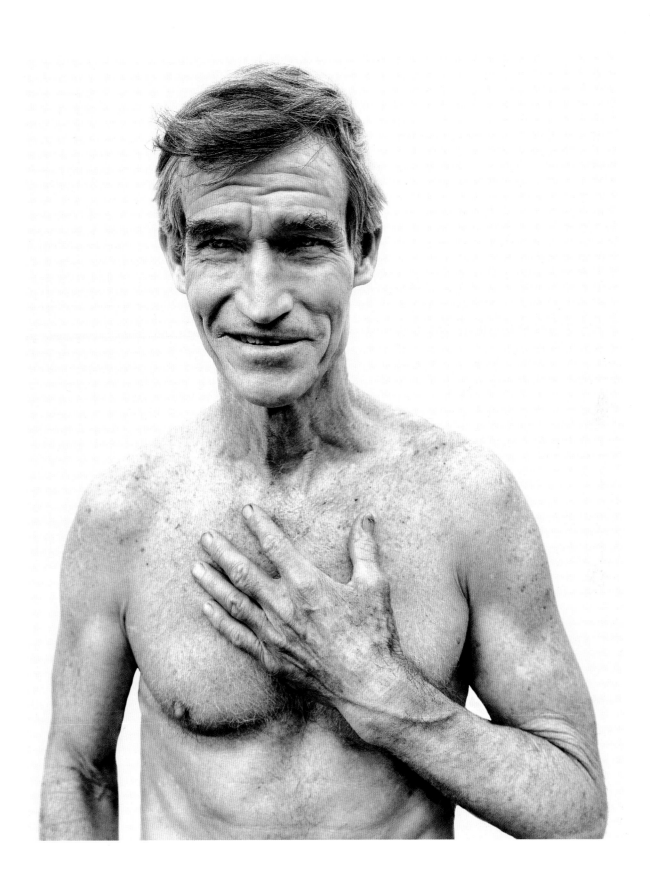

Opposite: Owen Wright, first surfer to post two perfect scores in a single event
Right: Jock Sutherland, legendary big-wave surfer

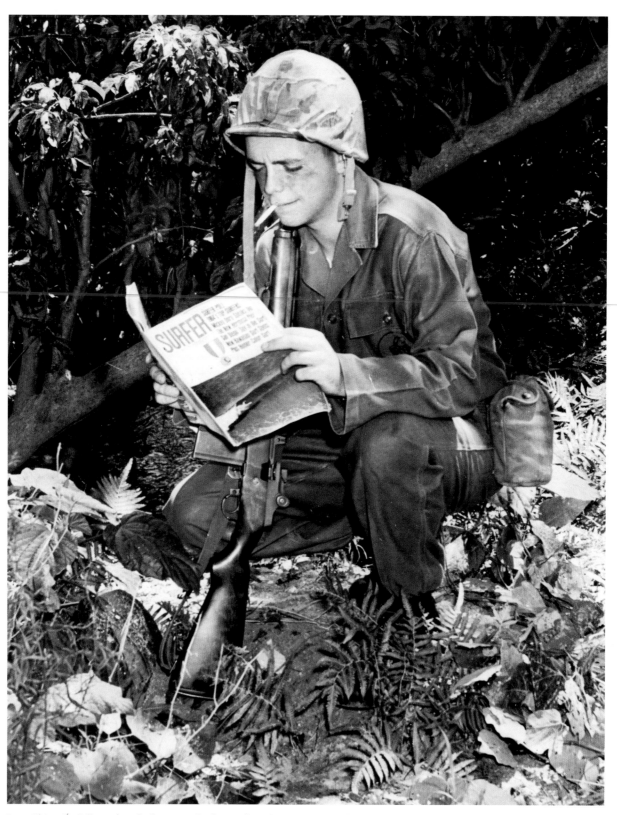

Jerry Shine, La Jolla surfer who became a Seabee in the U.S. Navy, smuggled his surfboard into Vietnam. His captain discovered the board and told Jerry that having it was a court-martial offense. However, when Jerry used the board to rescue four endangered swimmers in the South China Sea, he was recommended for a lifesaving medal. His captain, now in a catch-22 position, ended up giving Jerry duty at South Beach.

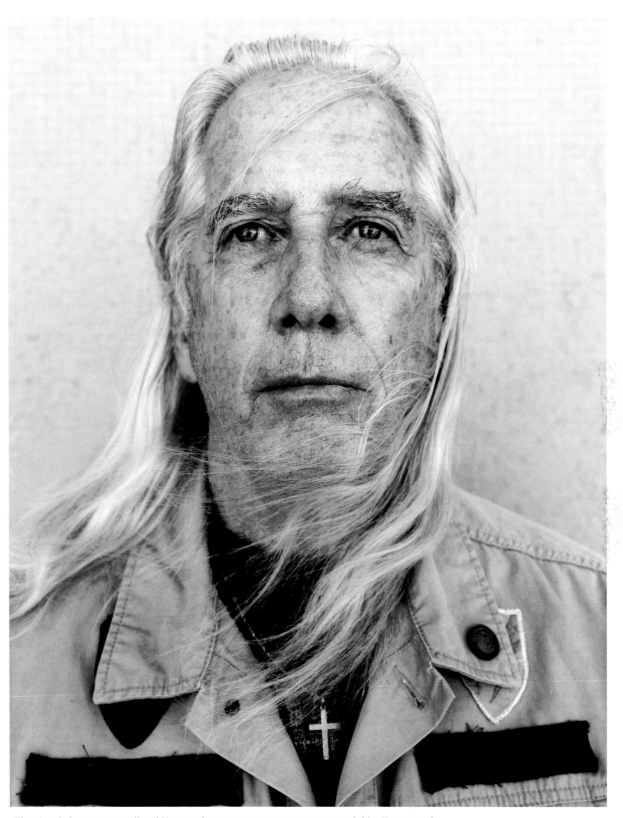

"There's a dichotomy, mentally, of Vietnam being a pristine environment, much like Hawaii, with clear water and surf, small but wonderful, and beaches with white sand—yet at the same time knowing at any minute you could be under fire, in someone's gun site. That made it an experience that was basically surreal and at the same time, in some ways, satisfying, yet terrifying."
—Rick Mathews, Vietnam vet, 1969–1970

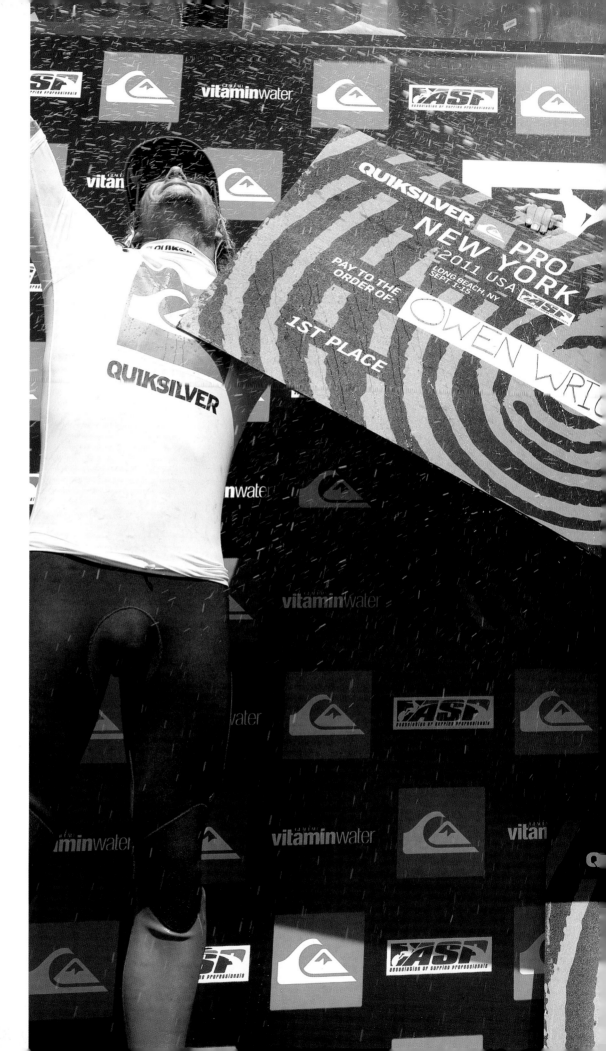

Quicksilver Pro New York, 2011—winner Owen Wright with Kelly Slater

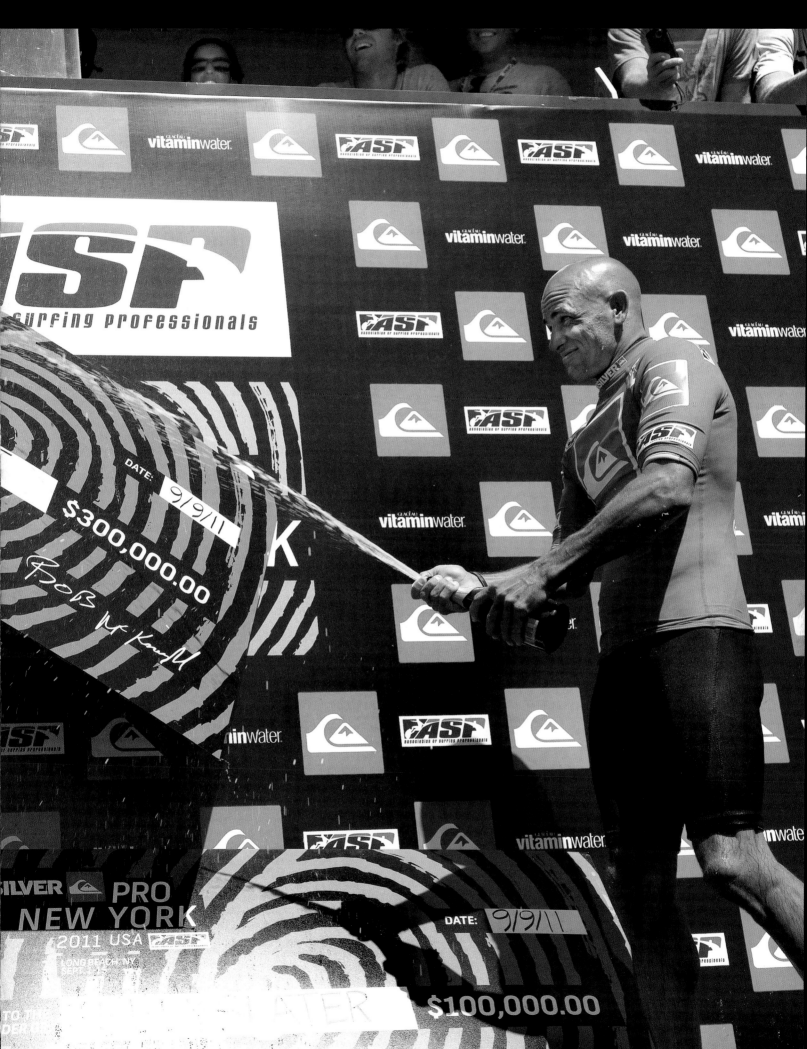

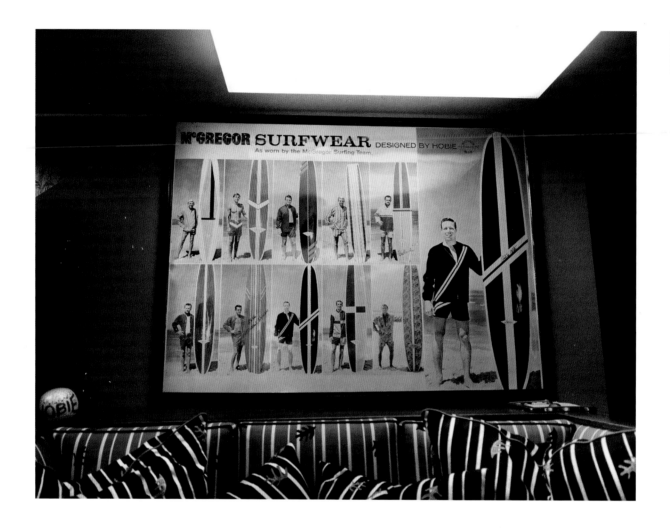

Left: Hobie Surfboards company lobby
Opposite: Allen Sarlo's home, Malibu

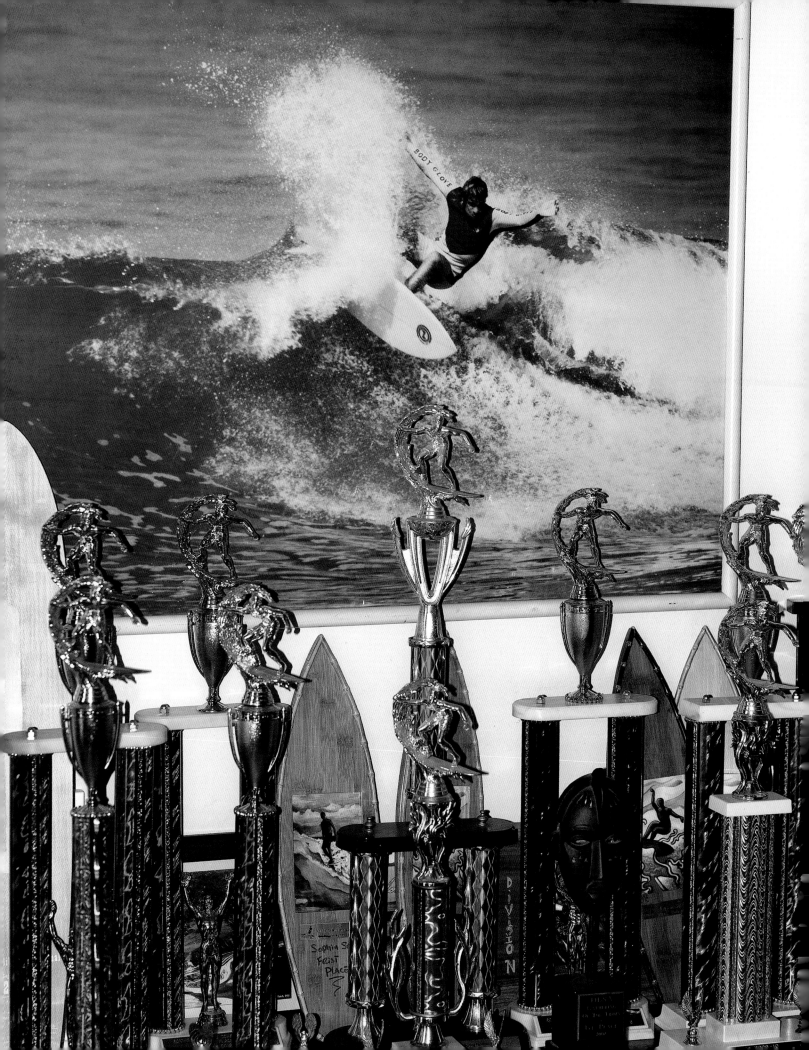

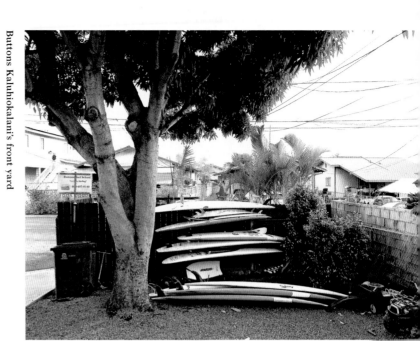

Buttons Kaluhiokalani's front yard

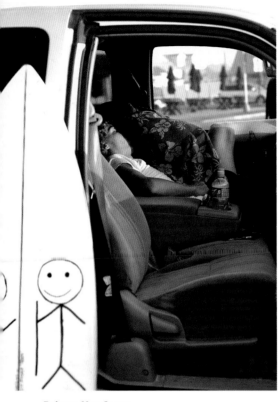

Belmar, New Jersey

Jack O'Neill, inventor of the wetsuit
and founder of the O'Neill surf brand

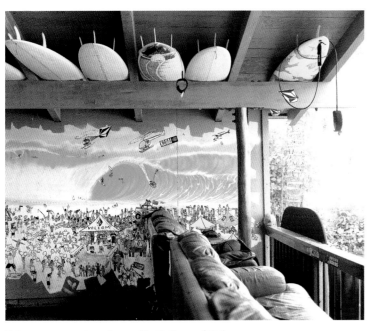

Volcom company team home, North Shore of Oahu

Italo Ferreira, Brazilian pro surfer who has competed on the
World Surfing League Men's World Tour since 2015

Billabong team home at Pipeline

Garrett McNamara's kitchen area

OVER
CO ME

THE
FEARS

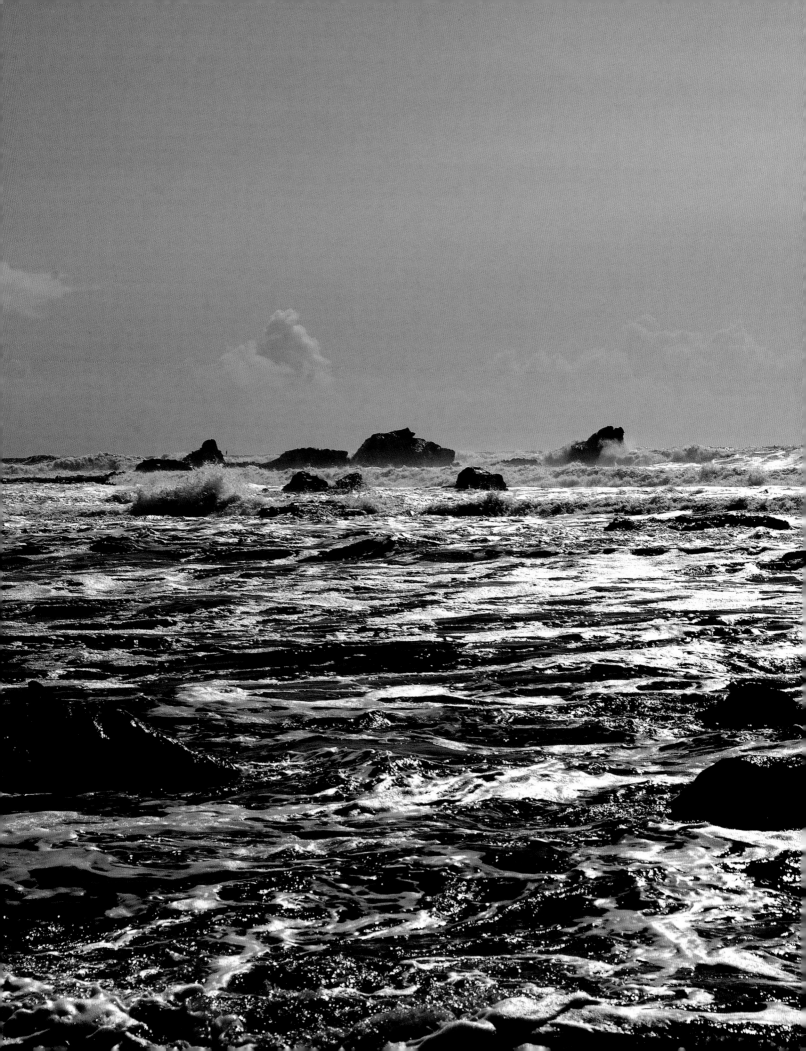

Thom Gilbert: It's well known that you were first to surf the very dangerous and unpredictable big waves at Mavericks in Half Moon Bay. Could you take us through a personal moment that allowed you to overcome those dangers to surf Mavericks and repeatedly do this alone for years to come?

Jeff Clark: Growing up on the beach in Half Moon Bay, I could see that the winter waves were much bigger than people were comfortable with. I could see that in a lot of the older guys and also my friends. I spent so much time at the beach, I was always in that element. The waves were small sometimes; other times, pushing the limit. As I grew into my knowledge of the ocean from direct interaction and not through stories from others, I was able to get stronger with my vision and instinct. It all started to grow within me. I then could see my strength to surf Mavericks. Others thought that it was just complete craziness. For me, I understood those elements that were at work. It allowed me not to challenge but rather coexist. The ocean has immense power and danger, which does exist if you don't understand it. That danger exists if you don't know how to move and dance with its energy and power. I knew, since I had spent so much time there, that there are risks in some things, yet I have this spirit within me that thinks I can do anything. My knowledge of the ocean is a cautionary knowledge. Like they say, "You never turn your back on the ocean, because of the unexpected." If you go into something knowing that that always exists, and you are always aware of it, you're never surprised. When that day came up at the point, and we looked out, it was just this gorgeous swell. I knew it was time. I had already spent time at Ocean Beach in San Francisco in very big waves. I also surfed big waves in Santa Cruz. Having those experiences with twenty- to twenty-five-foot waves already in my surfing log helped me deal with that much power and energy. When I looked at the waves that day at Mavericks breaking fifty feet—it wasn't the first time I had seen them. But I felt there was no way I could surf it.

I did appreciate the size, the shape, and the power. I also thought I could just surf it with my mind and not actually be out there. Then I thought I should not be denied, since I had been in waves this big before. I understood what I was looking at. I would have liked to have had company out there with me. I wasn't going to let that hold me back. I made the decision and put my wet suit on, picked my path to get out into the deep water, and paddled out to Mavericks. People always say to me, "You must have been so scared the

first time you paddled out to Mavericks."? My answer to that, the first time asked, was that I was waiting for this day for so long. I wanted this more than anything. I watched the big, beautiful wave break, and no one rode it for years and today was the day. I wasn't going to let this slip by. These were perfect twenty- to twenty-five-foot base waves. You know, a lot of going out there was the understanding of currents. We didn't have GPS back then in 1975, but I could paddle out and line things up with a tree or a crack in a cliff. It's using lineups that you learned in Boy Scouts or the Explorers. This helps you position yourself a half-mile offshore on the outside edge of a reef, where this wave is going to stand up and break. You have to understand the dynamics of the swell. This includes the energy of the swell, how it hits the symmetry of that ocean floor, and positioning yourself by calibrating. I understand all that, and it's exactly what it did. All this has allowed me to be back in that exact position on the outer part of that reef every time. I was in that perfect position when that twenty-foot wall of water spit up in front of me. Then it was time to turn and go. The wave lifting me up and then the wave getting steep enough to where gravity takes over and I start to free-fall down the peak of that wave all happens so fast. That is something only you know that you can accomplish. At that point, fear has nothing to do with what you're doing. There is no fear there. If I was scared, I would have never gotten off the beach. I find a lot of people surfing Mavericks who are scared. Seems the only reason they got into the water was from peer pressure, as well as feeling they have to do it in order to be a big-wave surfer. Many people have come and gone. What got me to push myself over the edge was just pure passion and love for the power of the ocean. I've never been happier than when I'm in water, whether the waves are big or small.

I'm sure you took back with you the power of this accomplishment, both physically and emotionally. You share that with many people through your talks to help them accomplish their own goals and ultimately empower themselves. Can you speak about overcoming our fears?

The biggest misconception is that there was fear involved in my decision to go out there. There wasn't fear, just the unknown. A lot of people are afraid of the unknown. Our whole society revolves around the fear of the unknown. What if you're not afraid of the unknown? It just becomes a new experience. I think that is how more of us need to operate. I have spent years and years in the ocean. I understood the environment, as well as my ability and my capability at that point. Yet I was not limited by my ability and capability or my vision. I really think this is the most important thing. Are you going to let those fears and your perceptions of those fears stop you from doing or believing what you think and what you can ultimately do? That's what it all came down to for me. I believed in my ability and instinct and what I was looking at, as well as understanding what I was looking at. That was all I needed to completely erase anything that others may have tried to instill. Fear never really existed for me. It was just new experiences. Paddling out and surfing Mavericks, as well as sharing that moment, is how I tried to get people to trust in themselves. If you have an instinct, meditate on it or pray on it. It's whatever it takes to get you into you and to trust what your next steps are. If you are ever going to change something in your life, it will usually come with an uncomfortable time. Most people will not want to persevere. We want our comfort zone. A lot of times change is uncomfortable and hard, but most of the time it's very beneficial. We are creatures of habit and we don't like change. More people should try stepping outside that comfort zone. Try something you always wanted to do but were afraid to do. Try it! Why not? You might find it really challenging and you might fail, or it might take you a thousand steps to achieve success. It's all in the perception of how you look at things. Failing is actually a step in the progression. I try to get people to not give up on themselves. Challenge yourself. Take the steps you need to make yourself better. When I talk to people, I want them to get excited with whatever it is. You know, I ride giant waves and I'm also a fairly good golfer. It was the study of something I was so bad at that gave me motivation to not give up.

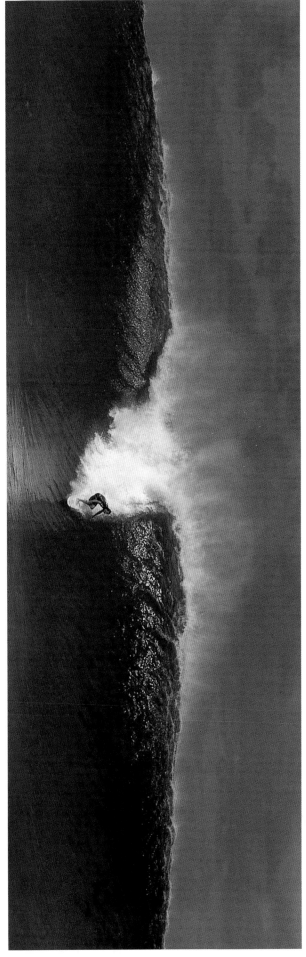

"Warm Ups," Oahu, 2012

Opposite: Michael Ho, Hawaiian pro surfer who has won the Hawaiian Triple Crown, the Duke Classic, the World Cup, and the 1982 Pipe Masters; brother of Derek Ho, another champion surfer; father of Women's World Tour surfer Coco Ho and son Mason Ho. Right: Josh Kerr, Australian pro surfer; on the WSL competitive circuit since 2007

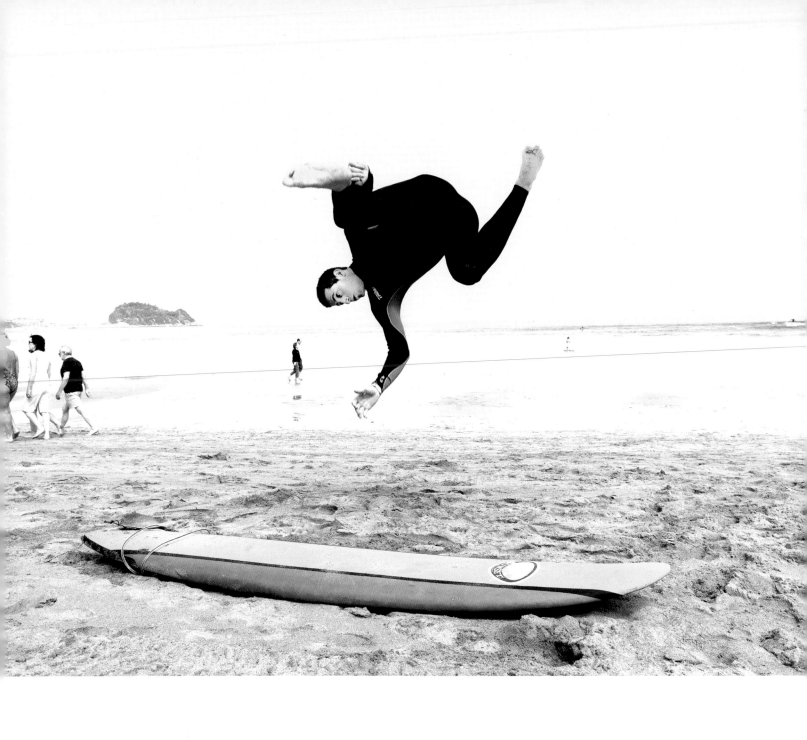

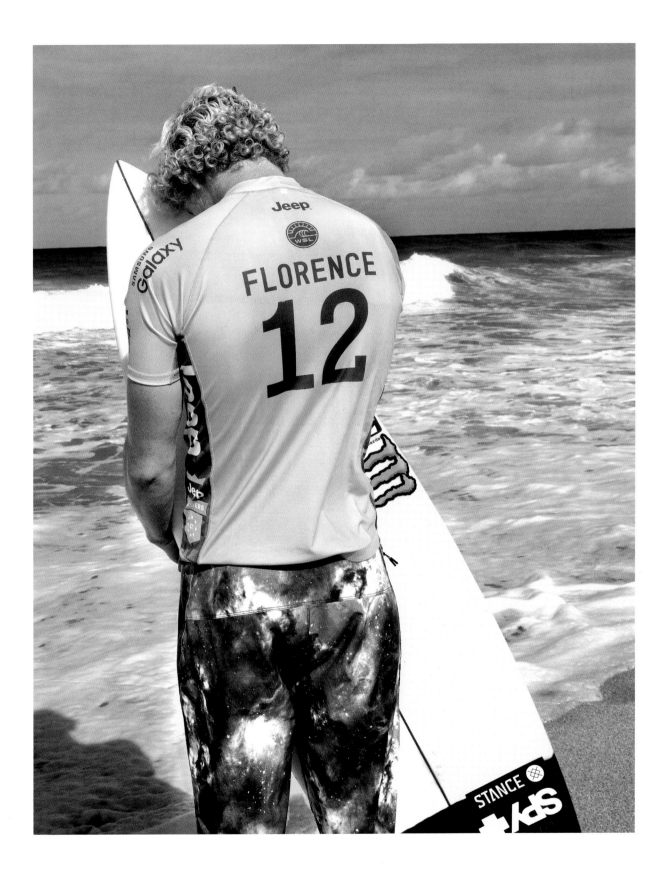

Opposite: "Jumping for Joy," San Sebastian, Spain
Right: John John Florence, Pipe Masters, 2016

Following spread, left: Jack O'Neill, inventor of the wetsuit and founder of the O'Neill surf brand. Following spread, right: Stephanie Gilmore, Australian pro surfer and six-time world champion

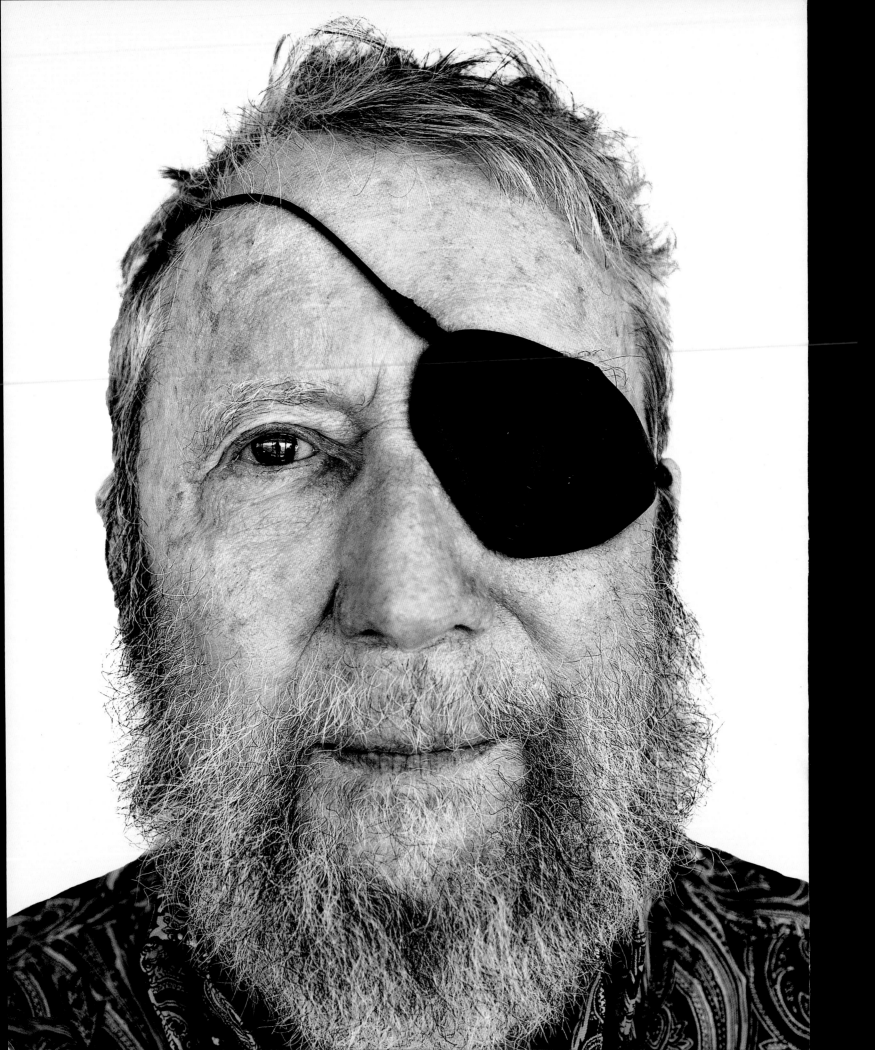

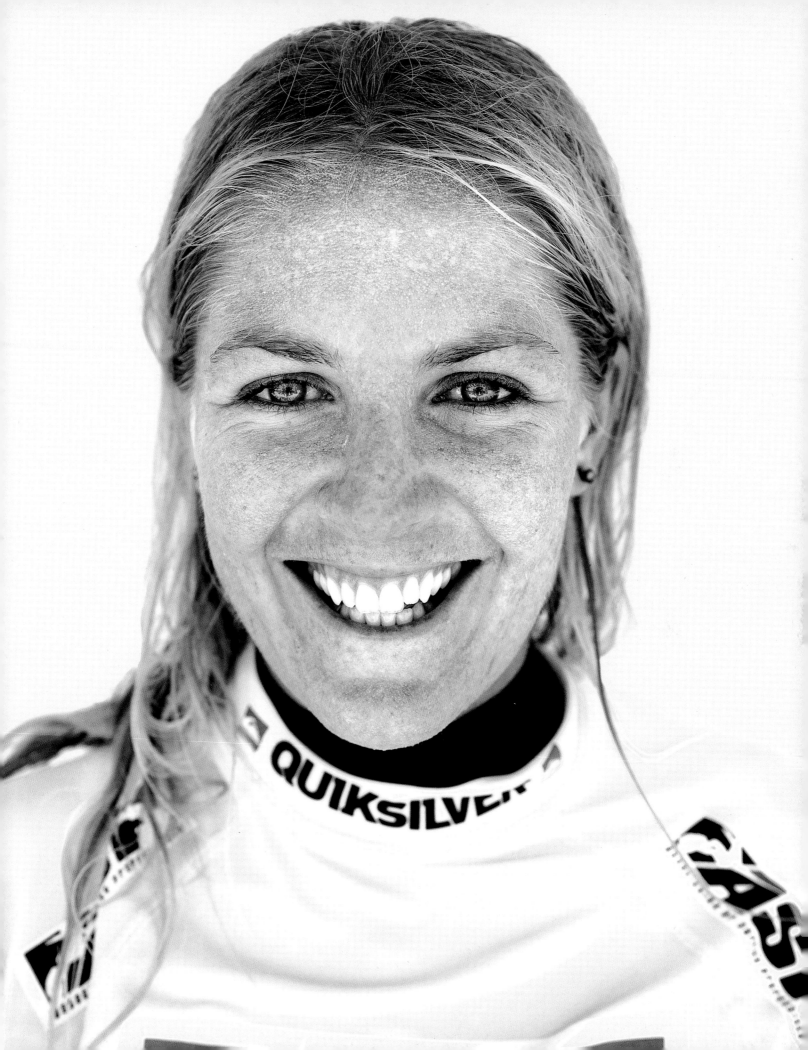

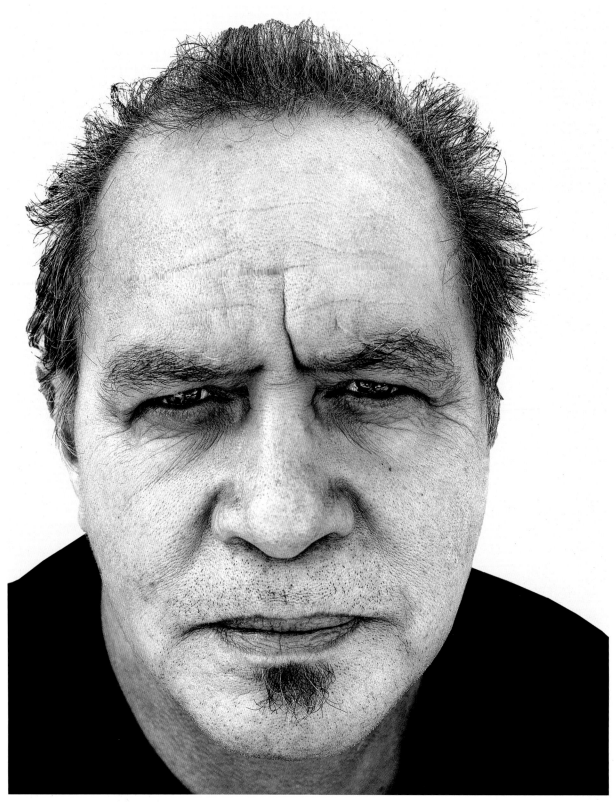

Left: Clyde Aikau, winner of the first Eddie Memorial event; brother of famed Eddie Aikau. Opposite: Opposite: Surfboard used by Eddie Aikau to get help to save a capsized double hull canoe in Hawaii. The crew was later saved, but Eddie was never found. He saved more than five hundred lives as lifeguard on the island of Oahu and is memorialized at many surfing events.

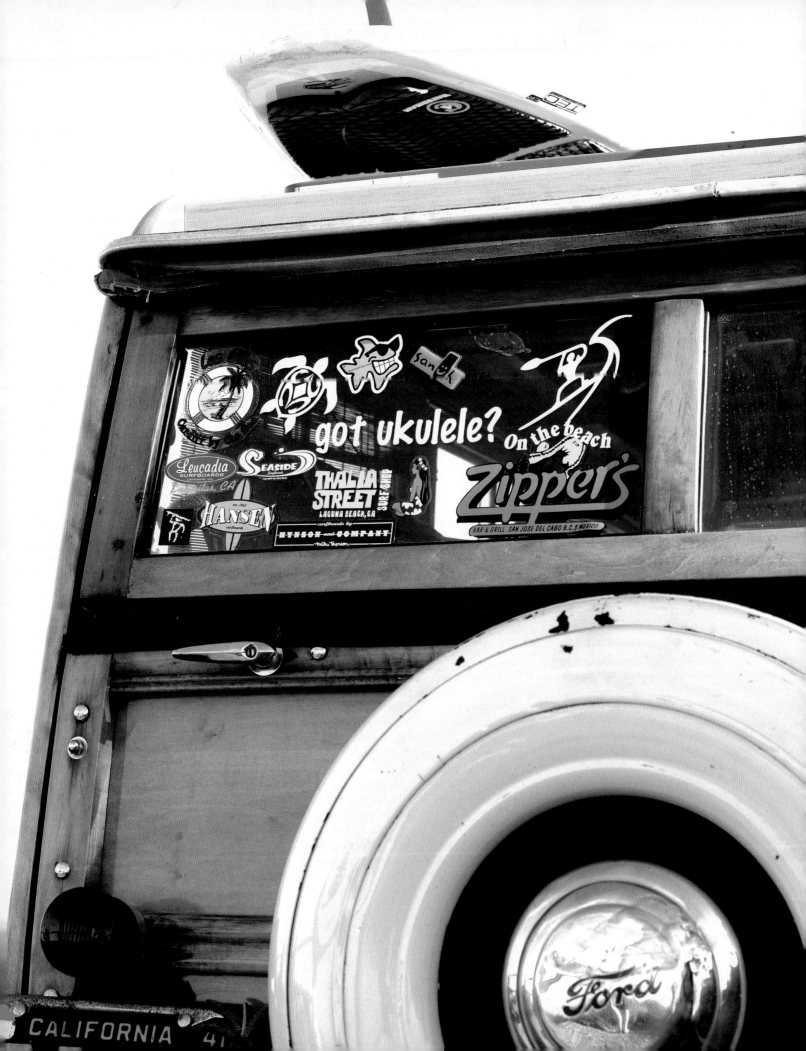

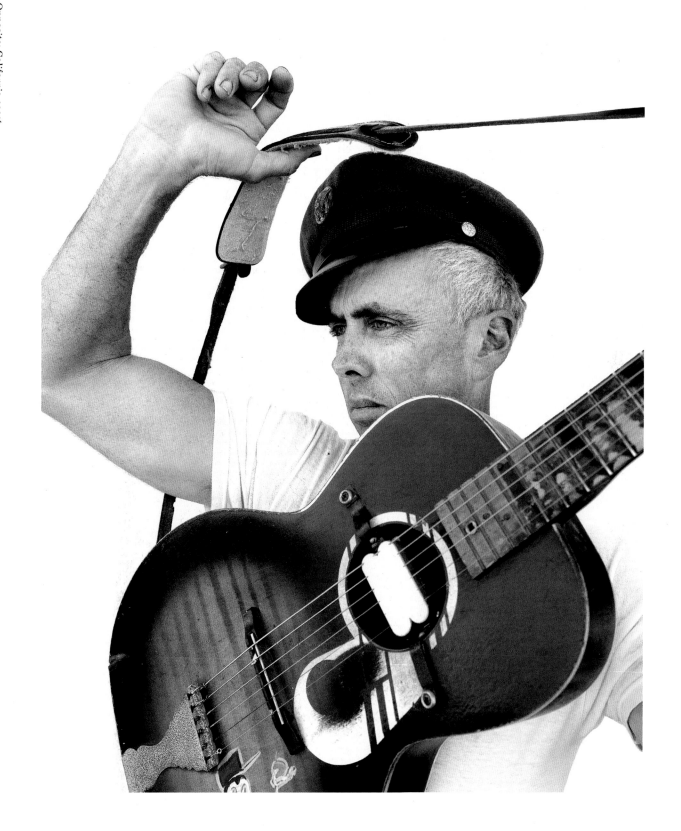

Opposite: California coast
Right: Brian Bent, surfer, musician, artist, and designer, San Clemente, California

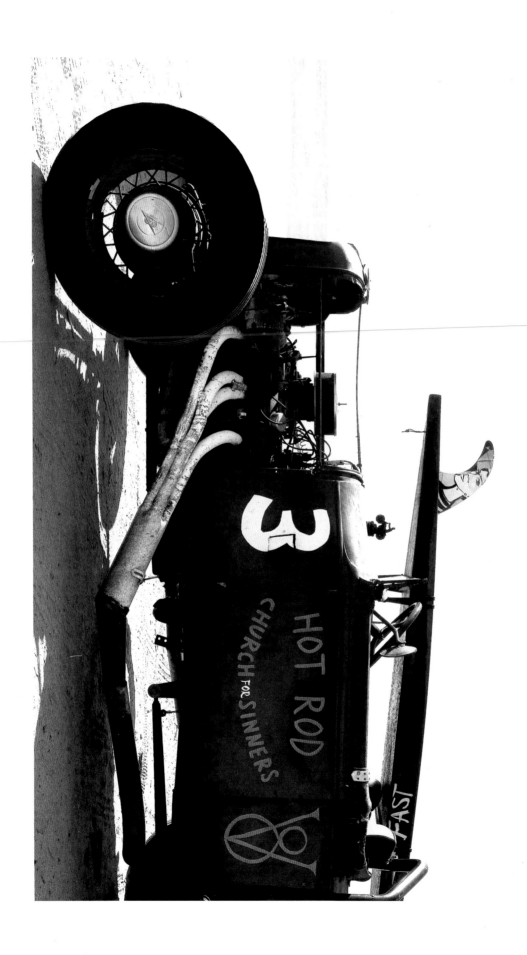

146

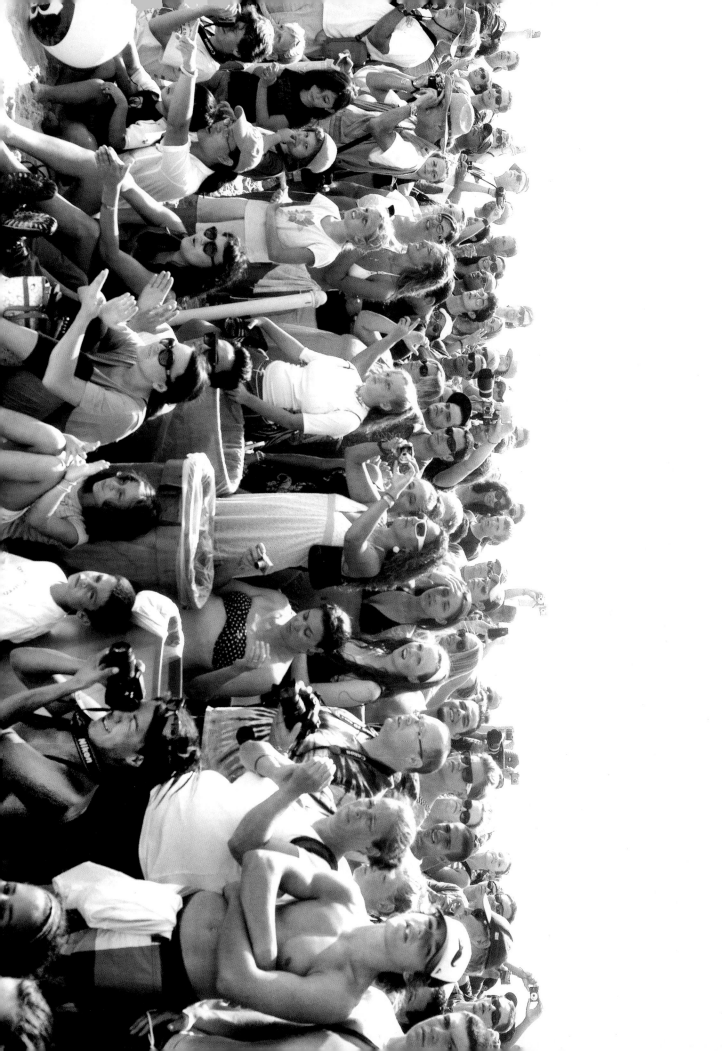

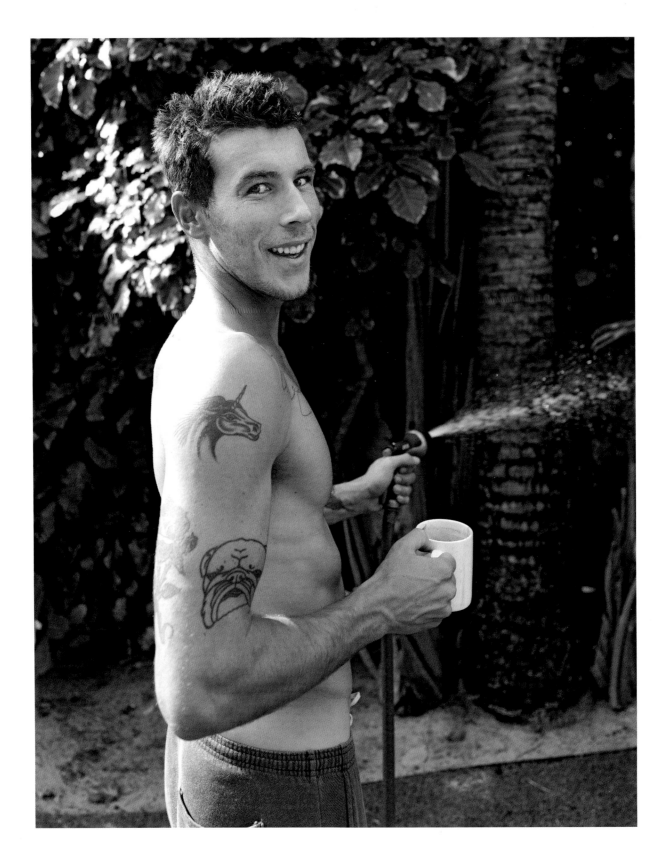

Jack Freestone, pro surfer, ranked #25 on Billabong Pi:e Masters, longtime boyfriend of pro surfer Anita Blanchard

148

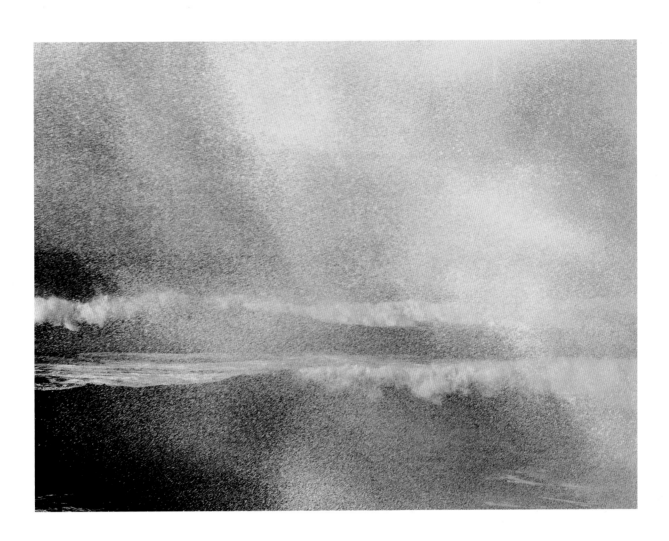

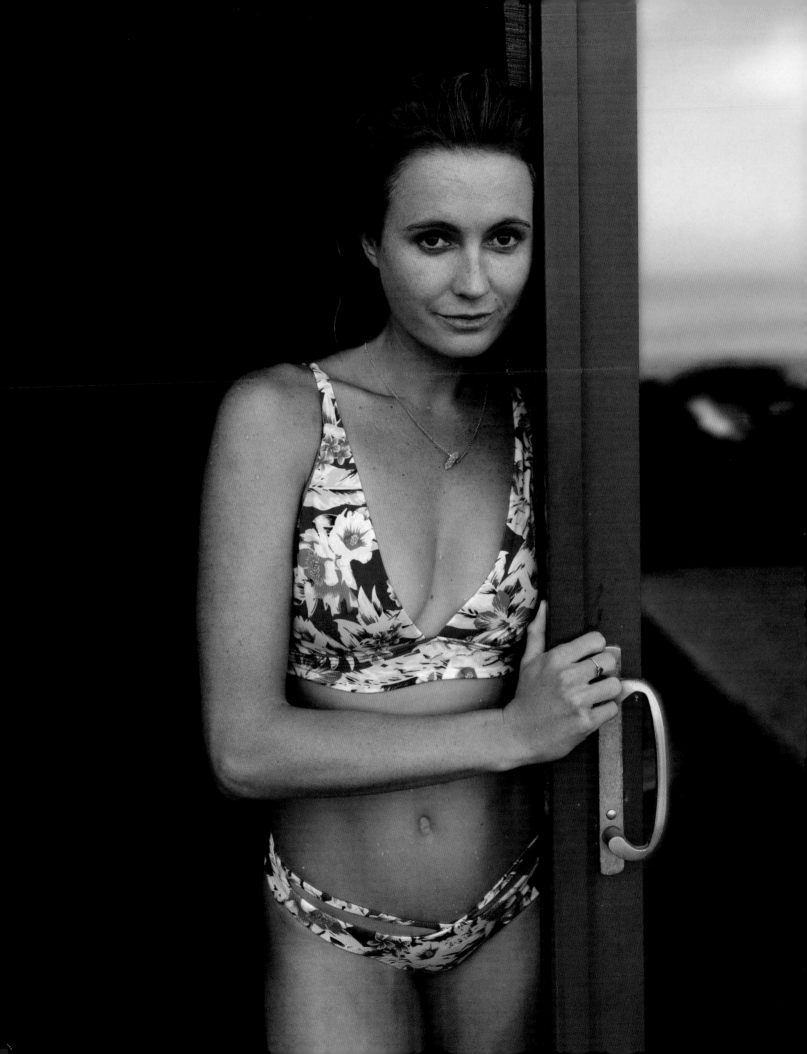

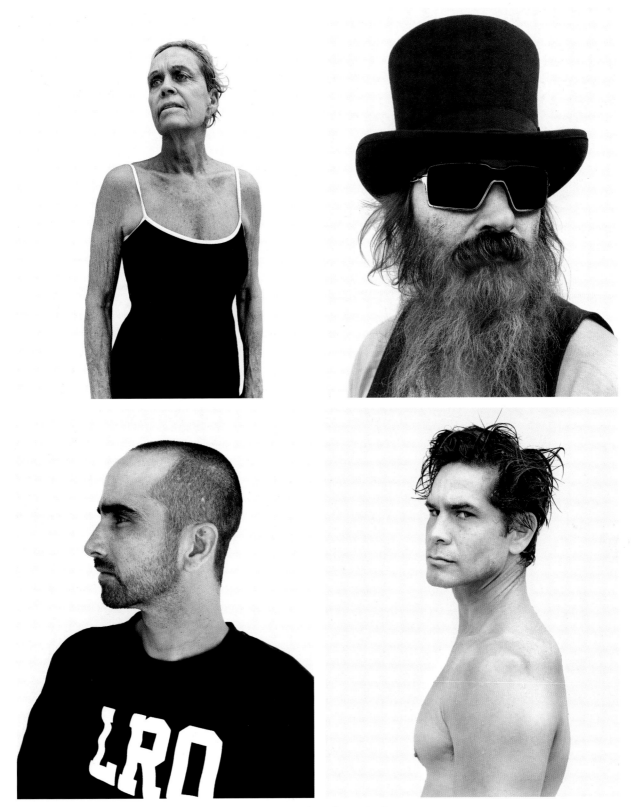

Top left: Mary Lou Drummy, competitive surfer in the 1960s and stand-in surfer for many
movies Top right: Top Hat, shop owner of Surf and Sail, Haleiwa, Oahu. Bottom left: Jesse Billauer,
well-known California surfer who suffered a head injury while surfing that left him paralyzed.
Heads the foundation Life Rolls On, which focuses on awareness and activism for spinal cord injury.
Bottom right: Myles Padaca, winner of the Vans Triple Crown of Surfing, 2001

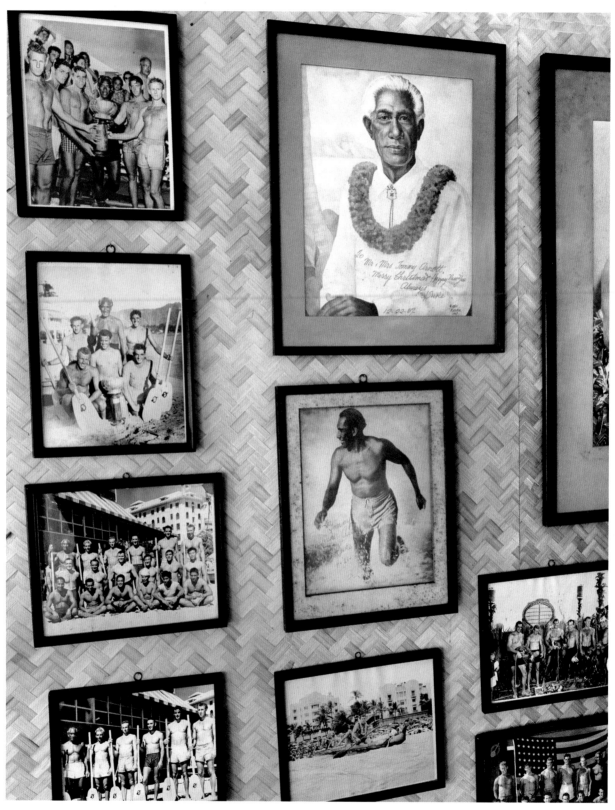

Duke Kahanamoku (August 24, 1890–January 22, 1968), Hawaiian competition swimmer who
popularized the Hawaiian sport of surfing; five-time Olympic medalist in swimming, law enforcement
officer, and actor; rescued eight men from a fishing boat in 1925 with his surfboard; celebrated
in many traditional ceremonies before surfing events. Many believe his spirit will always live on.

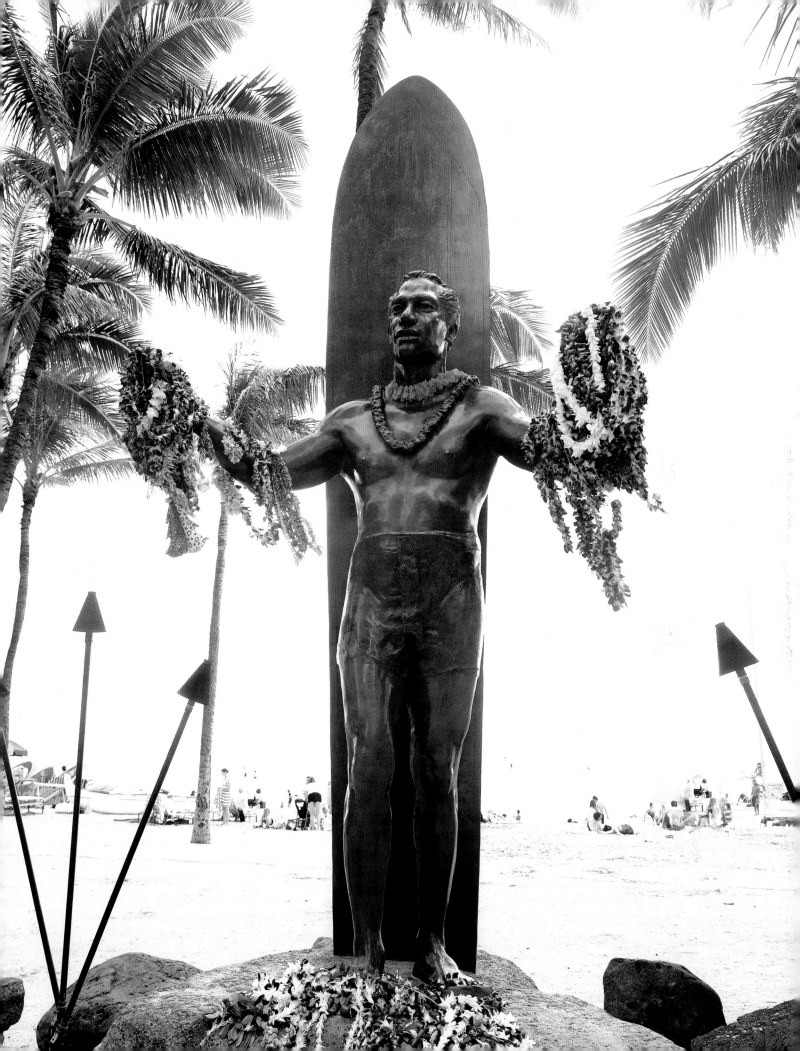

<u>Top left</u>: Kolohe Andino, Long Island, 2011; holds the record, among other records, for the most National Scholastic Surfing Association championships won by a male competitor. <u>Top right</u>: Jamie O'Brien; contest accomplishments include Pipeline Masters 2001, first place at 2003 Hansen's Pipeline Pro, first place at 2004 Fosters Expression Trestles and Rip Curl Pipeline Masters. <u>Bottom left</u>: Max Holloway, undisputed UFC Featherweight Champion, attending Pipe Masters 2016, Oahu. <u>Bottom right</u>: Woody Ekstrom, big-wave surfer; largest wave he said he rode was at Windansea Beach in La Jolla, 1945

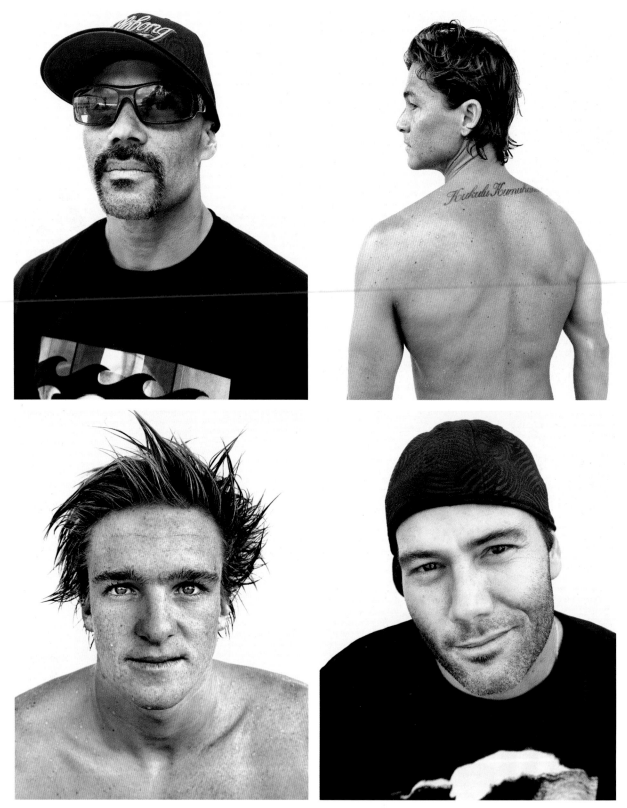

Top left: Rainos Hayes, coach and team manager for Billabong in Hawaii. Top right: Kalani Robb, retired "goofyfoot" superstar pro surfer from Hawaii; defined an entire generation of progressive surfers. Bottom left: Ryan Callinan, runner-up, Australasian Junior Series, 2011; 3rd place, 6-Star WQS Lacanau, France, 2011; 1st place, Fantastic Noodles Pro Junior. Bottom right: Shaun Lopez, big-wave surfer

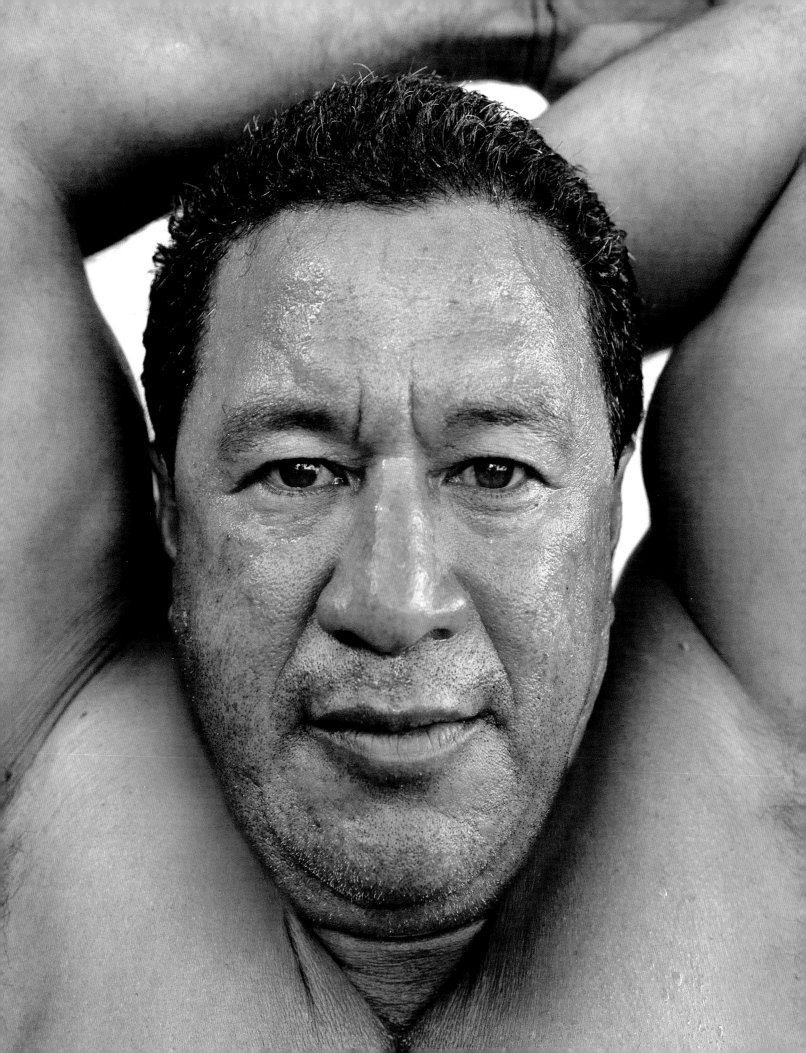

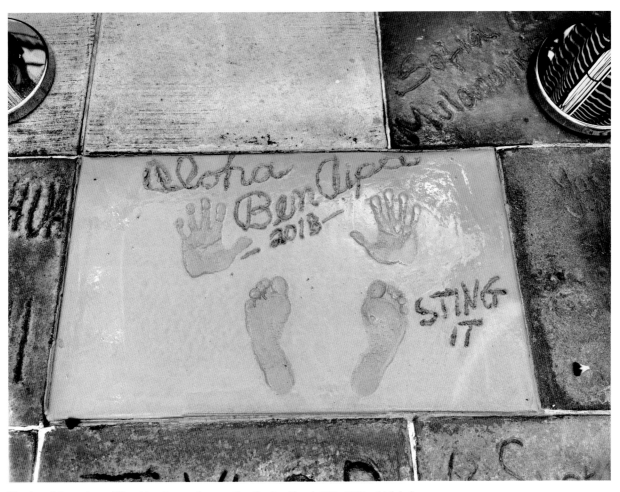

Hand- and footprints of Ben Aipa, known for creating the "swallow tail" in 1972, which helps a surfer make quick turns: "I picked the name 'swallow tail' because of the way the bird makes really fast turns." A favorite quote from Ben is "You don't stinger the wave, you sting the wave!," recounting a day when Larry Bertlemann surfed the first "sting."

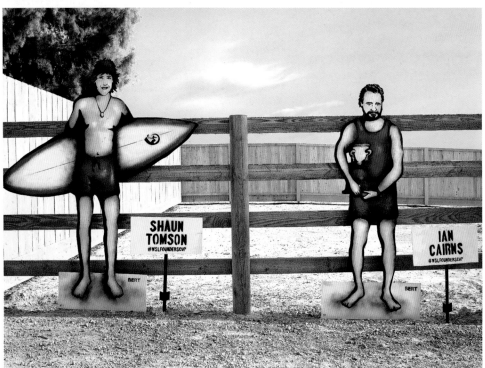

Left: "Founding Fathers": homage to the surfers who established the first world surfing circuit, including Randy Rarick

Opposite: Pipeline Master Champions board winners, Bonzia Pipeline reef, Oahu

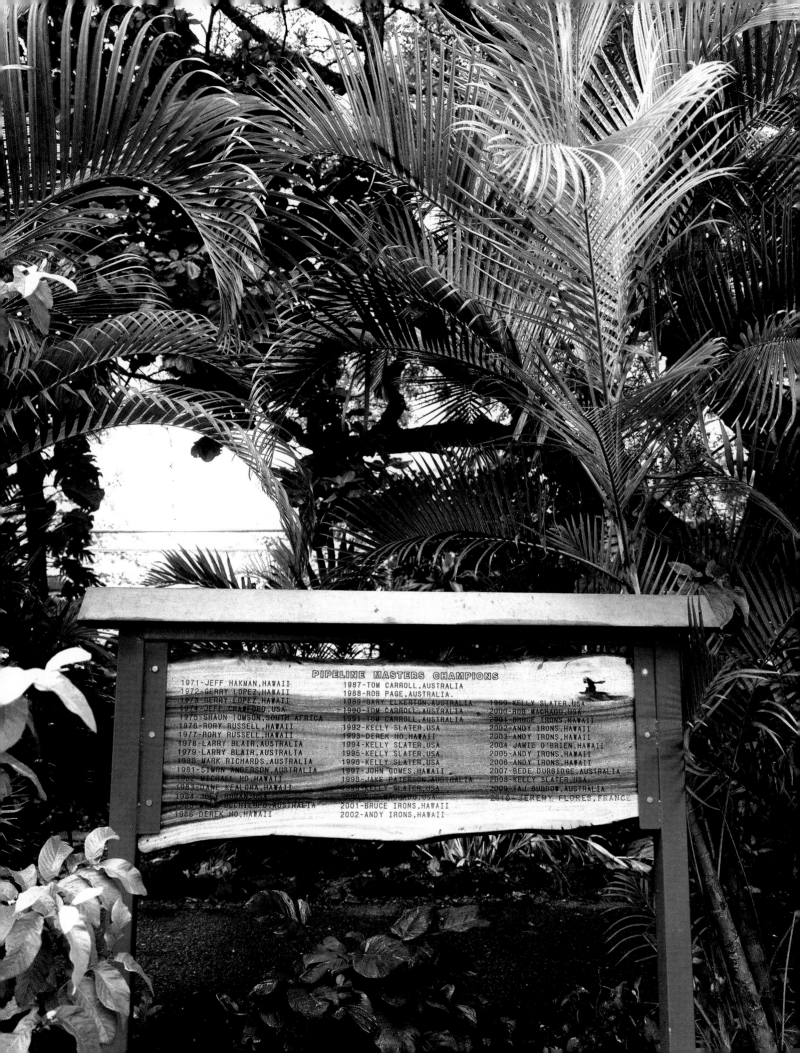

PIPELINE MASTERS CHAMPIONS

1971-JEFF HAKMAN,HAWAII	1987-TOM CARROLL,AUSTRALIA	
1972-GERRY LOPEZ,HAWAII	1988-ROB PAGE,AUSTRALIA.	
1973-GERRY LOPEZ,HAWAII	1989-GARY ELKERTON,AUSTRALIA	1999-KELLY SLATER,USA
1974-JEFF CRAWFORD,USA	1990-TOM CARROLL,AUSTRALIA	2000-ROB MACHADO,USA
1975-SHAUN TOMSON,SOUTH AFRICA	1991-TOM CARROLL,AUSTRALIA	2001-BRUCE IRONS,HAWAII
1976-RORY RUSSELL,HAWAII	1992-KELLY SLATER,USA	2002-ANDY IRONS,HAWAII
1977-RORY RUSSELL,HAWAII	1993-DEREK HO,HAWAII	2003-ANDY IRONS,HAWAII
1978-LARRY BLAIR,AUSTRALIA	1994-KELLY SLATER,USA	2004-JAMIE O'BRIEN,HAWAII
1979-LARRY BLAIR,AUSTRALIA	1995-KELLY SLATER,USA	2005-ANDY IRONS,HAWAII
1980-MARK RICHARDS,AUSTRALIA	1996-KELLY SLATER,USA	2006-ANDY IRONS,HAWAII
1981-SIMON ANDERSON,AUSTRALIA	1997-JOHN GOMES,HAWAII	2007-BEDE DURBIDGE,AUSTRALIA
1982-MICHAEL HO,HAWAII	1998-JAKE PATERSON,AUSTRALIA	2008-KELLY SLATER,USA
1983-DANE KEALOHA,HAWAII	1999-KELLY SLATER,USA	2009-TAJ BURROW,AUSTRALIA
1984-JOEY BURAN,USA	2000-ROB MACHADO,USA	2010-JEREMY FLORES,FRANCE
1985-MARK OCCHILUPO,AUSTRALIA	2001-BRUCE IRONS,HAWAII	
1986-DEREK HO,HAWAII	2002-ANDY IRONS,HAWAII	

Owl Chapman, considered one of the fathers of the short board revolution

Following spread: "Waiting for the Winner," Long Island

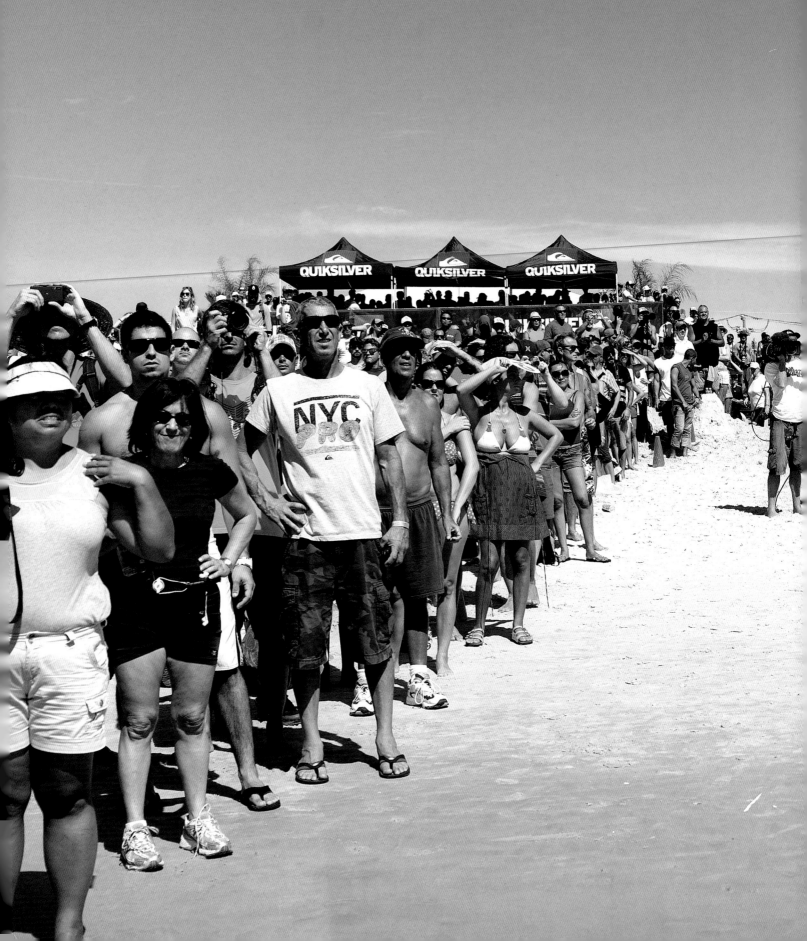

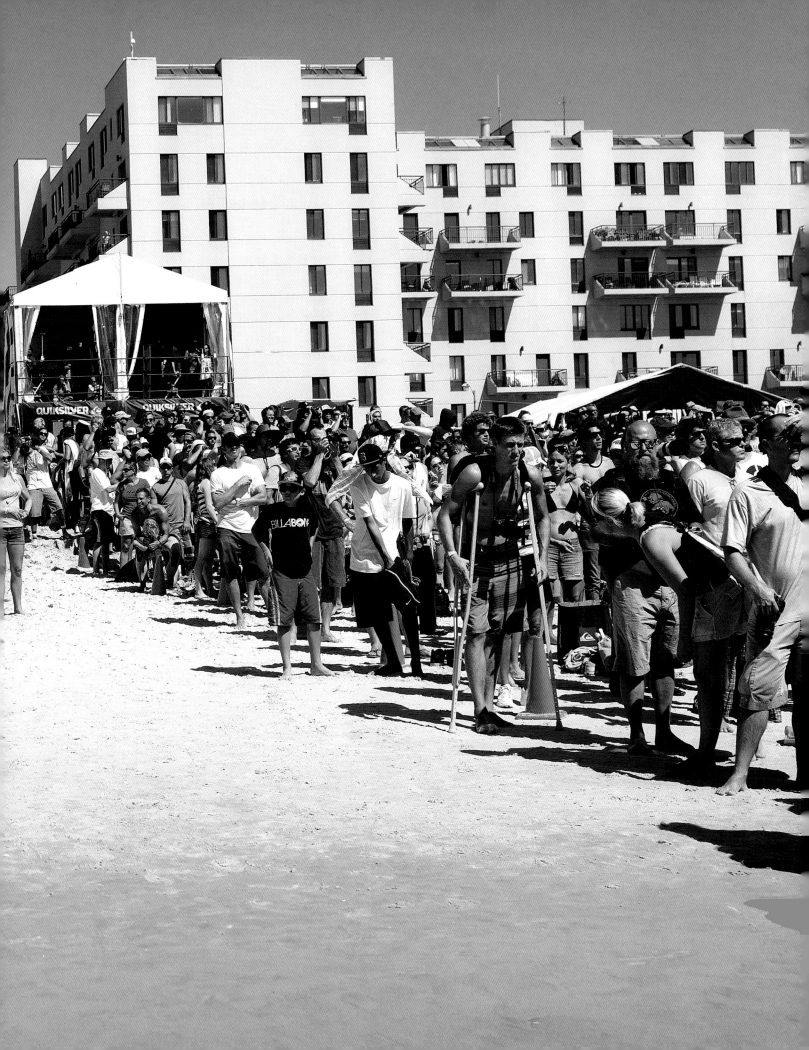

Left: Northern California
Opposite: San Clemente, California

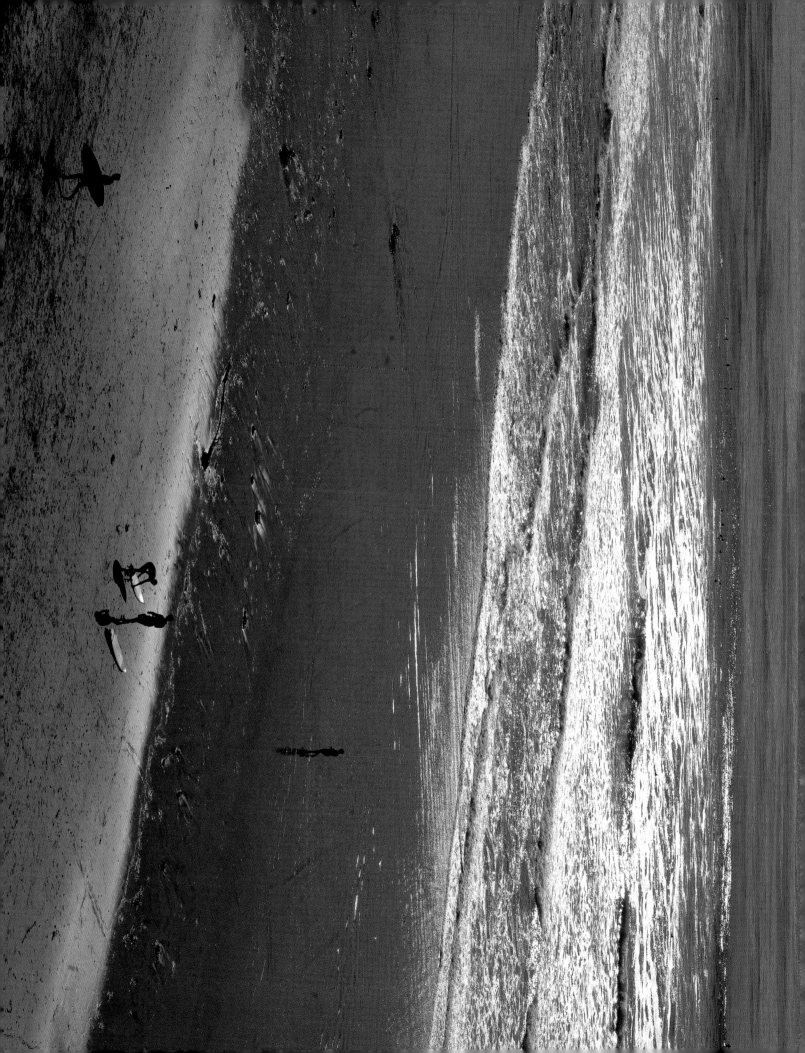

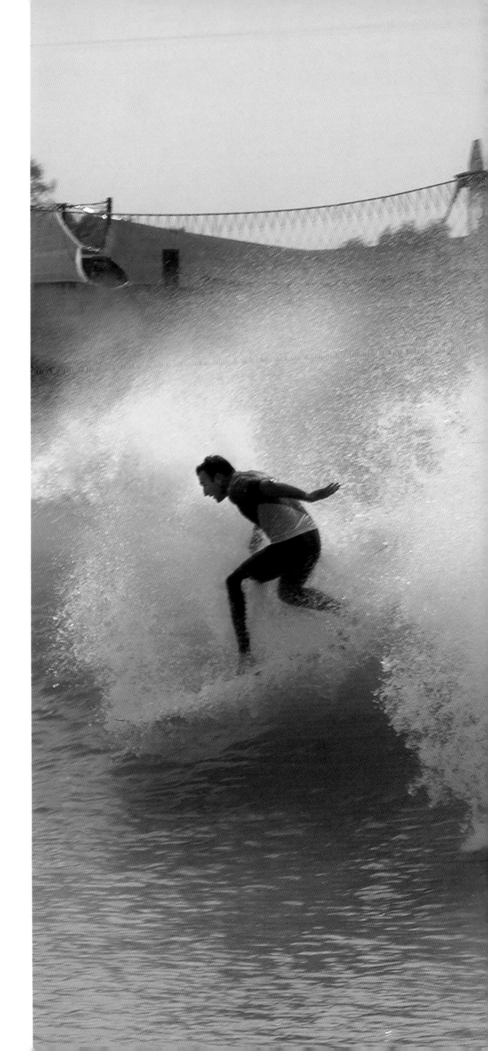

Joel Parkinson at surfing's first Founders Cup, 2018, at Kelley Slater's Surf Ranch, Lemoore, California

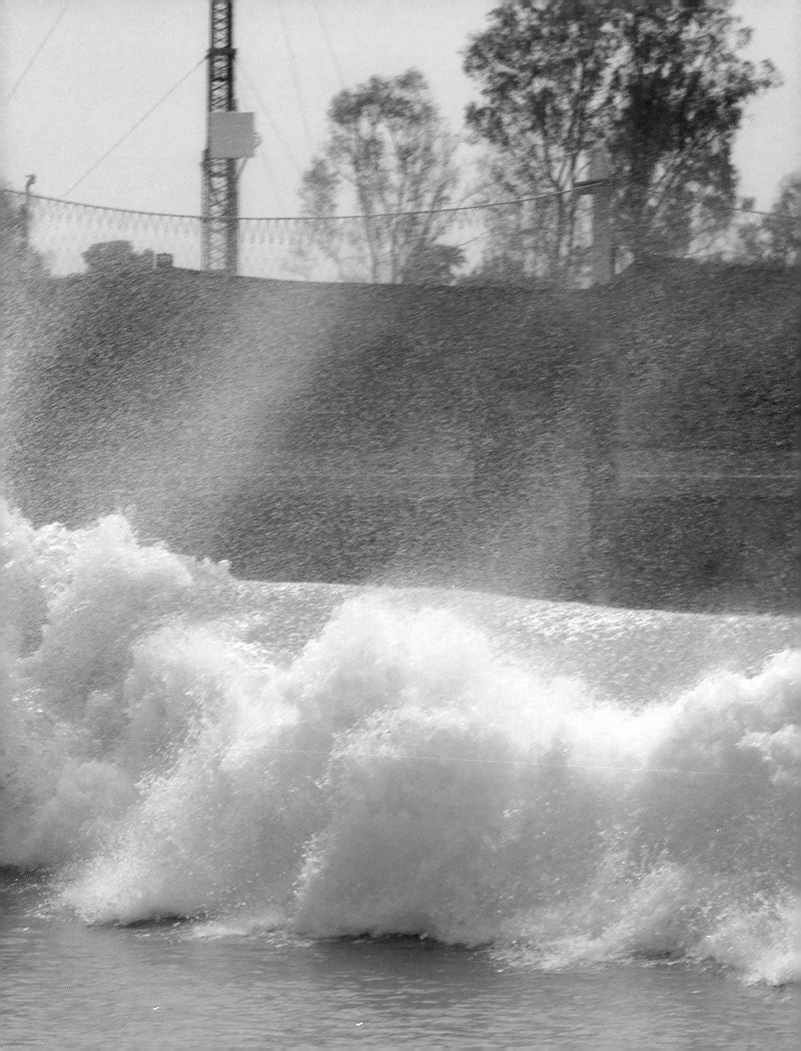

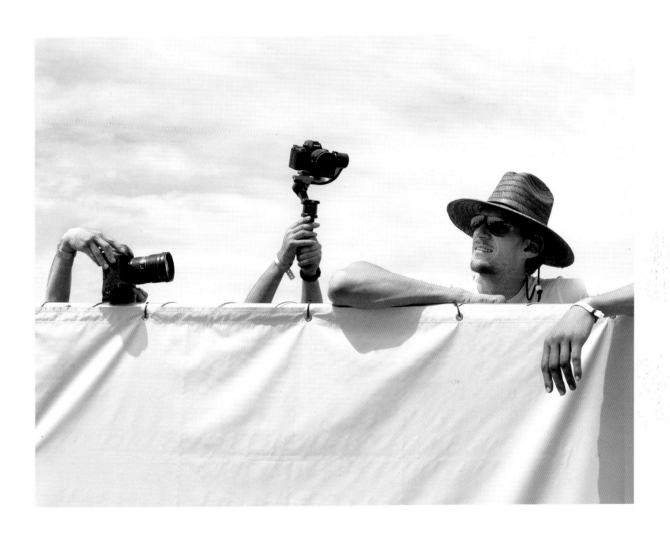

Seven-foot-three surfing spectator and NBA player Boban Marjanović, California, 2018

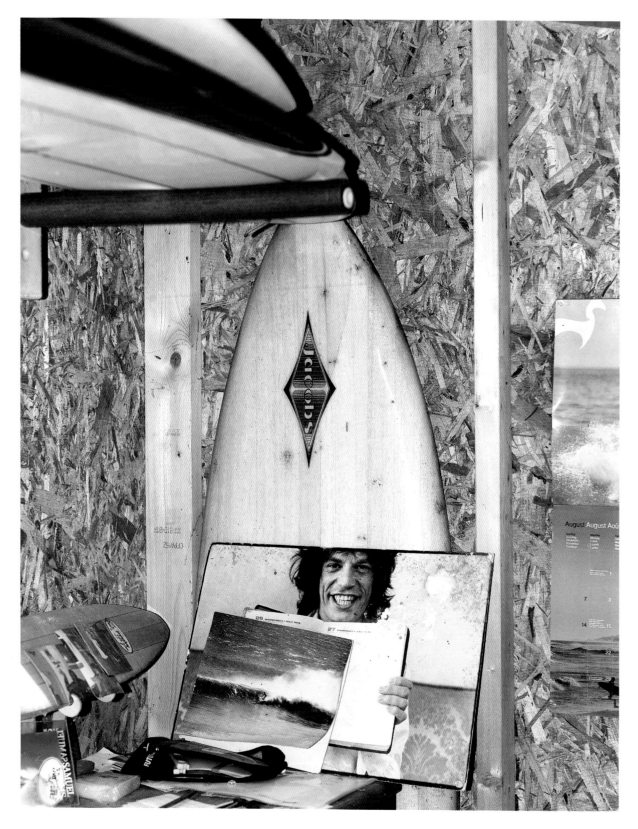

Left: Tony Caramanico's Montauk home. Opposite: Christian Fletcher, developed modern aerial performance surfing; from a family of surfing champs, including Herbie, his father; Joyce Hoffman, his aunt; grandfather "Flippy" Hoffman; and brother Nathan

174

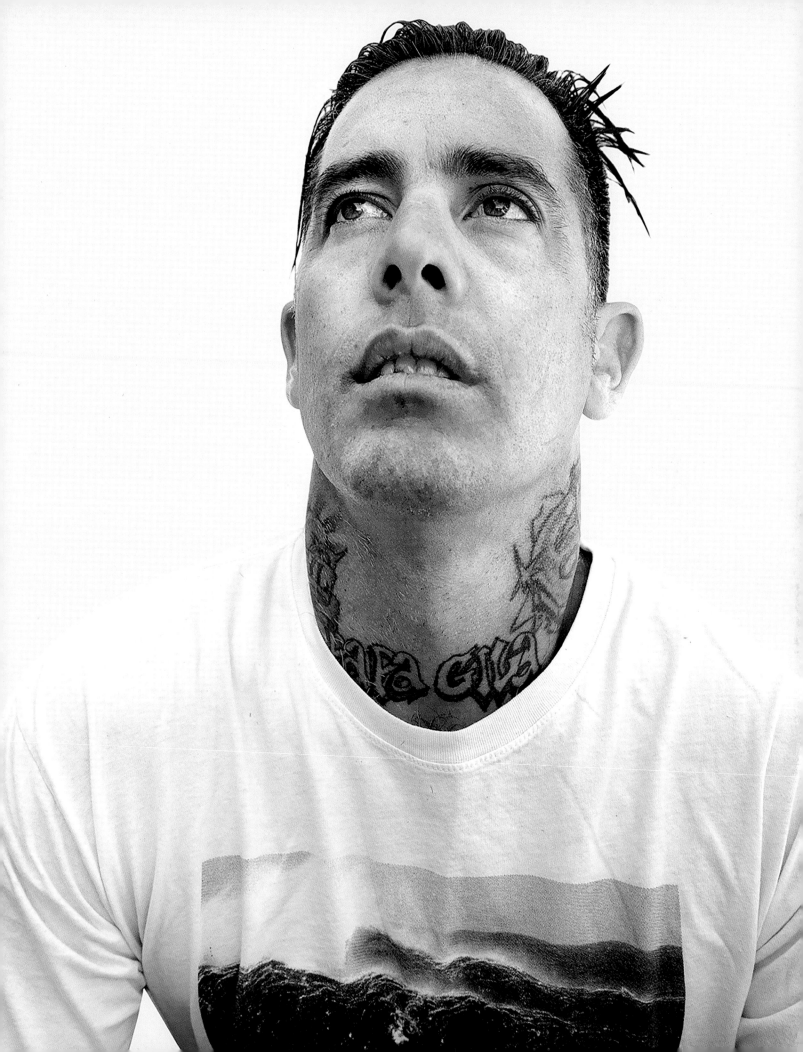

Top left: Spectators at Pipe Masters 2016, Oahu
Bottom left: "Sleeping Beauties," New Jersey shore
Opposite: Kauai, Hawaii

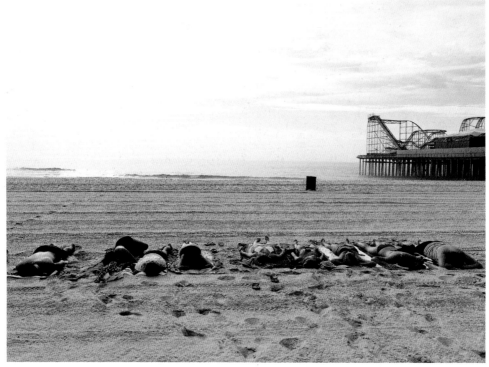

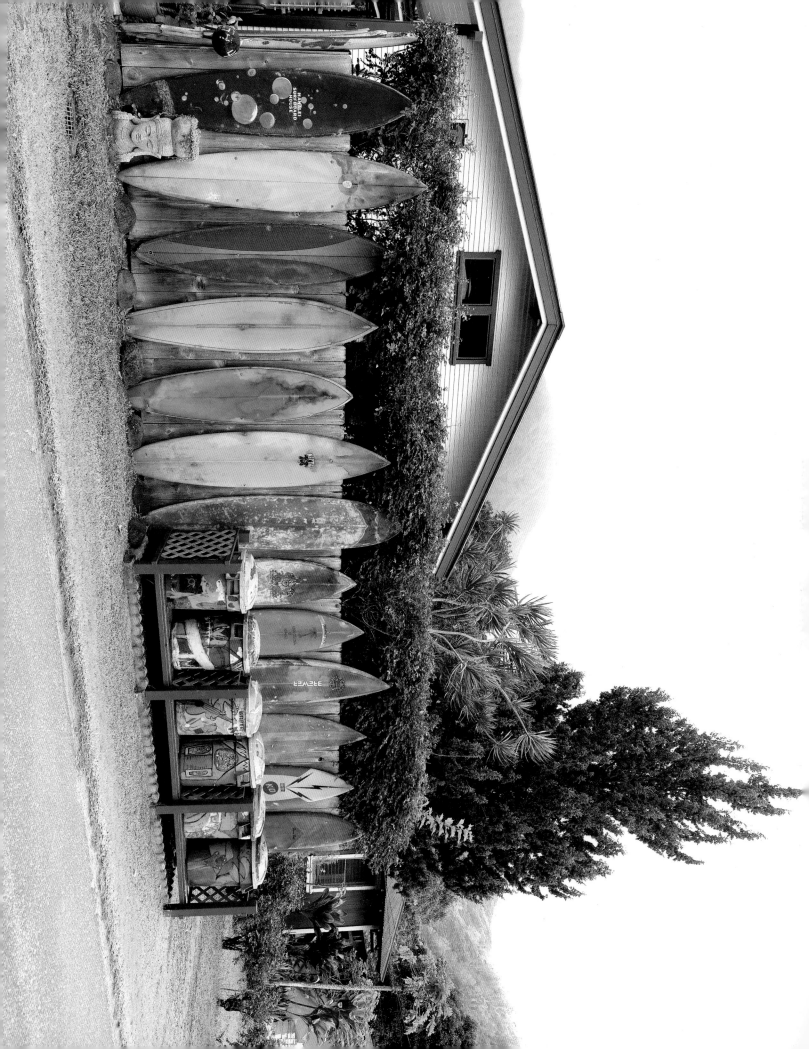

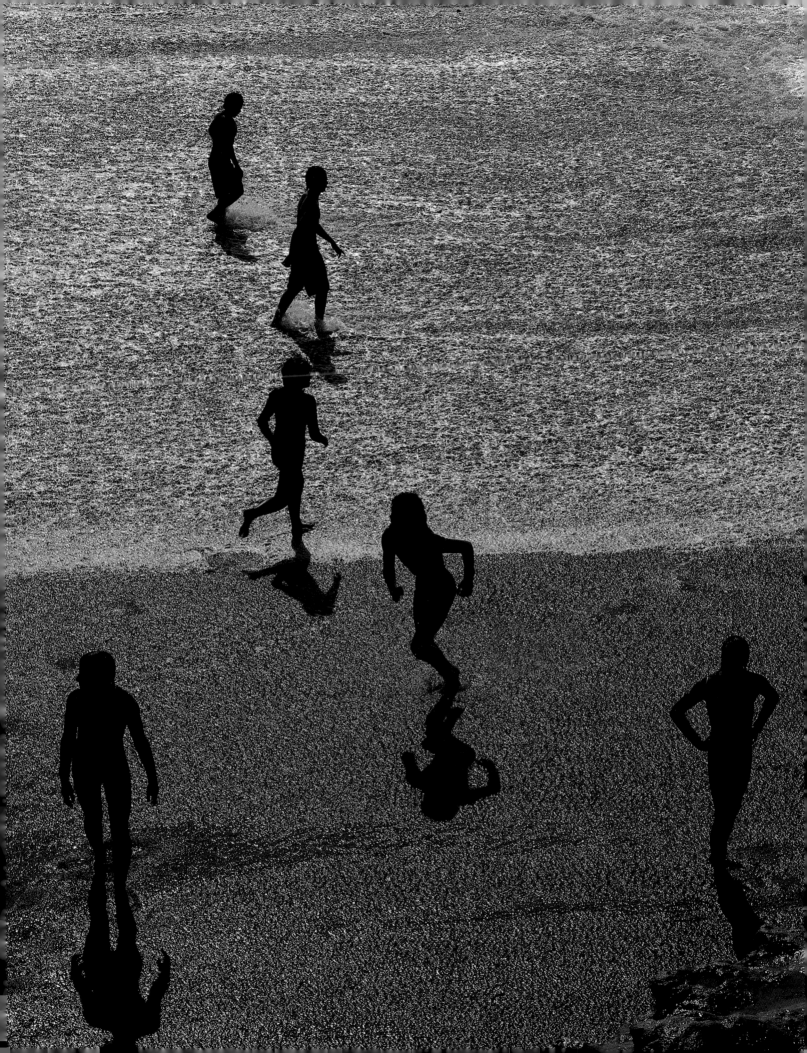

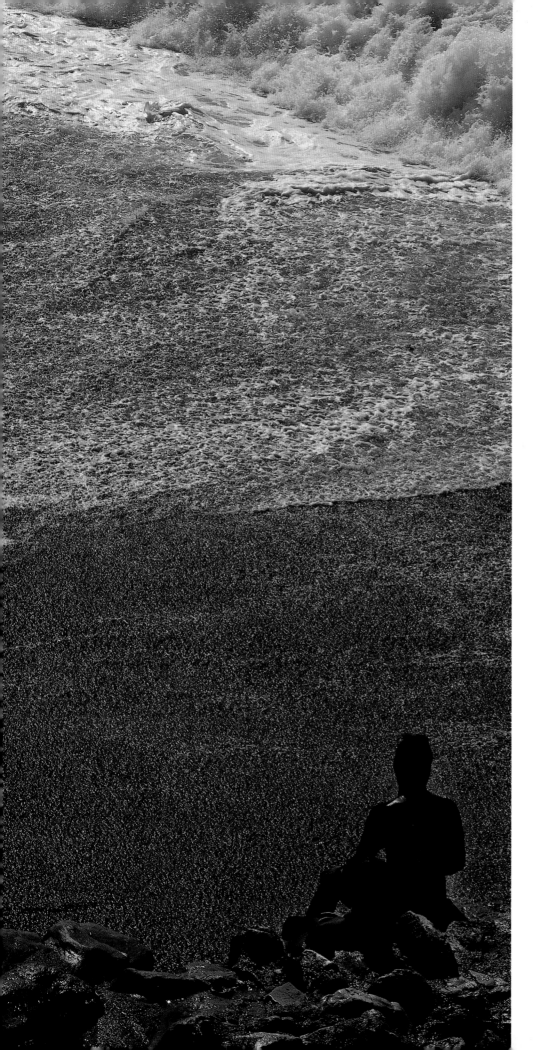

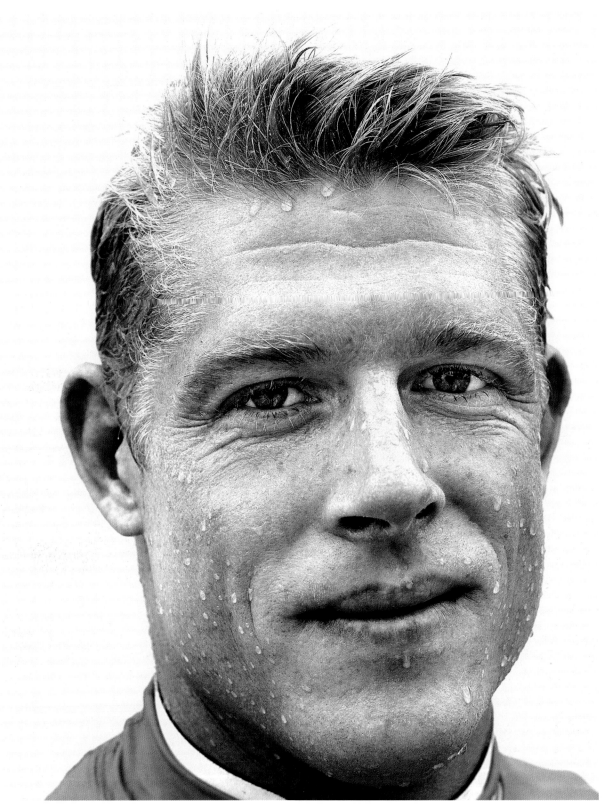

Left: Mick Fanning, Australian pro surfer; won the 2007, 2009, and 2013 ASP World Tour; in 2015, survived an encounter with what is suspected to be a great white shark during the J-Bay Open finals in South Africa. Opposite: Leonard Drago, Hawaiian longboarder

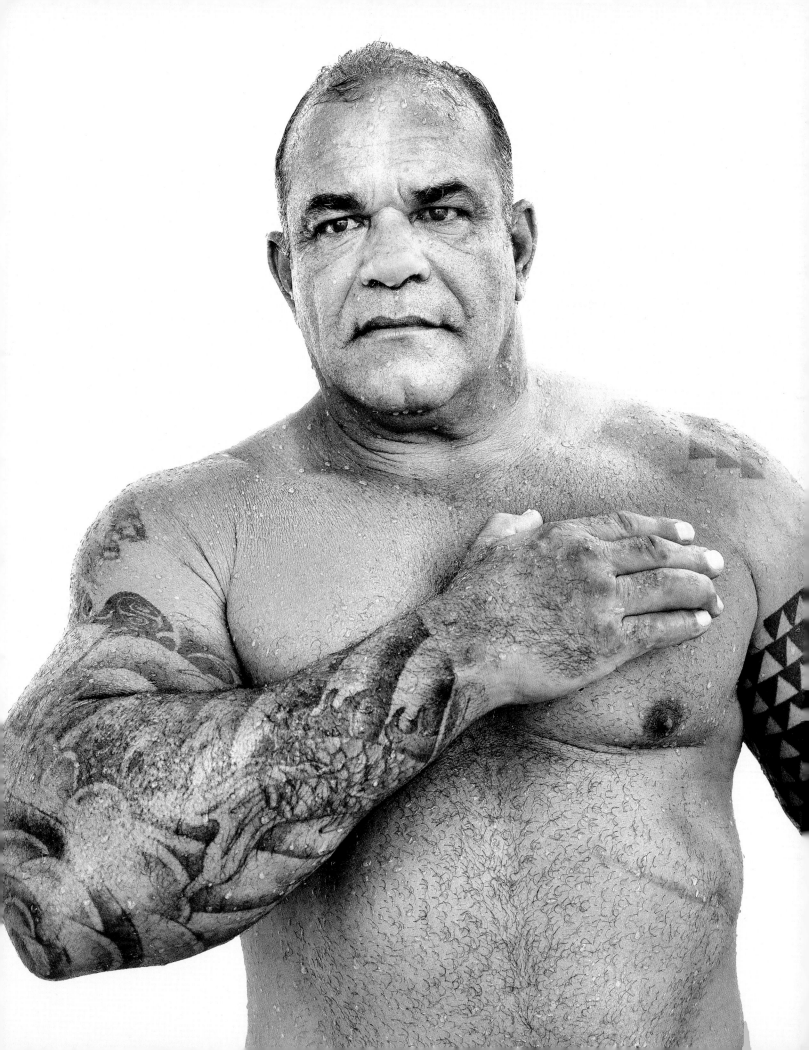

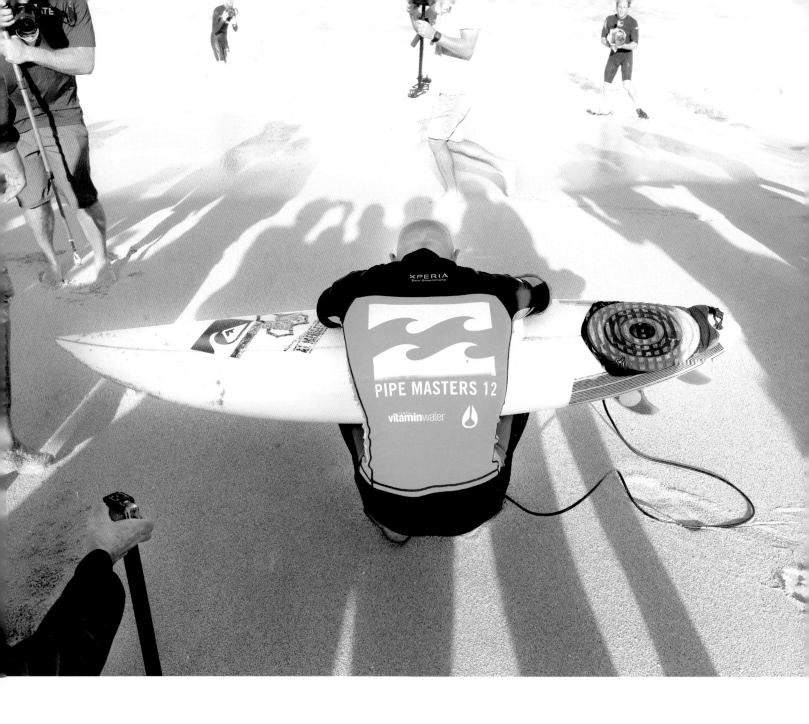

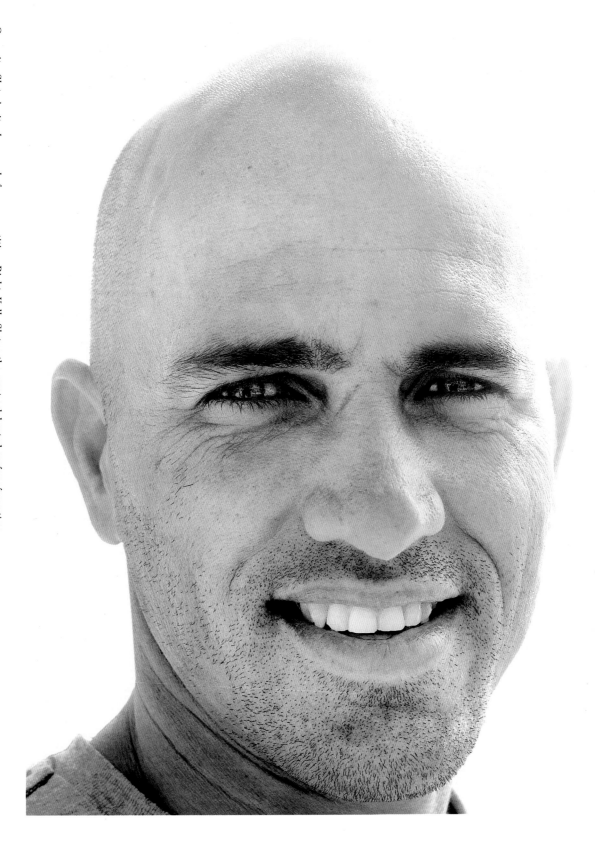

Opposite: Slater's ritual prayer before competition. **Right:** Kelly Slater, the most celebrated surfer of our time; World Surfing League Champion a record eleven times, including five consecutive titles in 1994–98. Kelly is entrepreneurial, both with his own organic clothing company and with his new synthetic "Wave Maker."

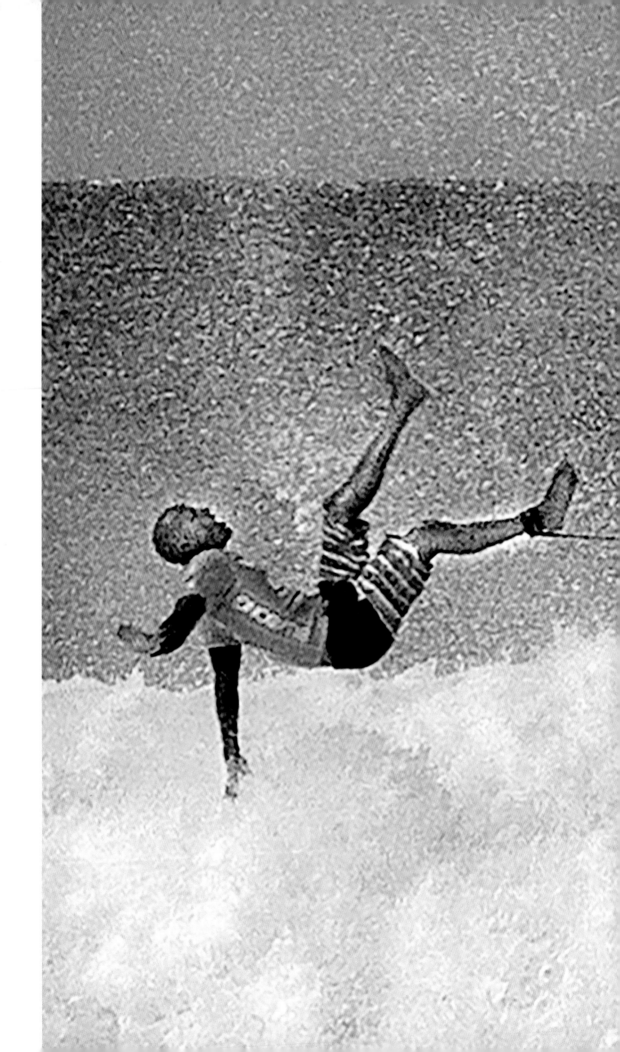

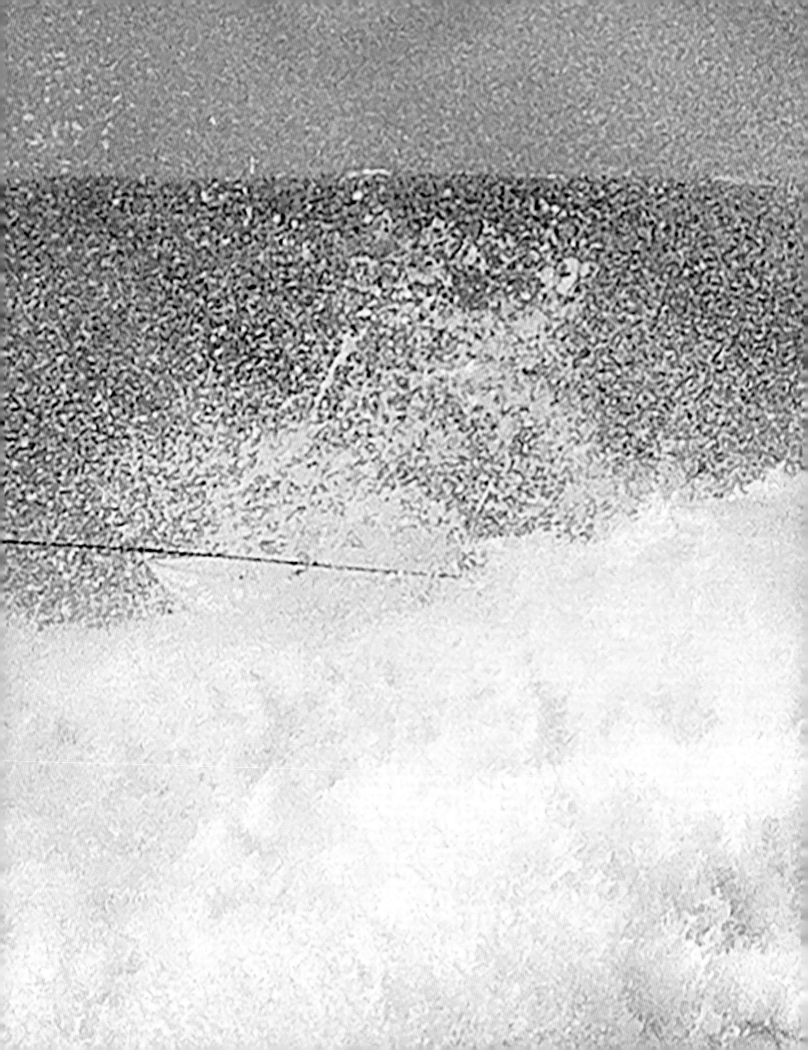

Opposite: Clarissa Ho, three-time world champion, ranked #4 in 2018
Right: Frederico Morais, Portuguese pro surfer who has competed on the
World Surfing League Men's World Tour since 2017

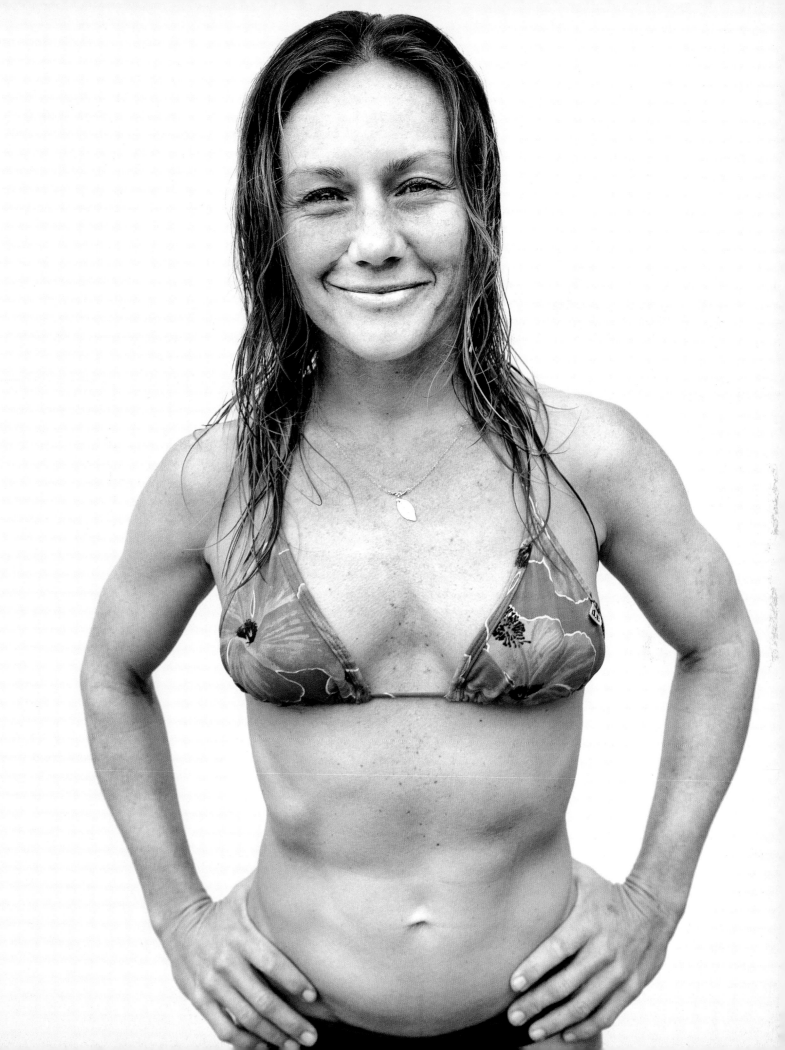

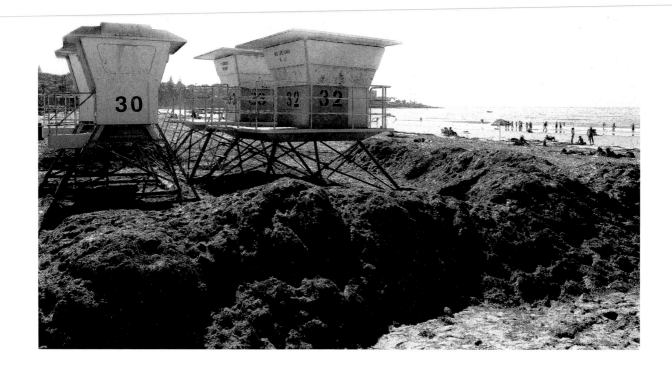

Left: Malibu. Opposite: Sage Erickson, American pro surfer, ranked #9 in the World Surfing Tour in 2016

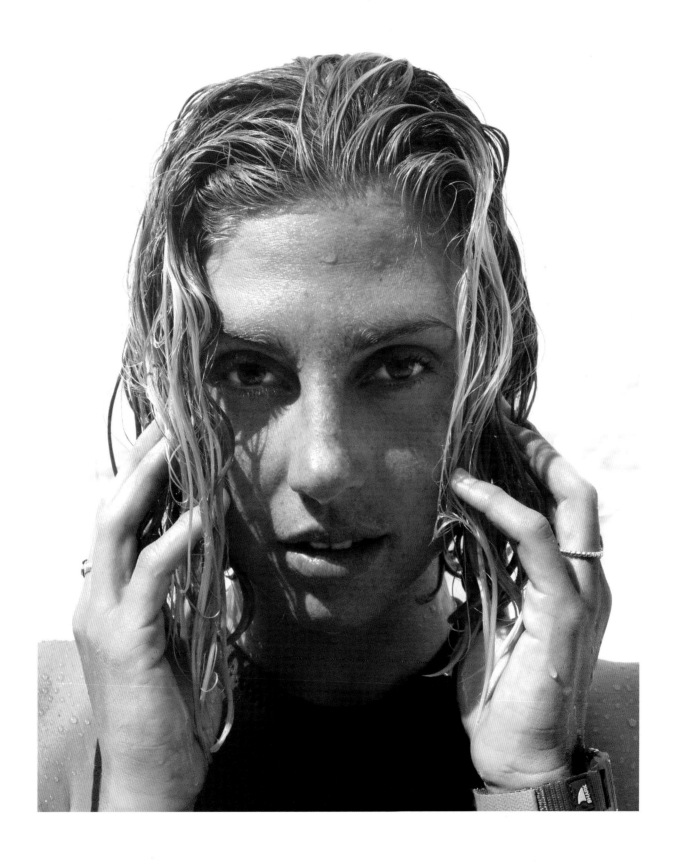

Previous spread, left: Joyce Hoffman, pioneer of women's surfing. Previous spread, right: Rochelle
Ballard, big-wave surfer; considered the best female barrel rider in the world

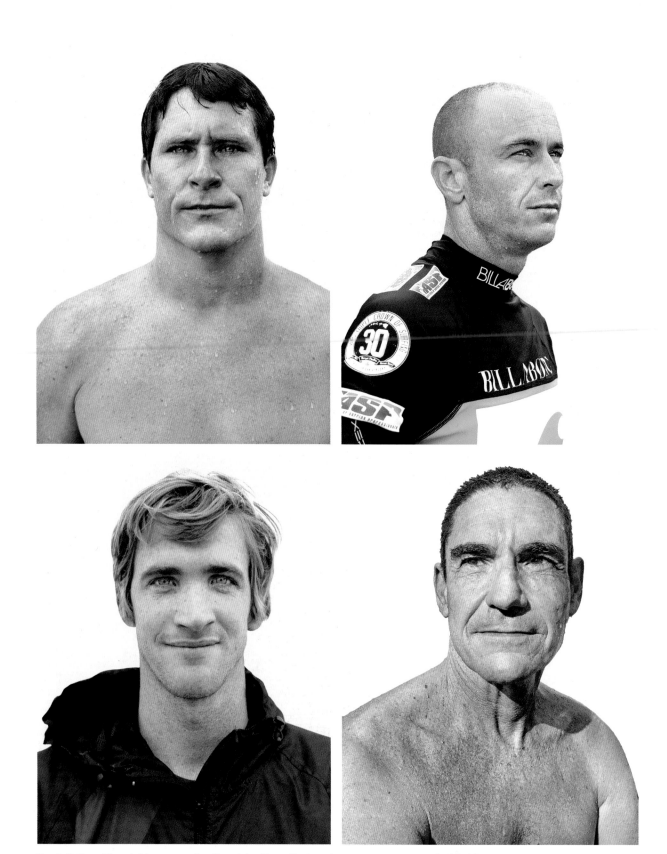

Top left: Dave Wassel, big-wave surfer. Top right: Shane Dorian, eleven years touring on the World Championship Tour; one of the best in the world at big-wave riding. Bottom left: Brett Simpson, Huntington Beach; won 2009 and 2010 U.S. Open of Surfing; inducted into Surfers' Hall of Fame, 2018. Bottom right: Butch Perreira, "underground" North Shore surfer and regular at Sunset Beach in Oahu since 1970

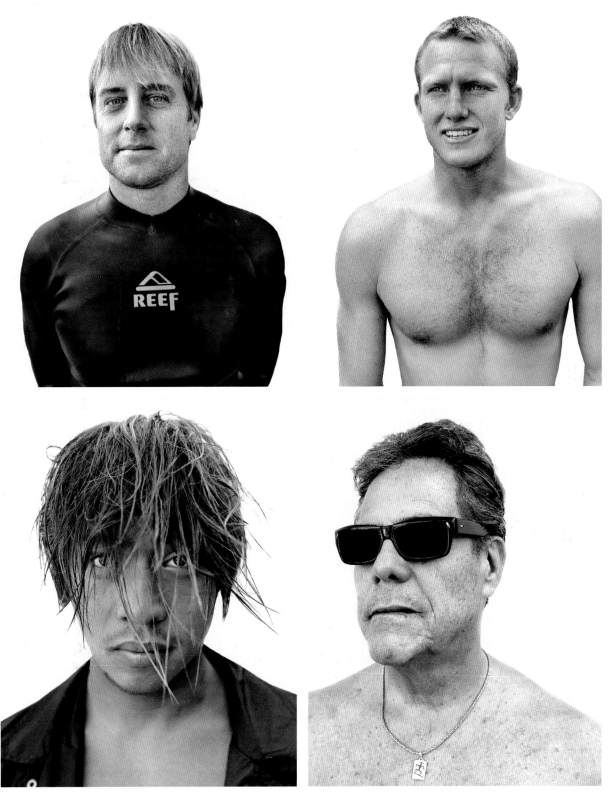

Top left: Ross Williams, former Championship Tour surfer and current WSL lead analyst; coach for John John Florence. Top right: Dusty Payne, pro surfer; suffered serious wipeout after hitting the reef at Backdoor at Banzai Pipeline, Oahu, and was underwater for five waves, for approximately 1 minute, 20 seconds. Bottom left: Arashi Kato, pro surfer from Chiba, Japan. Bottom right: Paul Strauch, winner of 1963 Peru International; creator of the cheater five or "Strauch crouch" noseride; Barry Kanaiau considered him the best surfer in the world for his time.

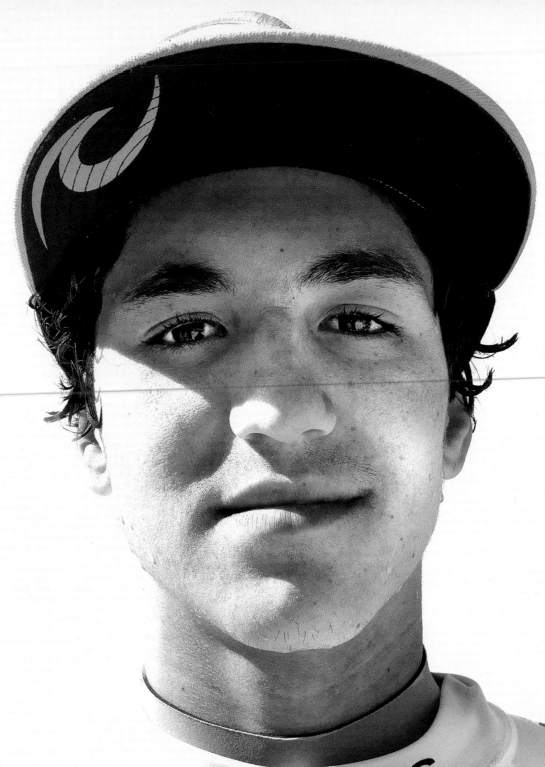

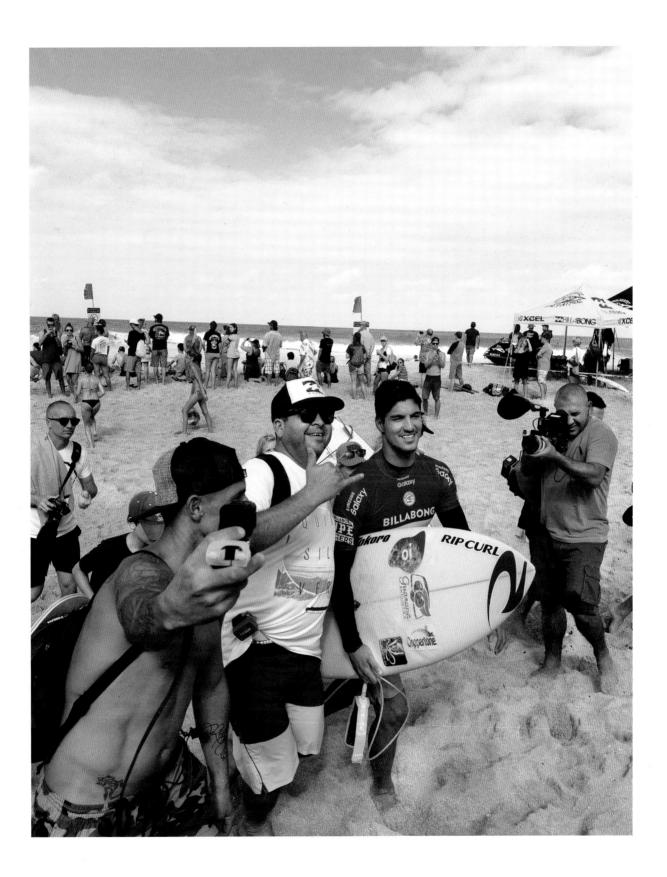

Opposite: Gabriel Medina, Brazilian winner of 2014 WSL World Championship and 2015 Hawaiian Triple Crown of Surfing. Right: Gabriel Medina, 2016 Pipe Masters, Oahu

STEVE PEZMAN

Steve Pezman is a California surfer/publisher and creator of *The Surfer's Journal*.
Pezman has brought surfing to the level of scholarship and merit and is
often quoted in films and publications. This is about his life and philosophy.

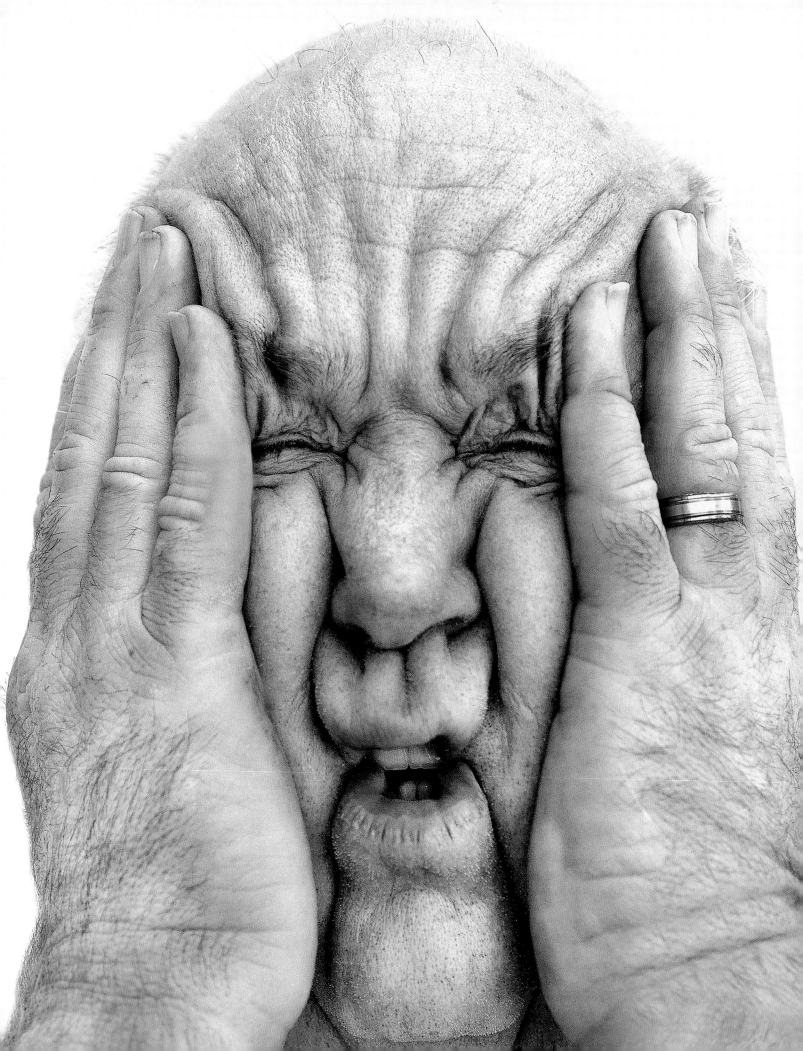

Glenn Sakomoto:
Tell us a little bit
about yourself.

Steve Pezman: I was born in 1941, and I grew up in Los Angeles. My family lived in Los Feliz originally, and then later moved to Brentwood, above the city, in the Santa Monica Mountains. We eventually ended up in Long Beach in an area called Naples—a little community of canals. This introduced me to life at the ocean versus an annual trip to the beach every summer with the family.

I started off skin-diving, in the mid-fifties, in the Alamitos Bay area. Surfing was just starting to happen in '56 or '57. By 1957, I was beginning to surf at Ray Bay in Seal Beach and the Huntington Cliffs. The Huntington Pier beckoned, but we were afraid to go there until we had "earned our bones." Over the following years, I called the Seal Beach/Huntington zone home and began surfing Trestles [in San Diego] in 1960 and hit Mazatlán [in Mexico] in 1961 and then Hawaii in '62.

I lived on the North Shore when only a dozen or so surfers lived out there, so although [great surfing] had been happening for five years, it still felt like we were pioneering. I rode Waimea, Sunset, and Laniakea—had that foundational surfing experience. I ended up coming back, lifeguarding, doing other odd jobs, then shipping out as a civilian in the merchant marine [to Vietnam] in 1965, carrying a cargo of stale beer to the PXs. When I came home, I was a partner in a silk-screening business. Then we started the Good Earth Health Food Bar at George's Surf Center in Huntington with some money I had inherited.

Later I learned to shape surfboards. I shaped momentarily for several labels, including Weber and Hobie, and did longer stints with Vardeman and Chuck Dent. Next a friend, Stu Herz, and I built an experimental shaping machine and started the first private-label surfboard manufacturing business out of Goat Hill in Costa Mesa—making boards for shops in Texas and on the East Coast. Later we started our own label, Creative Design Surfboards, first on PCH in Newport Beach, then smack-dab in Surf City, downtown Huntington, in '68 and '69.

How did you get started in publishing?

Duke Boyd, who started Hang Ten, was also serving as managing editor at *Petersen's Surfing Magazine*. He was helping publisher Dick Graham reposition his title as competition to *Surfer*. Duke was hip enough to merchandise the magazine around the Huntington Underground, which was flowing back and forth between there and the North Shore, at a time when *Surfer* was still a bit oblivious to what was going on. This was the latter sixties. He invited Stu and I to write surfboard articles and later brought me in as an assistant editor. After *Surfing* folded six months later [the advertisers stuck with *Surfer*], I went down to *Surfer* to see if I could freelance, and they hired me as an inside editor. Six months later, I fell into the publisher's job because John [Severson] had sold the magazine and was looking for someone to fill that chair. I stayed as publisher for about twenty years until 1992, when my wife, Debbee [who had been the marketing director at *Surfer*], and I left and started *The Surfer's Journal*.

What is your relationship to surfing?

Magazine-wise, I've been a student of the sport for over forty years in the sense of observing it and thinking about it and writing about it, and being responsible for describing it to other surfers in an accurate way. When you pay attention to something for that long, you acquire a sense of its historical timeline, and that gives you reference points with which to understand much more of it—to be able to examine it and have a relationship with it. My life has been about articulating that relationship. I've been lucky to earn a living involved with something that I really care about deeply, which is better than welding bridges or something. [*Laughs*]

With The Surfer's Journal, *do you see yourself as the curator of the sport?*

I am one of the curators. Fortunately, or unfortunately, when you print information, it has the tendency to be taken as the truth . . . and it seldom is the whole truth. That is a big responsibility—if you take it seriously—which I do. It's also a rewarding creative process. It's like being an art gallery owner who loves art and gets to install a new show every two months. Every issue is articulated through a matrix of hundreds of people who must join together just so to make this thing come out. It's really a miracle that it gets done. You become the conductor of that ensemble, and the results reflect the team. It's like we put ourselves out there, standing naked before the world, and the readers give you thumbs up . . . or thumbs down. We get plenty of both.

Describe what surfing is for you.

At the time, I was an accomplished surfer, I would ride maybe twenty-five to thirty-five waves or more in a go-out. I was involved in the close-up detail of each ride. The longer I surfed and the older I got, the more basic it became; the relationship became simplified. I was satisfied with a less complicated ride and sought elegance versus busy action—trim versus lots of movement. You begin to see the bigger picture from a higher elevation. A deep takeoff with a pure, clean trim becomes very satisfying. At that point, the number of rides reduces. I would ride maybe three in a go-out instead of thirty-five. However, the pleasure of the whole experience was just as large. It filled the same space that thirty-five rides had. You begin to rise away from the detail clutter each year. I'm sixty-eight. I hate to think how many years I've been surfing. My God, it's been over fifty years! As you start floating higher and higher above it, you view a broader swatch. You lose the little detail and see the big picture of it all. After a while, just sitting on your board in the lineup becomes joyous. You are immersed in the sensation, and you appreciate the perspective it affords.

There is something cosmic about surfing. Waves are nature's mode of transferring energy from A to B. They occur in many forms: thought waves, heat waves, radio waves. Ocean waves happen to be something that we can see, and then we actually learned to ride them, which in itself seems very improbable, so improbable that the surf culture was detached from the mainstream. Wave-riding has always been an integral part of the Hawaiian culture, but in Western culture, it was seen as such an anomaly, such an unusual sidebar, that it didn't seem seriously worth doing. When you go surfing among the many other things you might do in a day, it makes the day feel good—somehow round and complete. That connection to the basic cosmic core of energy at the center of Life in the Universe somehow makes wave-riding deeply satisfying. It is something that you can spend your time doing, and it feels like a life well spent—a nonproductive, nondepletive act that is purely aesthetic. [Timothy] Leary was doing lectures at college campuses in the seventies that he called "Man, the Evolutionary Surfer." Of course, that caught our attention at *Surfer* magazine. We interviewed him, and his point was that surfers weren't the dregs of society. They were the "throw-aheads"! Surfers understood that life was all about the aesthetic, not how many acorns you could store in a tree beyond what you needed to eat. Leary felt that the evolution of Man to his highest possible form would be toward a purely aesthetic state of being. Further, Leary believed that surfers were already traveling that path. Therefore, their role among mankind in general was to lead us [*laughs*] to a higher place. [*More laughter*] As spacey as that might seem to some folks, there is something within that idea that gives surfers a sense of justification about making time for surfing—and that being time well spent. It's all a rather verbose, bombastic statement, but I think there is something to it.

What can you tell us about the sensory aspects of surfing?

From a publishing standpoint, surfing itself is so sensory that when a surfer is familiar with the sensation of doing it, looking at a photograph will give him a percentage of that sensation by being mentally connected to it. It's the basic foundation for the success of surf magazines—you're providing pretty intense vicarious experiences to surfers who can relate to them.

I actually like myself as a surfer, and my sense of surfing aesthetic. However, I don't like the way I am deteriorating because of old age. I can't pop up anymore. [The common old-guy lament.] That destroys your choreography because it means you can't take off where you want to; you take off where you have to. [*Laughs*] It's all about feeling trim across the green wall. That's my dream image. Man yearns to fly. It's the Icarus complex. Surfing is as close to what I imagine swooping and gliding like a bird would be like. The wave is a liquid base. Everything about it is soft and fluid, so the ride itself is a fluid experience, a deeply gratifying flight. It touches something in your soul that makes you feel so good that when you glide out over the back of the wave after a ride, you are still flushed with the sensation, and you paddle out compelled to have another one . . . and another one . . . and another one.

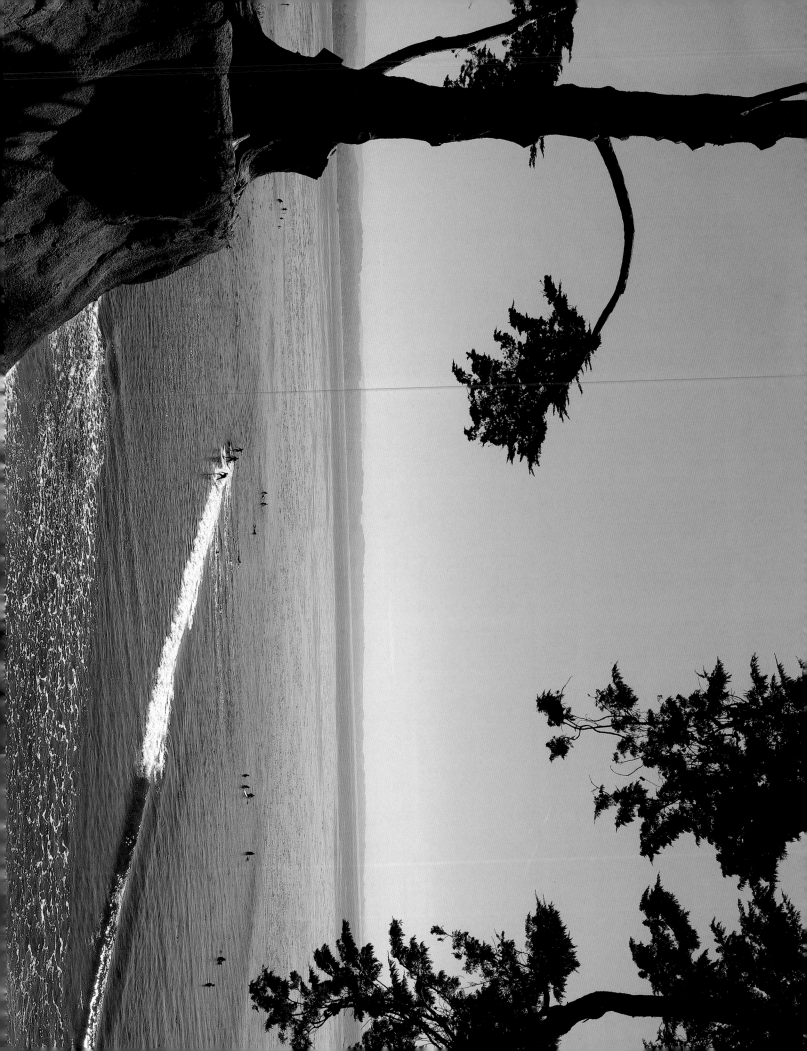

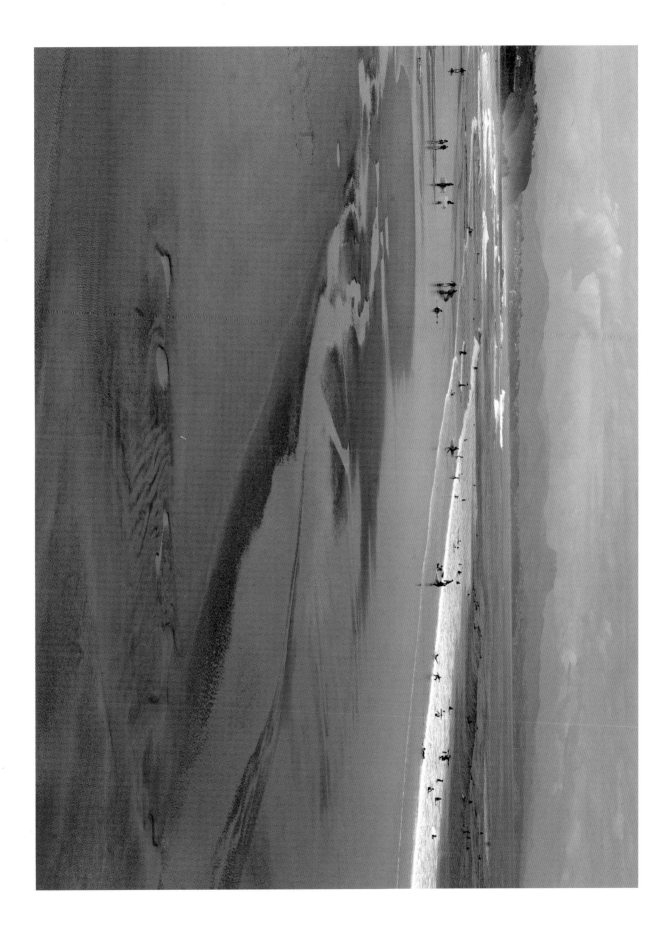

Opposite: Santa Cruz
Right: Biarritz at low tide

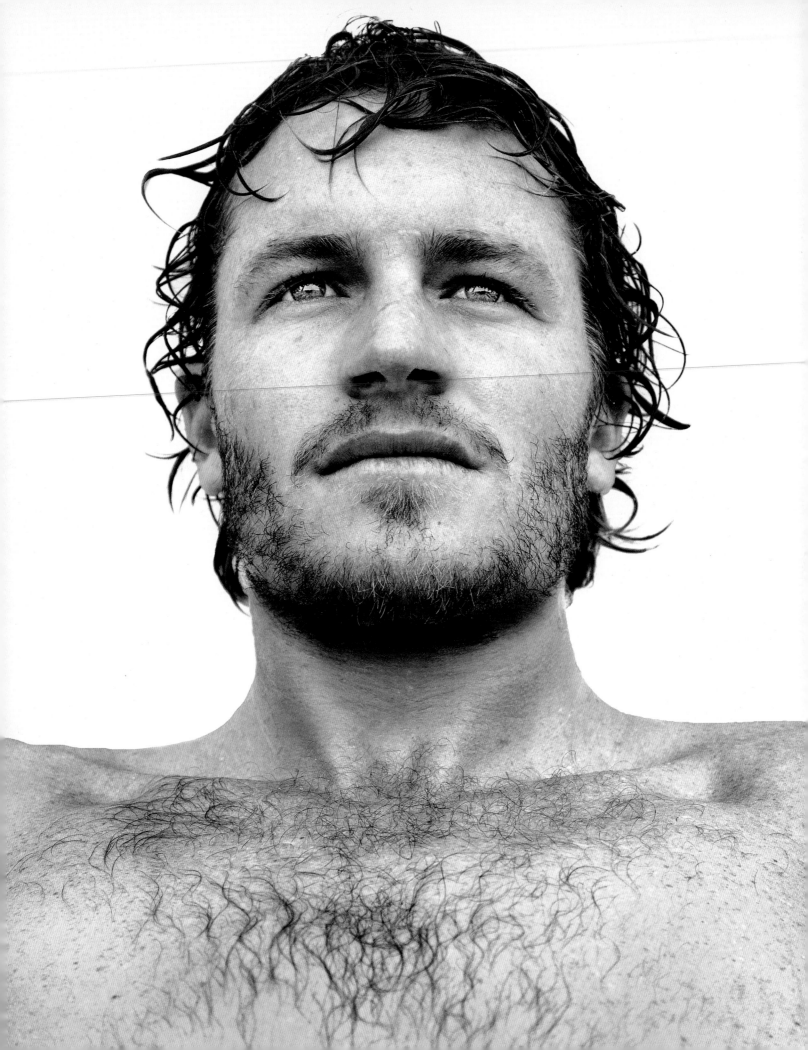

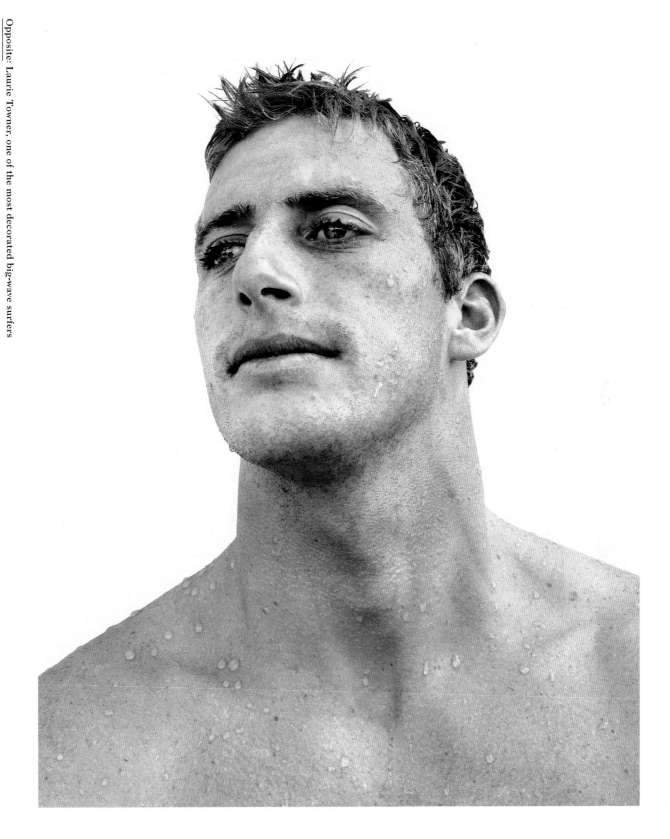

Opposite: Laurie Towner, one of the most decorated big-wave surfers
Right: Sebastian Zietz; in 2012 qualified for the Championship Tour while winning the Vans Triple Crown of Surfing; finished his debut season on tour ranked #16

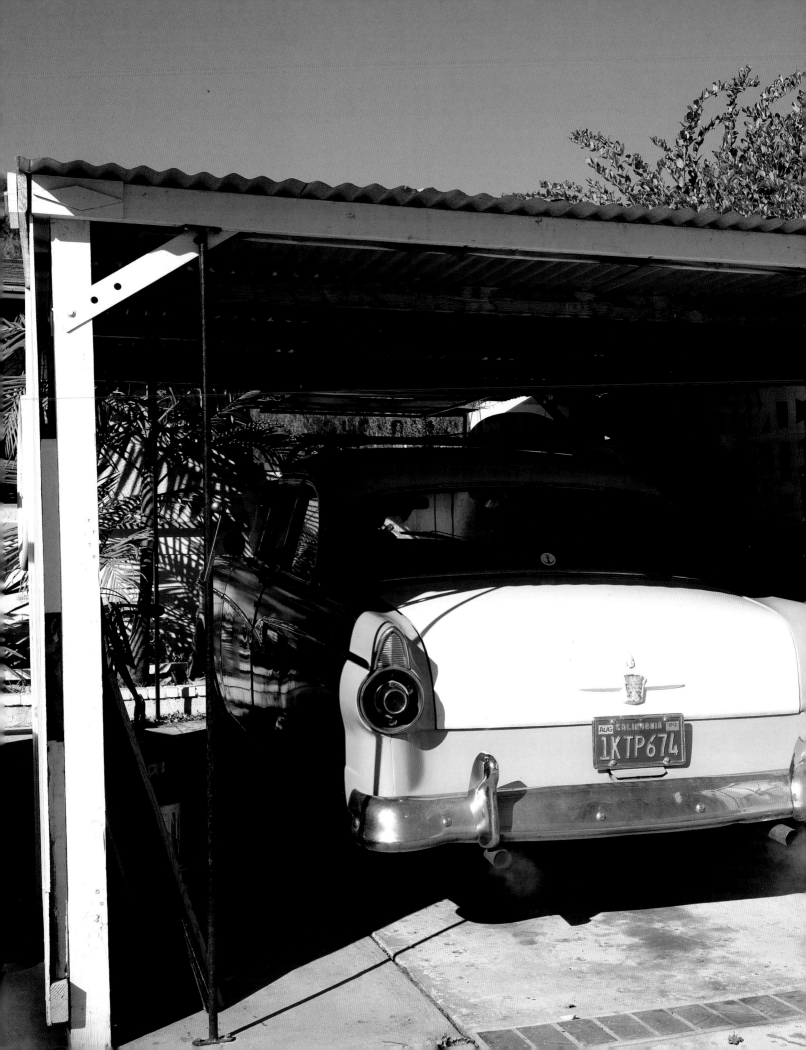

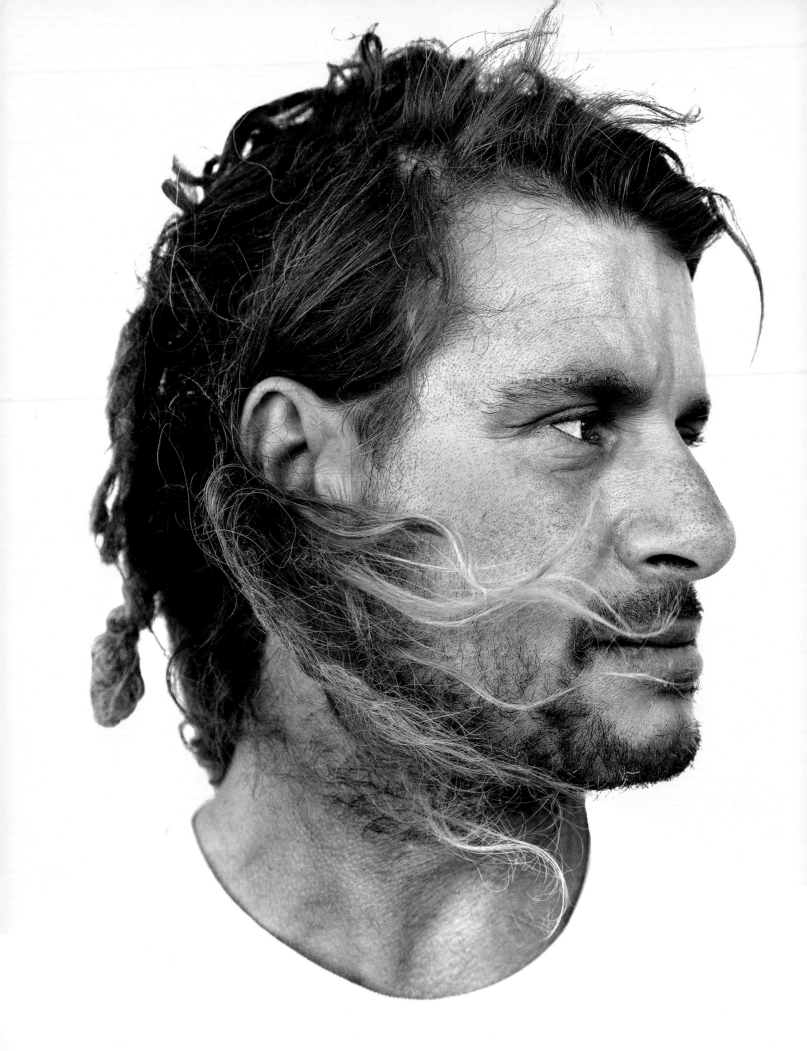

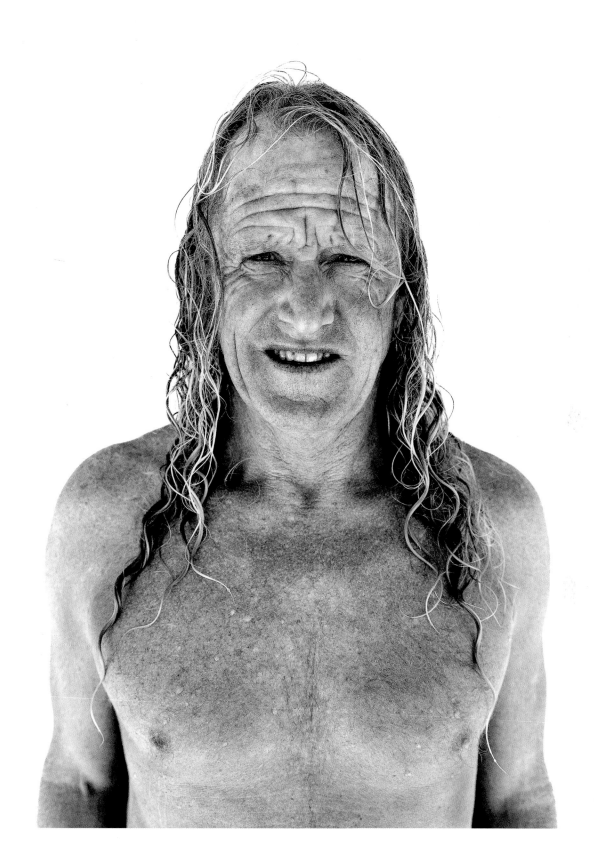

Opposite: Mark "Occy" Occhiupo, Australian surfer and winner of the 1999 ASP World title and 1985 Pipe Masters
Right: Skip Frye, shaper for Gordon & Smith who later launched his own brand

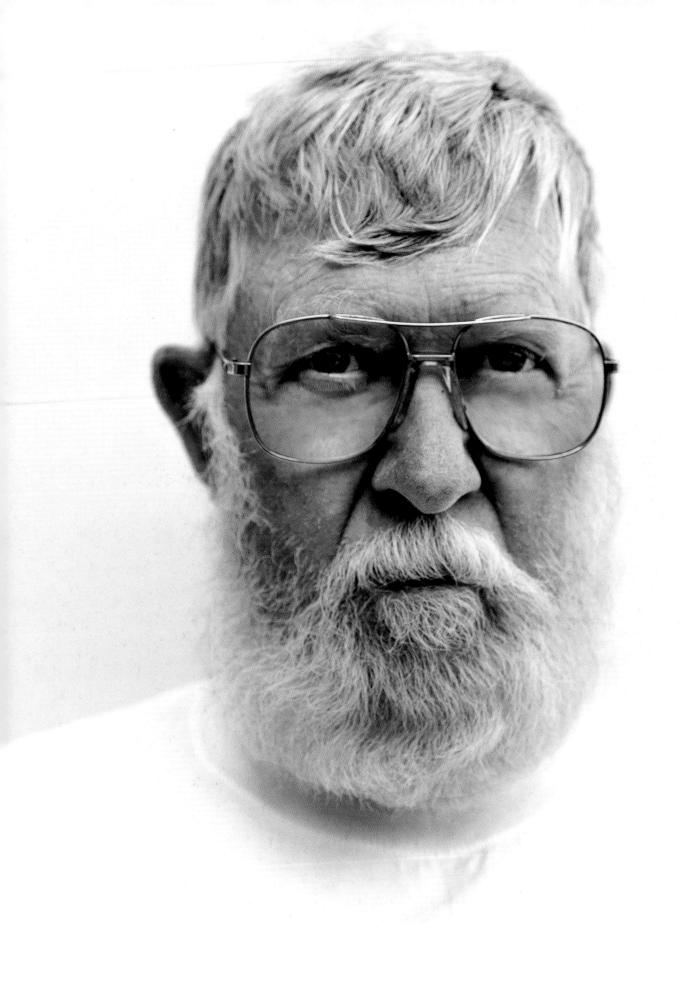

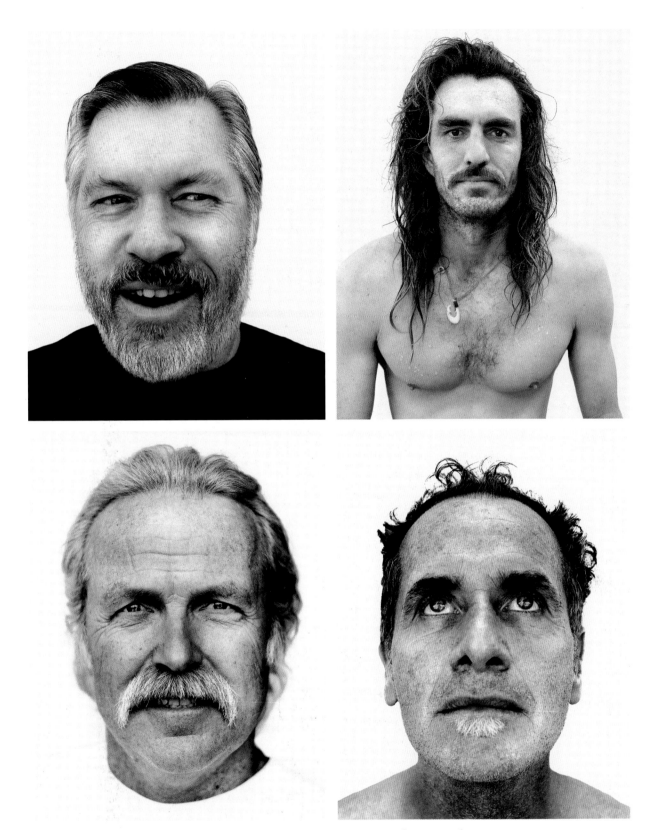

Opposite: Terry Martin, Hobie Surfboards shaper; holds record for most amount of boards shaped; sixty years and more than eighty thousand boards

Top left: Hobie Alter, owner of Hobie Surfboards company. Top right: Aamion Goodwin, pro surfer; says "World travel is the best educator for our kids." Bottom left: Bob Pearson, owner of Pearson Arrow Surfboards, Santa Cruz. Bottom right: Tim Bessell, surfboard shaper

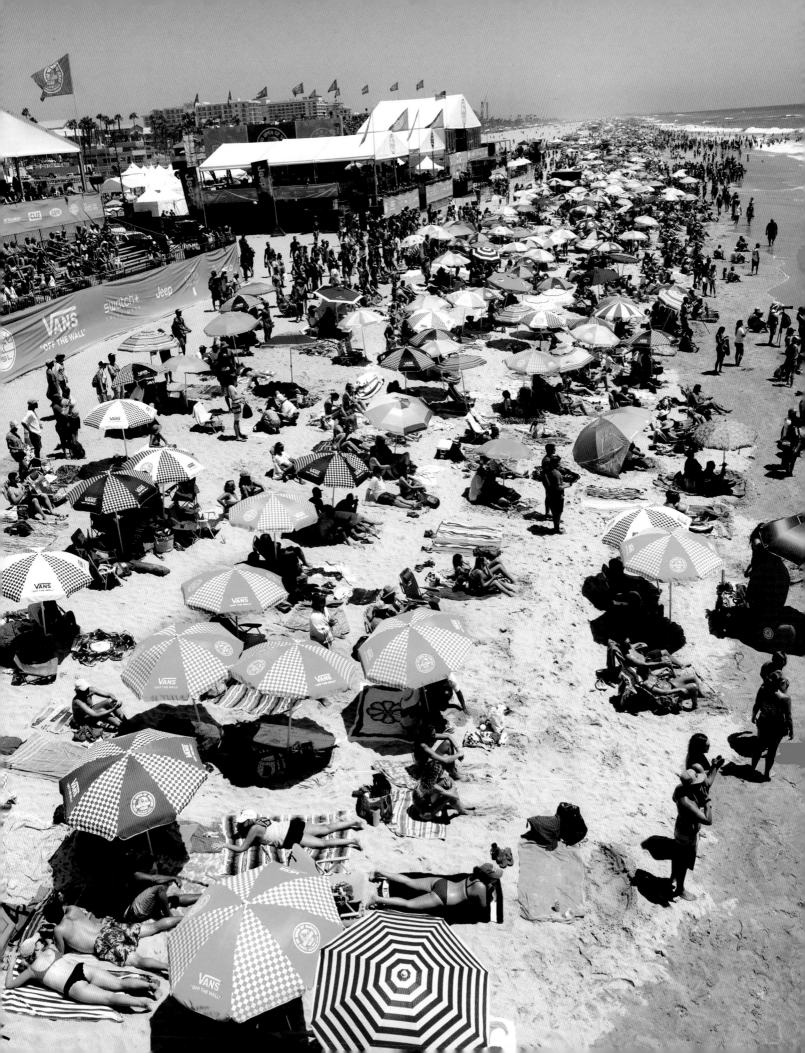

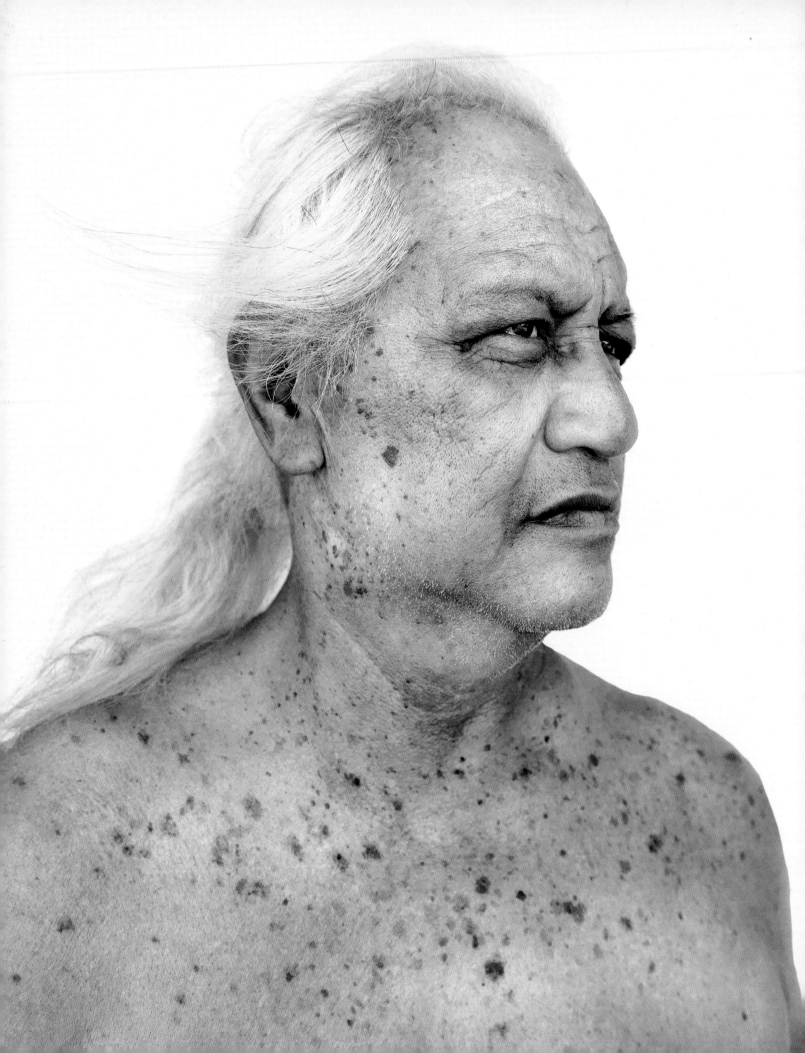

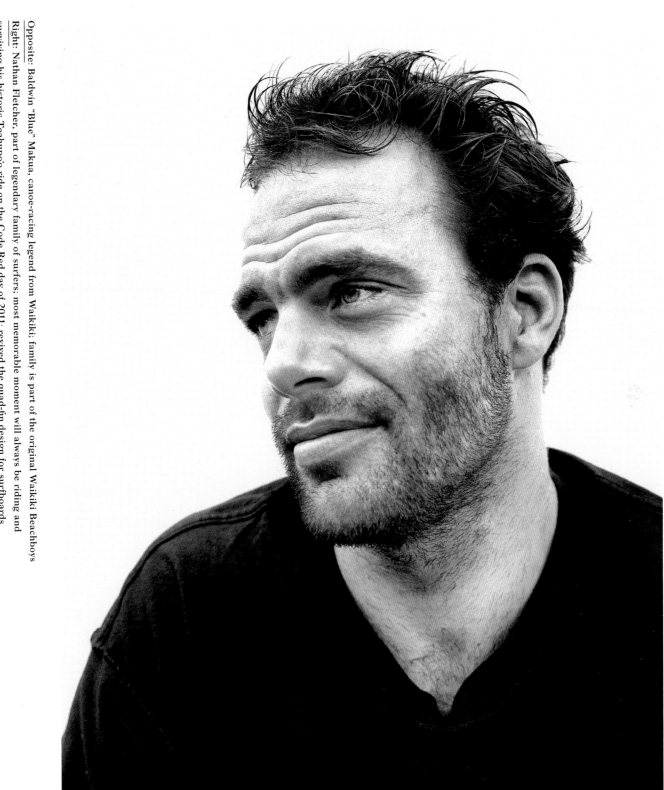

Opposite: Baldwin "Blue" Makua, canoe-racing legend from Waikiki; family is part of the original Waikiki Beachboys
Right: Nathan Fletcher, part of legendary family of surfers; most memorable moment will always be riding and surviving his historic Teahupo'o ride on the Code Red day of 2011; revived the quad-fin design for surfboards

Opposite: Bunger Surfboards, Long Island factory
Right: Outdoor shower, Montauk

Following spread, left: Sally Fitzgibbons. Following spread, right: Peter Mell, 2012/2013 Mavericks
Invitational Surfing Champion and surfing commentator, with son John, San Clemente

215

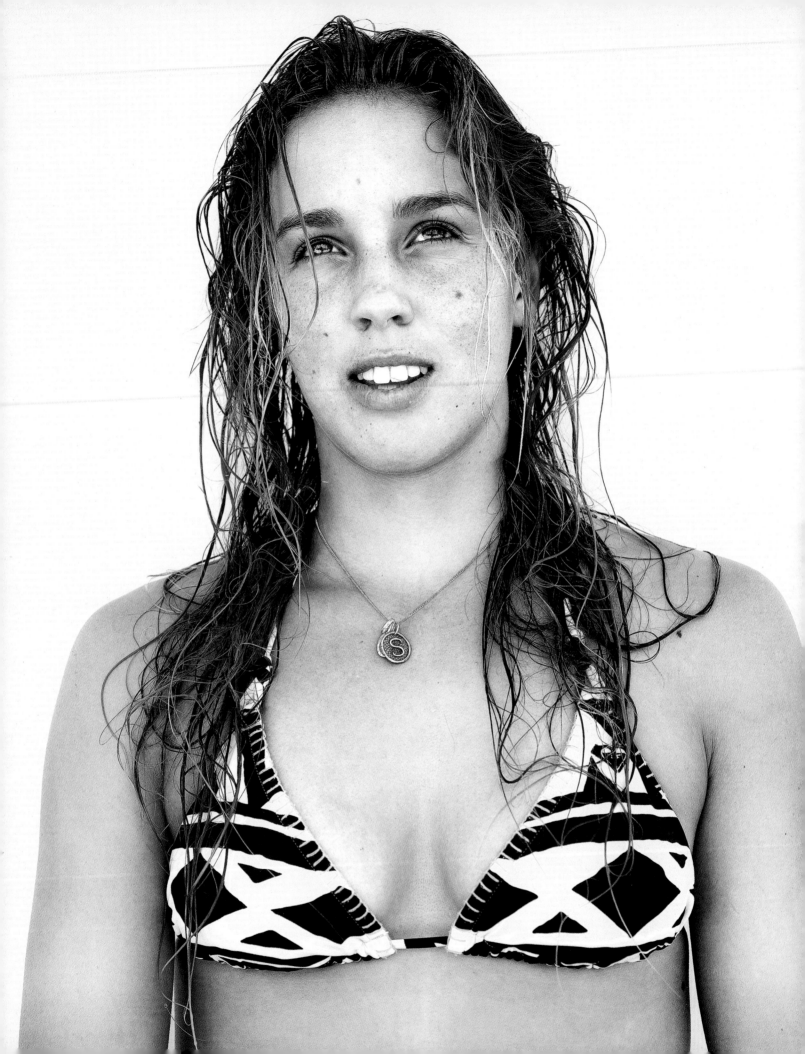

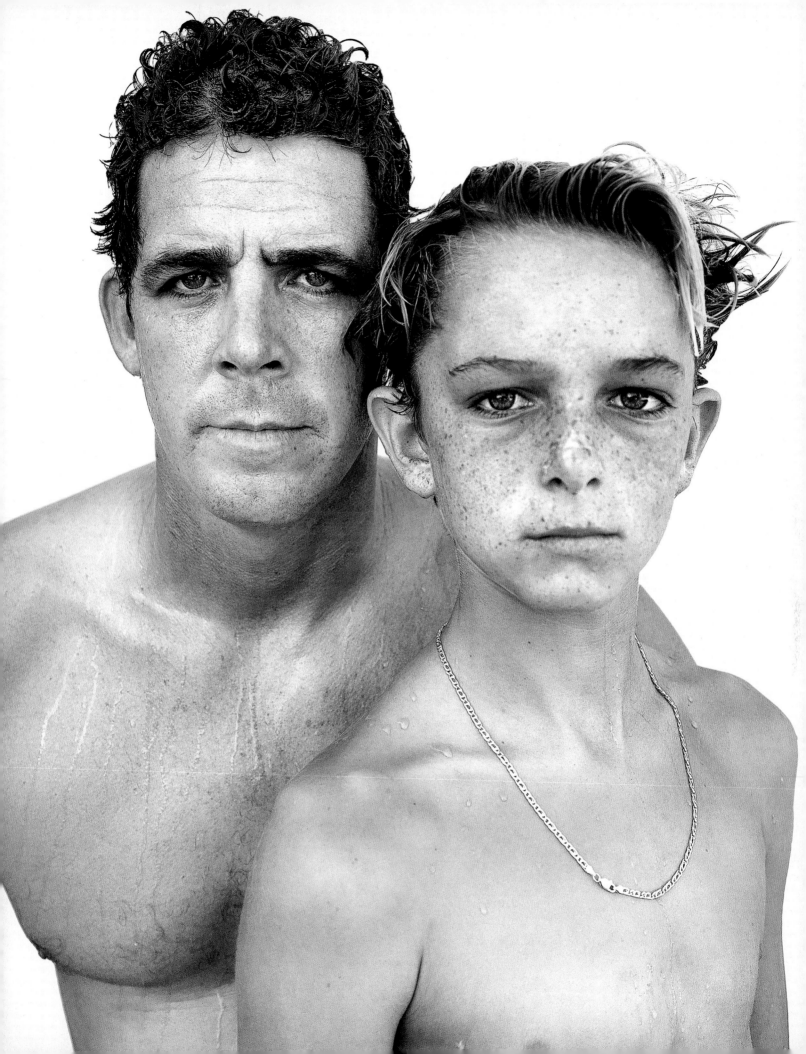

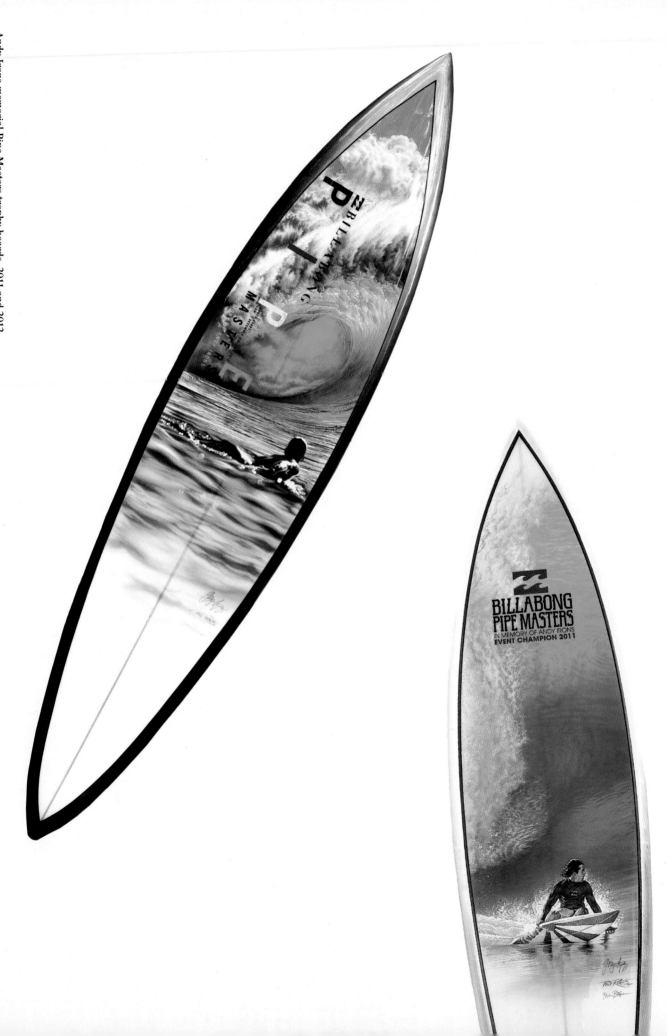

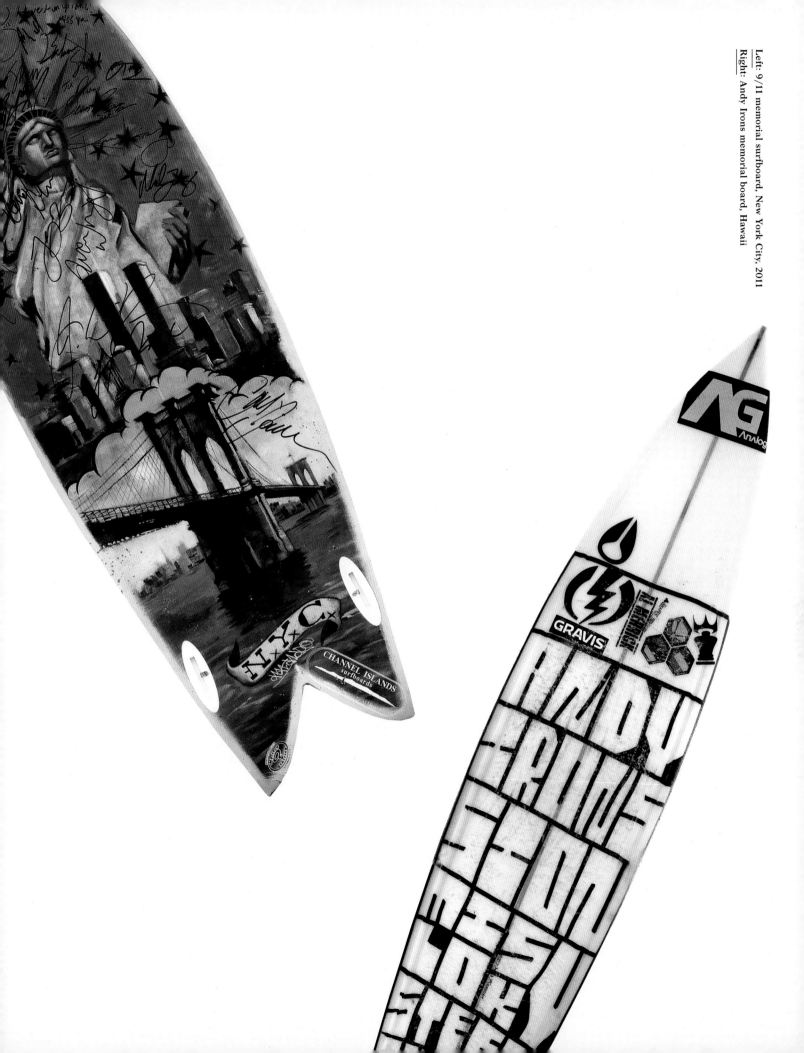

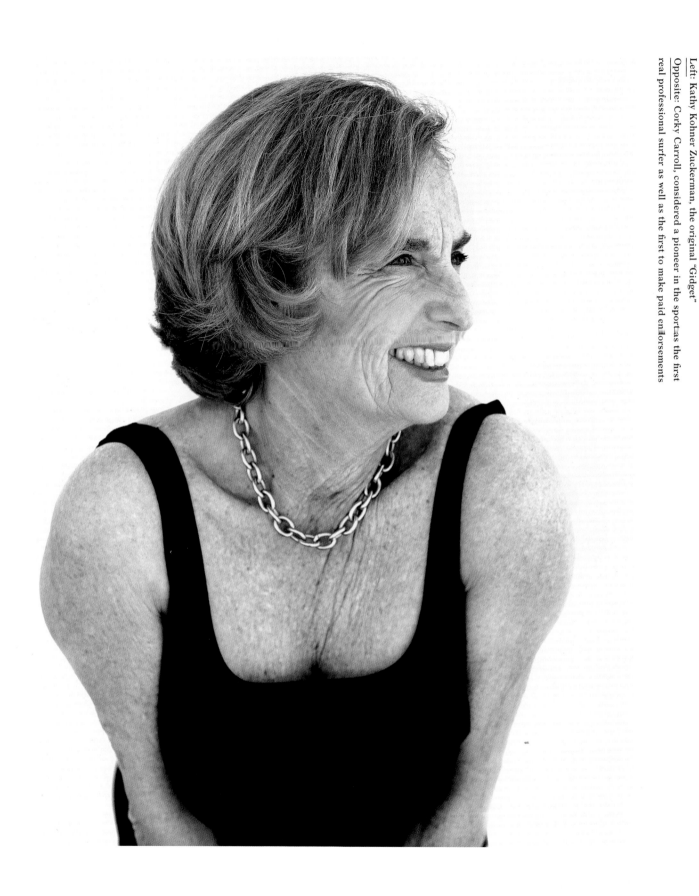

Left: Kathy Kohner Zuckerman, the original "Gidget"

Opposite: Corky Carroll, considered a pioneer in the sport as the first real professional surfer as well as the first to make paid endorsements

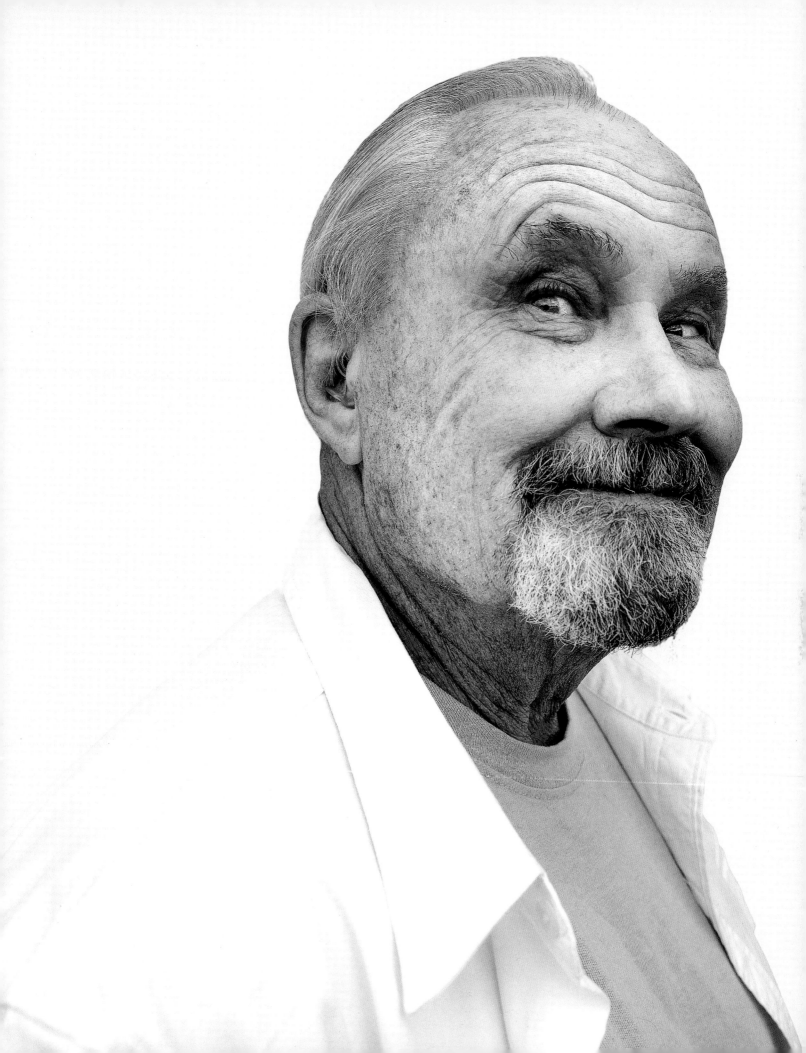

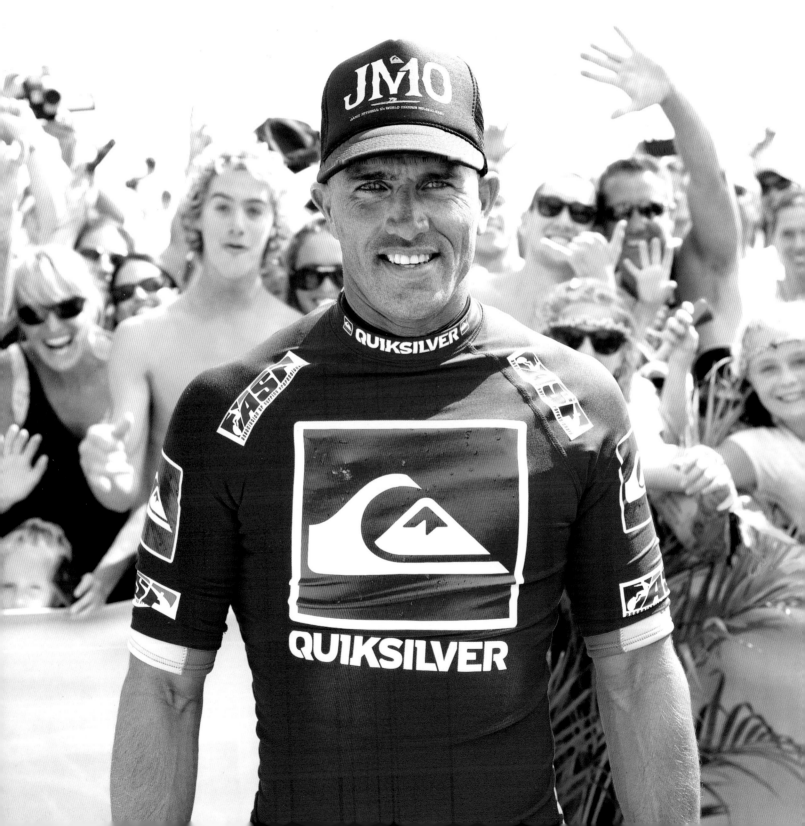

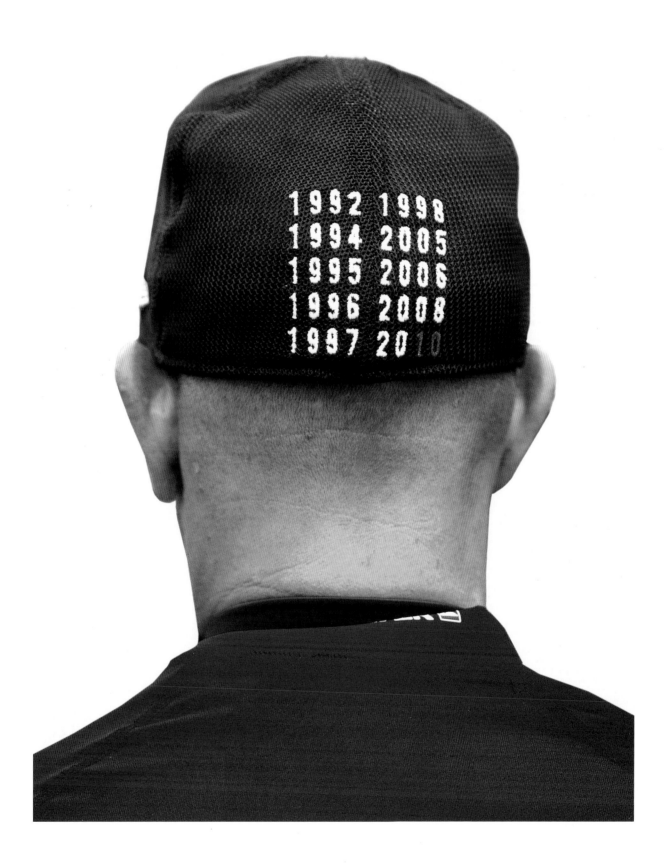

Opposite: Kelly Slater at Quiksilver Pro, New York, 2011
Right: Kelly Slater wearing hat listing world titles

223

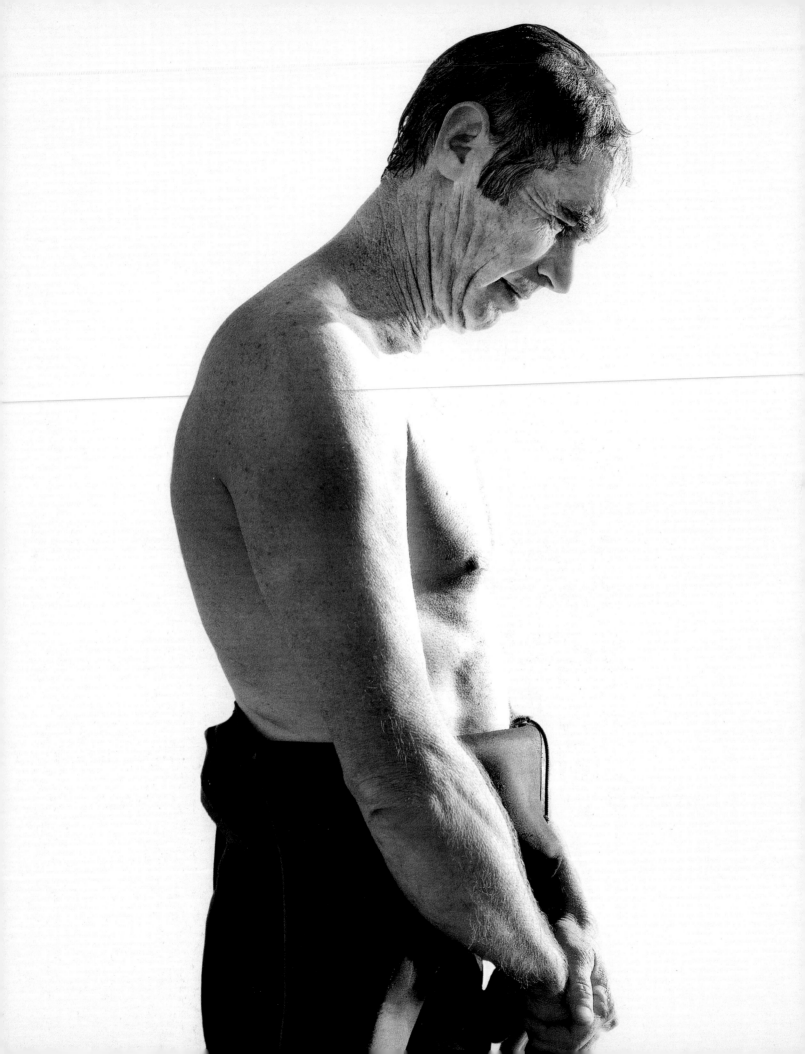

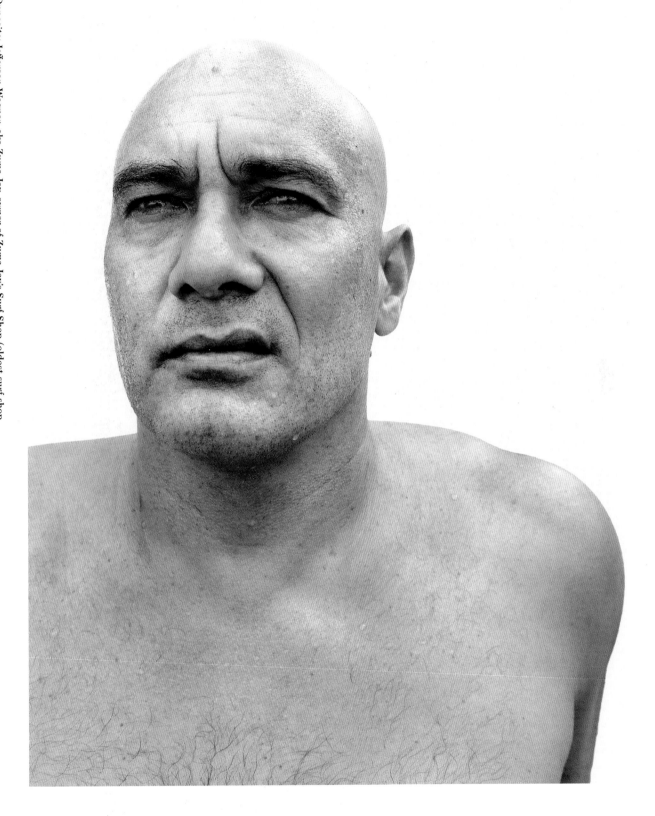

Opposite: Jefferson Wagner, aka Zuma Jay, owner of Zuma Jay's Surf Shop (oldest surf shop in Malibu); Hollywood stuntman and Clint Eastwood's stand-in; former mayor of Malibu

Right: Archie Kalapa, legendary Hawaiian big-wave surfer and waterman

225

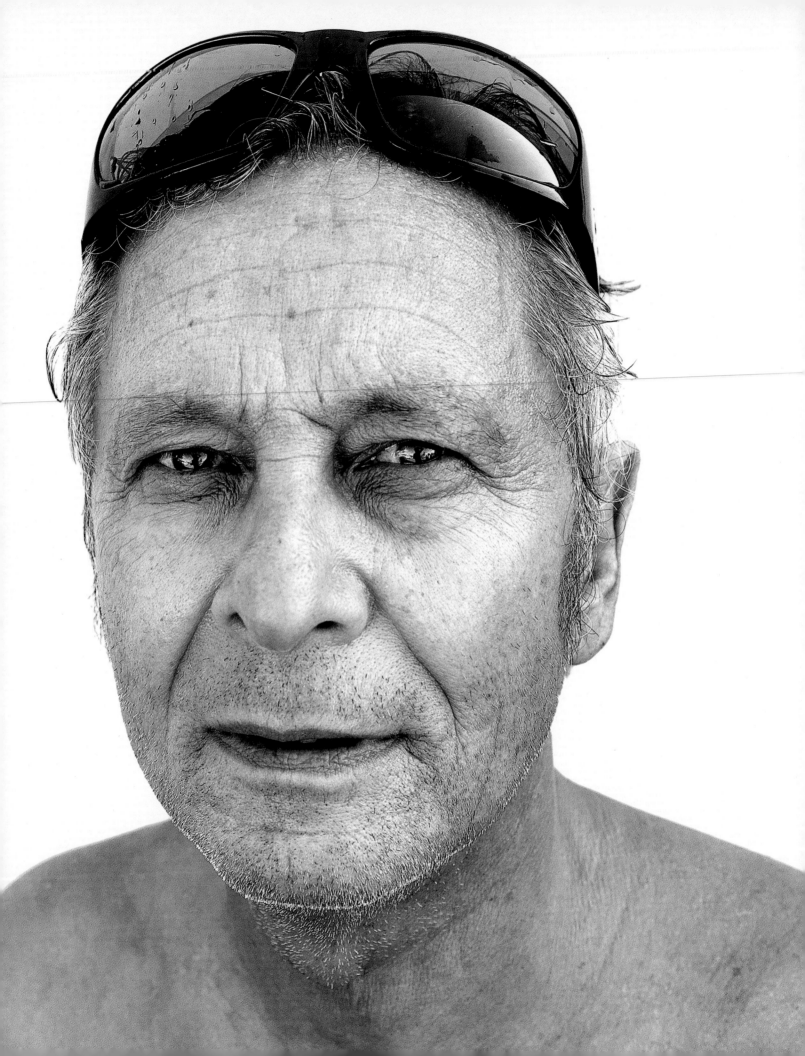

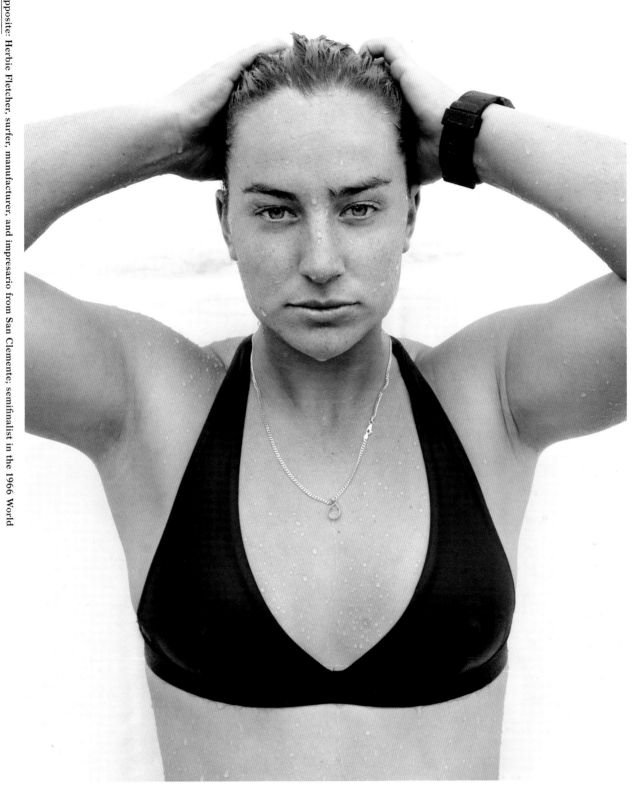

Opposite: Herbie Fletcher, surfer, manufacturer, and impresario from San Clemente; semifinalist in the 1966 World Surfing Championships; leader of longboard renaissance in the 1970s; owner of Astrodeck; father of big-wave surfer Nathan and arial surfing master Christian. Right: Tyler Wright, Australian pro surfer on the WSL World Tour, younger sister of pro surfer Owen Wright and currently the back-to-back WSL Women's World Champion (2016, 2017) of that era

227

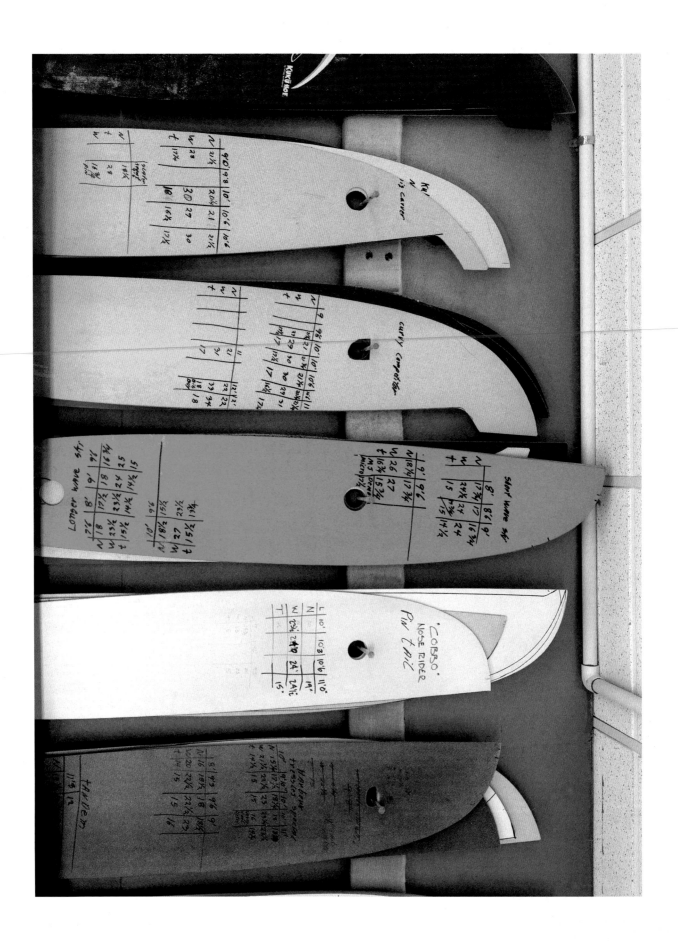

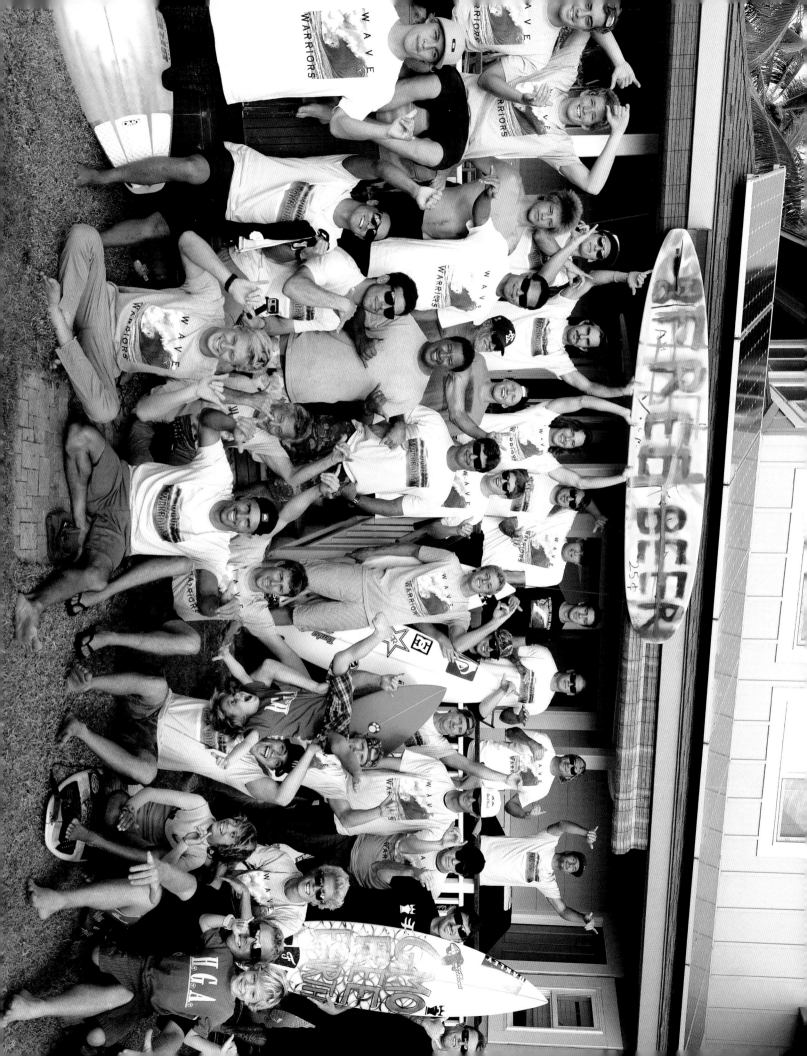

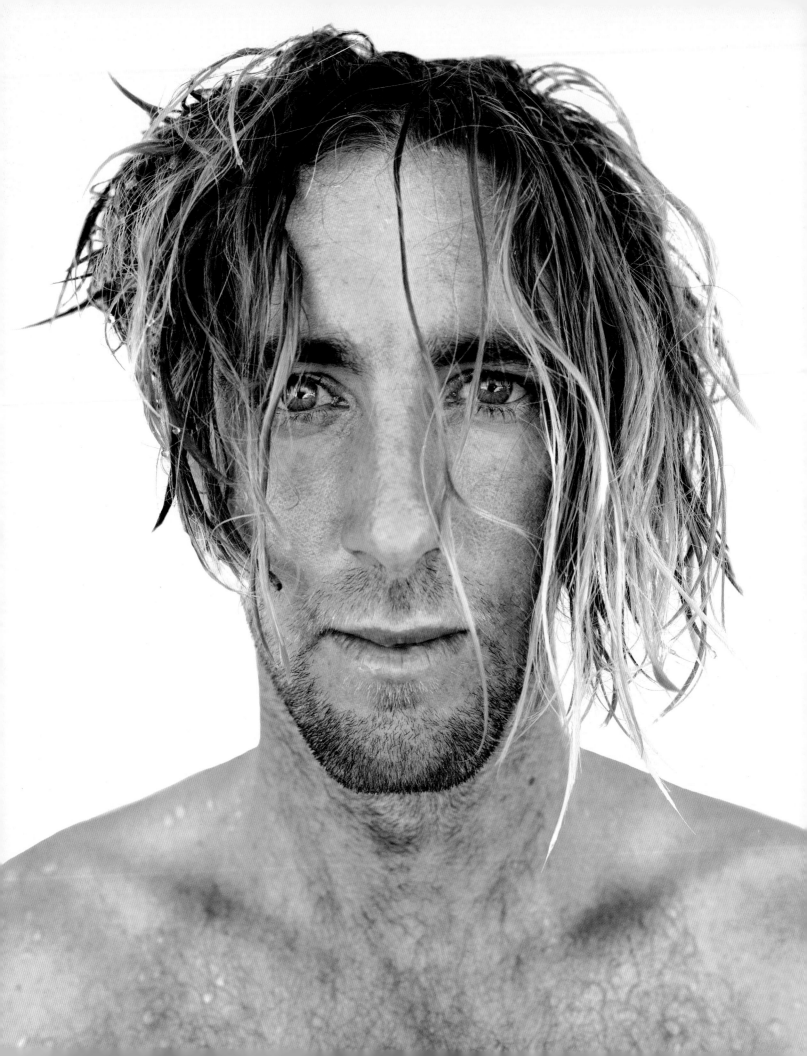

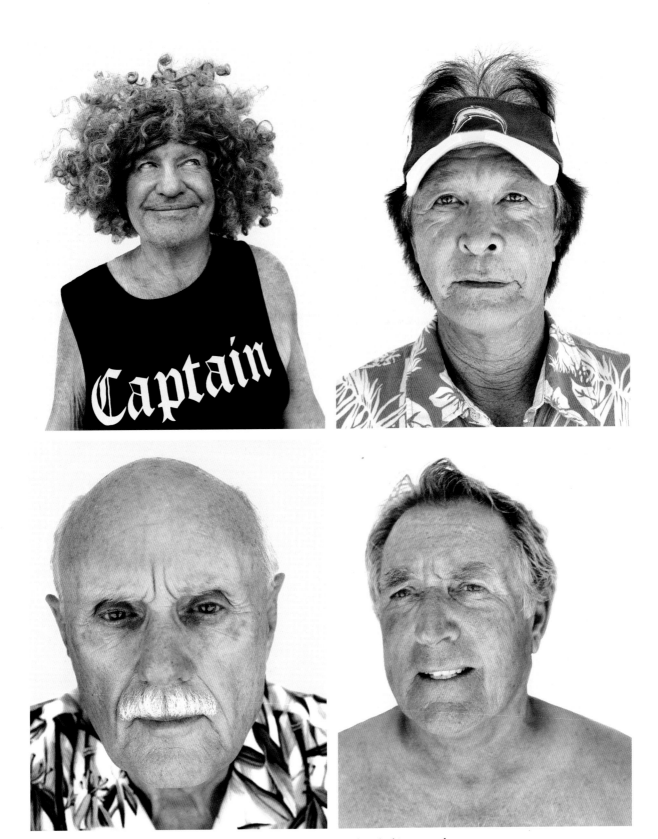

Opposite: Matt Wilkinson, pro surfer from Copacabana, New South Wales; winner of 2016 Quicksilver Gold Coast Pro and 2016 Ripcurl Bells Beach Pro on the WSL Championship Tour

Top left: Mike O'Brien, father of Jamie; since 1976, O'Brien pursued surfing the big waves of Oahu's North Shore full-time; acclaimed North Shore lifeguard. Top right: David Nuuhiwa, widely known for his soulful nose-riding and competitive surfing; regarded as the finest surfer of the 1960s. Bottom left: Dick Graham, cofounder of *Surfing* magazine. Bottom right: Steve Holt, original member of the "Hole in the Wall" surf team and an important part of the beginning of the "Surf City" image in California

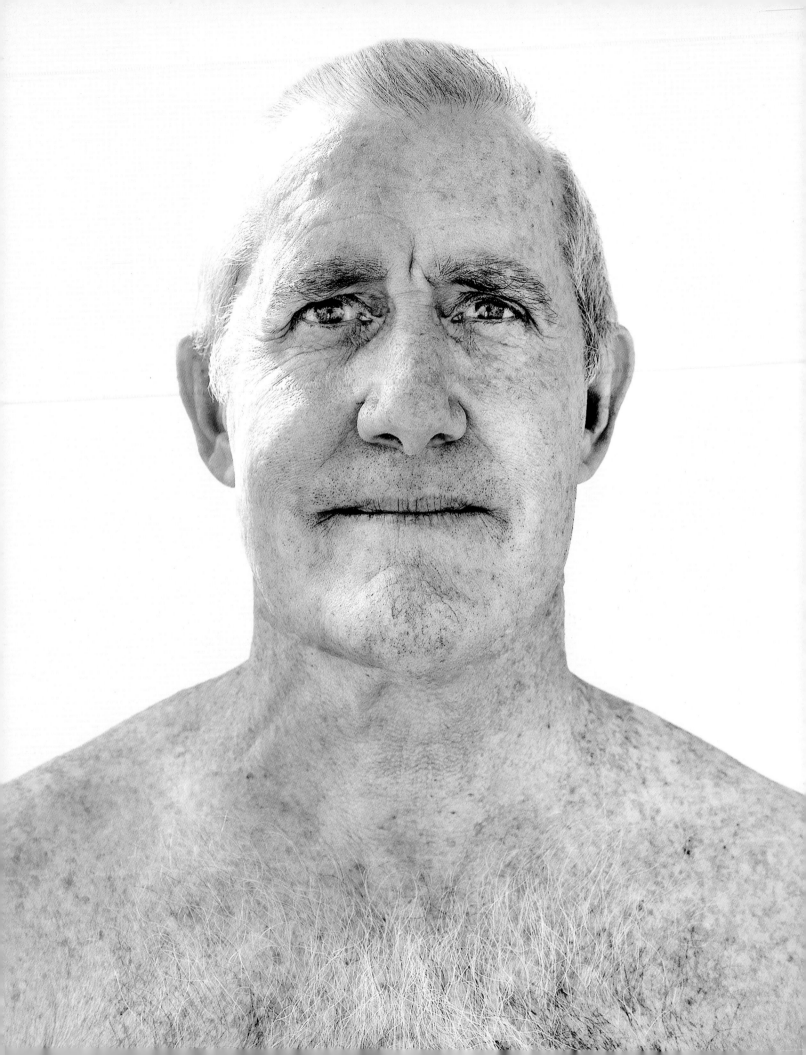

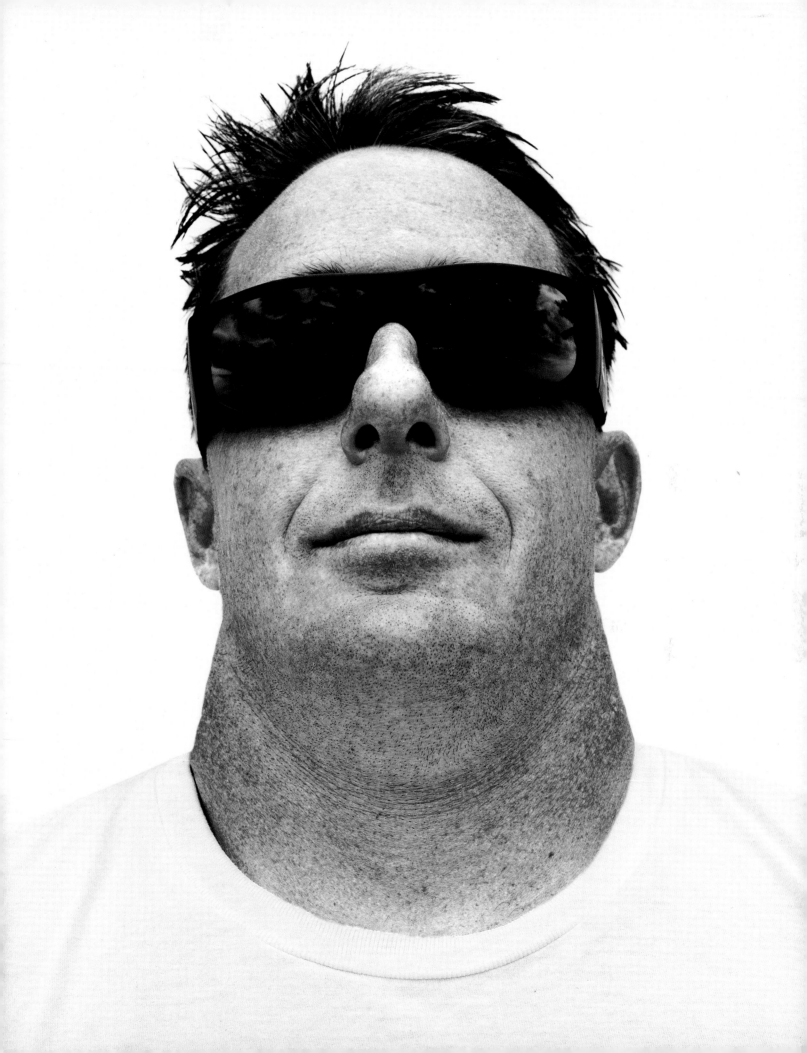

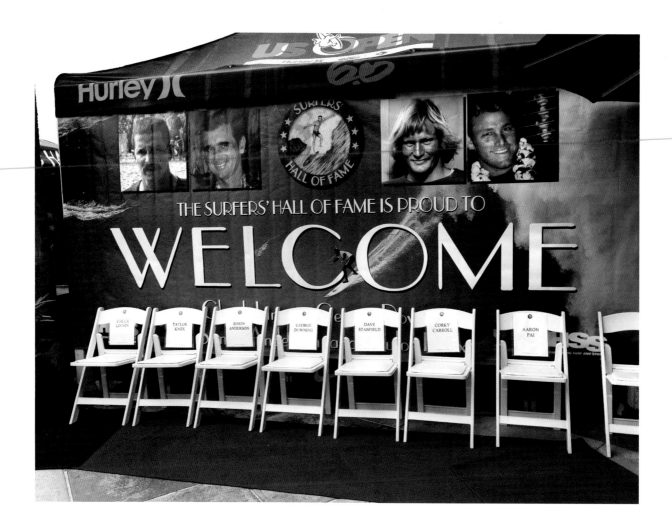

Inductees into Surfers' Hall of Fame, Huntington Beach, 2011

Previous spread, left: Jeff Hakman, first winner of Pipe Masters, co-founder
of surf company Quicksilver. Previous spread, right: Kalani Chapman, pro surfer

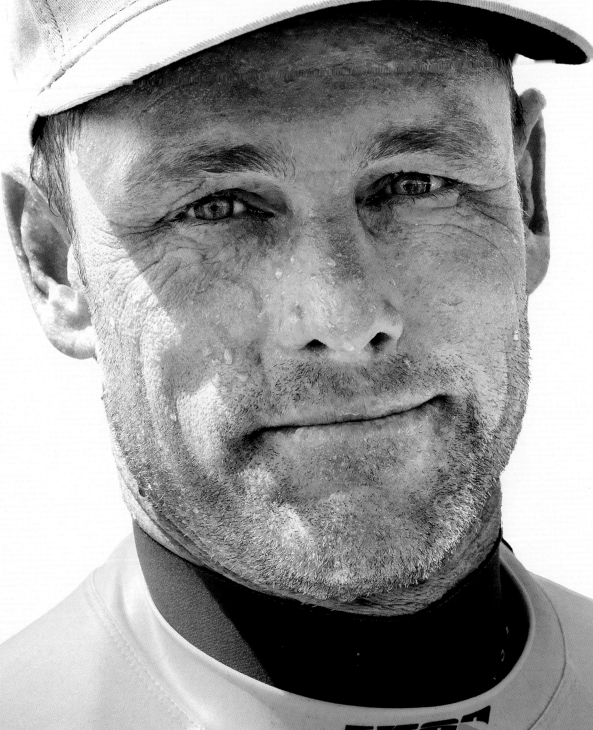

Opposite: Taylor Knox, celebrated pro surfer, inducted into the Surfers' Hall of Fame in 2015, said to have influenced an entire surfing generation. Top right: Taylor Knox, Surfers' Hall of Fame induction, Huntington Beach. Bottom right: 2017 induction into Surfers' Hall of Fame, Huntington Beach

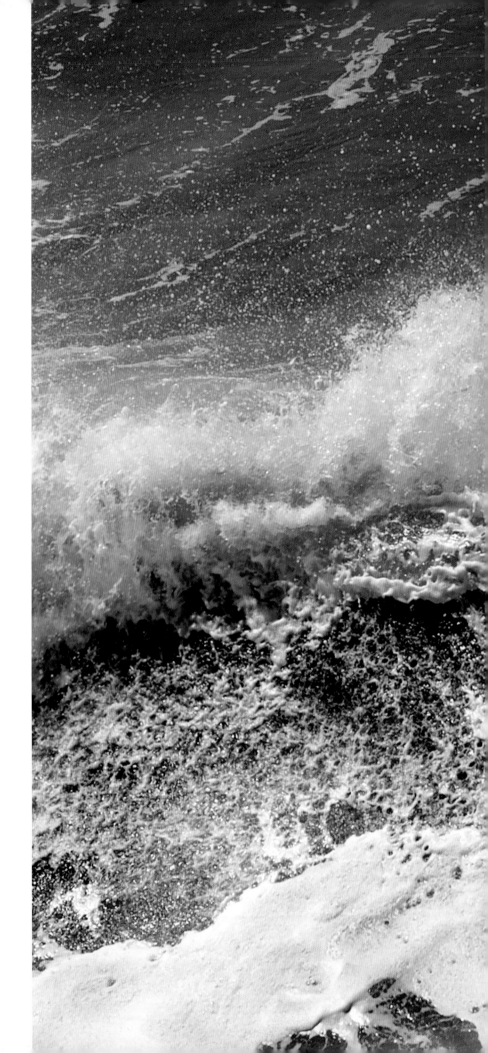

Joan Duro, Vans U.S. Open of surfing, 2017, Huntington Beach

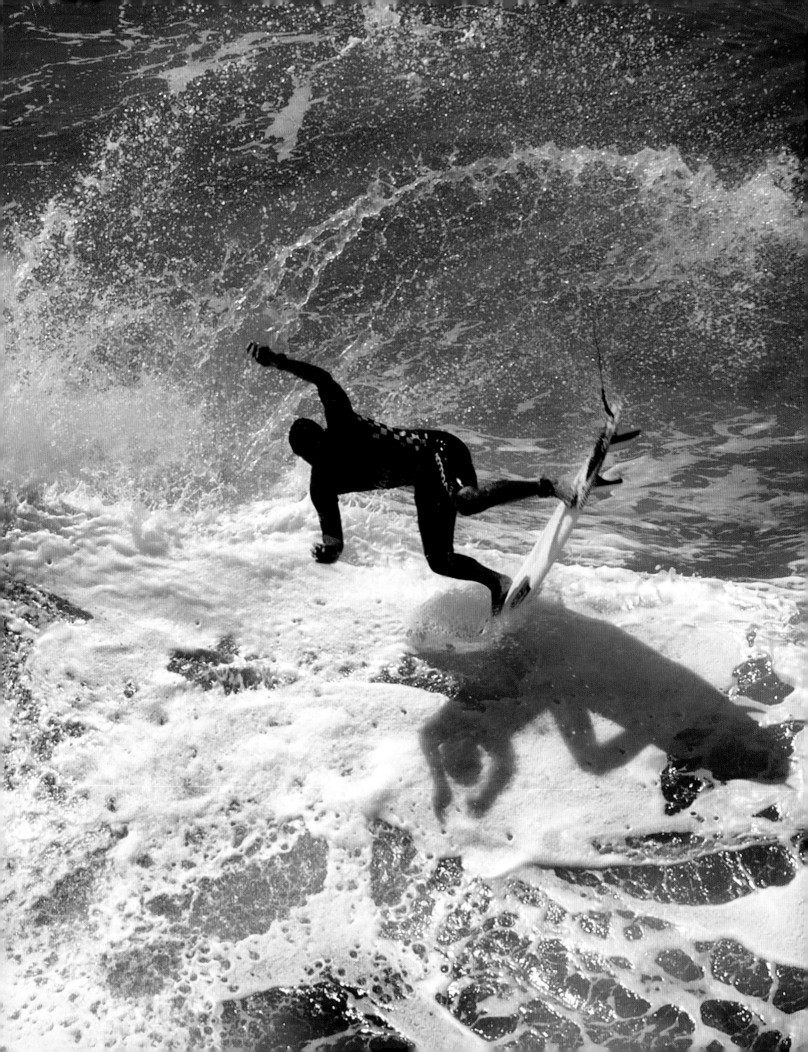

Acknowledgments

In memory of my good friend
David Spivack

Jodi Wilcott
Lauren Rolland
Steve Pezman
John Brancoti
Glen Gremillion
Amy Peterson
Eric Dieteman
Stephanie Goldman
Chris Pusey
Jeffrey Banks
Jane Lahr
Lyn DelliQuadri
Jed Noll
Barry Haun
 (Surfing Heritage Foundation)
Jared Henderson
 (California Surf Museum)
The good folks at Hasselblad USA

Contacts:

Literary agent: Lahr & Partners

Photo agent: Michael Ginsburg,
mg@michaelginsburg.com

thomgilbert.net

2X SUP World Champion
Surfer, Windsurfer, Kitesurfer, Stand up Paddler
Tow-in Surfer, foilboarder, Canoe Paddler
It is always about fun! Never give up

The SEA holds THE WATER OF LIFE

I was before MODERN SURFING

1961 U.S. SURFING CHAMPION #1
9TH INF. DIV VIETNAM - SURFED CAPE ST. JACQUES
FEATURED IN: CAVALADE OF SURF, BUD BROWNE
LOCKED IN
BETWEEN THE LINES

Surfing has helped me with life If It wasn't for surfing I wouldn't be here. I feel so lucky to travel the world and not knowing where I'll end up. Anyone can be a surfer. It's the Person who haves the most fun that inspires me.

Everyone needs a good board
in there life
Don't waste your life
go surfing.

North Shore Lifeguard 23 years
Big Wave Rider
Waimea & Sunset fixture in lineup for 5 decades

The GUARDIAN OF the SEA. Jose & Johnny. Angel. STAY in the Ocean.

Surf for 50 years
Surfed the world
Have my own Model Surfboards
Artist / Surfer

Still Surfing Age 90

Surfing Since the 50's. Team O'Neill life member. author of Surfing To Saigon. Featured in the movies! Cowell's & the New millenium, Between The Lines, Last Paradise & Santa Cruz Boardwalk

OLDEST Son of The LAST of The original Beach Boys FATHER was HARRY Rohello. MOTHER BARBRA KAHANAMOKU. I AM 3RD generation Kahanamoku 2nd generation Beach Boy. STILL in Waikiki. The only Thing I know is Waikiki. FOR Me Waikiki isn't A WAY of life iT is my life. IT's in The Blood.

SURFING Has ALLOWED ME ALL my opportunities in life.

2001 Triple crown cHampion

"NEVER GIVE UP ON YOUR Dreams"!

TOM ARNOTT Paddled w/duke 1943-1950
Canoe paddle, surfer, Sailor all around
Watermen - Volleyball w Sarge Kahanamoku 1947

Its a spiritual ride!!

I was ultra-lucky to have been raised among the real pioneers of the sport on the North Shore like Greg Noll and Jose Angel who took me under their respective wings - quite happy to be out in the waves with either or both of my 2 sons Matt and Kevin - surfing makes all else run smoothly. Aloha, Jock

1959 GOT STOKED, bought A boARD, WENT Surfing. BEEN DOING it EVER SINCE. WON THE MALIBU CLASSIC 2010 IN '60 AND OVER DIVISION.
Life long GUITARIST. DID SOUNDTRACK for GEORGE GREENOUGH'S "INNERMOST Limits of Pure Fun.
Co-wrote "BIG WEDNESDAY" with Director, JOHN Milius
GREW UP IN MALIBU, LEARNED TO SURF FROM THE GREATS - LANCE CARSON, MICKEY DORA, DEWEY WEBER, JOHNNY FAIN, AND KEMP AHBERG

6 Learned ^(surfing) from cousin King at
age 15 - always had a love of the ocean
Surfed Waikiki - Big Wave @ Makaha
20 feet

This guy is the Best.
He Knows what he is doing.
Plus, he has a Soul. Very very Deep!!!
Duh Dale

Started Hobie Sports retail store
with Hobie's blessing and ran them
for 35 years. Started Surfing
Heritage in 1999 in order to save
in perpetuity the History of
surfing for the World to enjoy.

Keep Surfing
R.B.

Surfing started in 1966 here on Oahu
Jock Sutherland was my first surfing here
and later influenced by Reno Abellira. I
had a meteoric rise into surf stardom in the
70's and by the mid 1980's I had taken
performance surfing at Sunset Bch to
a new level. Always loved surfing Sunset!

Ex Teacher High School Calif & Australia
Make Pearson Arrow Surfboards
Made over 70,000 Boards shipped all over the world
Rated #2 pro surfer on the mainland in 1975
"stay in the water + stay stoked"

a Ke Ak

Born on the westside of Oahu
Started surfing in 1979 and still in
love with surfing now. (I Love surfing
and thats all people need to know about
me!)

Founder, Editor Publisher - Surfing Magazine
VP Hang Ten International
President Lightning Bolt International
Stay Wet - It'll work for Ya!

"you can't choose how you die but you can
choose how you live"
I've been blessed to grow up in Hawaii and surf
in the shadow in the best surfers in Hawaii.
I'm honored to have had the opportunity to have
seen some of the best out at the best surf spots,
that's enough for me.

My DAD "First Surfed Malibu in the late 40's with
Simmons. The Night I was Born my Parents were
Playing Cards with MATT Kivlin and HIS Wife.
I've Surfed my whole Life... CAN't imagine not
Being ABLE to. OFTEN think what People what
Don't Surf Think About all Day.
Being A Surfer at MALIBu is Frustrating
HAVING A History there... even worse?
the thought of Being at MALIBu
During my DAD's Time ohhh

Can't leave, Can't sleep, Can't
talk about it. Something about
warm + salt mixed. AT 3 my
Parents took me to a lake,
I ran away from them, ran off
a dock + held my breath under water
until my mom pulled me up by my hair.
It's been a lot of
fun

TELL DEZMAN I'm STILL TRYING